NEW COUNTRY

teNeues

CONTENTS
INHALT

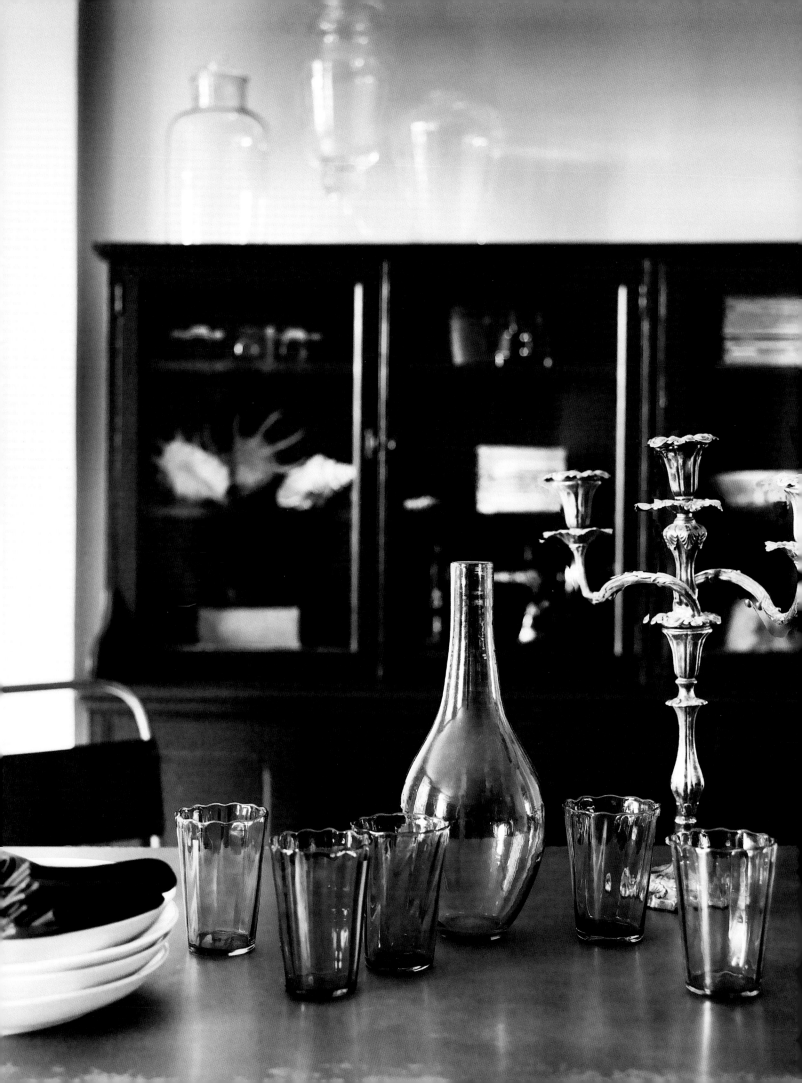

INTRODUCTION

These days, there are as many ways to live in the country, as there are to live in the city. Some spaces do simple. Imagine stripped-back, creamy lime plaster walls and austere paving slabs on the floors. Elsewhere, others make a feature of heirloom furniture emphasizing lots of ticking-striped cushions and deep, velvet-covered sofas huddled around the fire.

As far as decoration diktats go, the New Country look has undergone a renaissance. Long gone is the chintz, where rooms were stacked to their wallpaper seams with stuff. Today, the clued-up rural retreat is unfettered by the past, combining carefully selected ceramics, art, and furniture with a variety of styles and eras. At once charmingly period and strikingly modern, the most fashionable homes in the countryside know how to mix old and new with aplomb.

In this book, we look room-by-room, situation-by-situation at interiors that reset the needle on the modern, country look. From black-painted, timber cottages on the Scandinavian coastline to converted haylofts on the edge of somewhere wild, the chapters are packed with inspirational homes, beautiful color schemes and step-by-step guides on getting the look.

Be it an open-plan, glass-fronted contemporary barn or an eclectic interior filled with timeless furniture, what ties each of the special homes featured in this book is that they are all big on comfort and high on personal style. Which is exactly why they work so well. Like a much-loved pair of Stan Smiths or a luxurious cashmere sweater, the New Country look is something you will never grow out of.

EINLEITUNG

Auf dem Land findet man heutzutage genauso unterschiedliche Einrichtungsstile wie in der Stadt. Manche mögen es schlicht, mit cremeweiß getünchten Wänden und kargen Steinfliesenböden. Andere setzen lieber alte Familienerbstücke in Szene und gruppieren gemütliche samtgepolsterte Sofas um einen Kamin.

Der Landhausstil erlebt eine Renaissance und hat sich von alten Diktaten befreit. Das Ergebnis heißt New Country. Längst passé sind die Zeiten der Chintz-Bezüge, in denen die Räume bis zum Blümchentapetenrand mit Nippes vollgestopft waren. Heute hat sich der angesagte ländliche Rückzugsort von den Fesseln der Vergangenheit befreit und kombiniert munter sorgfältig ausgewählte Töpferwaren, Kunstobjekte und Möbel aus verschiedenen Epochen und allen möglichen Stilrichtungen. Charmant nostalgisch und atemberaubend modern in einem: Die schicksten Häuser auf dem Land wissen, wie man Altes und Neues mit Aplomb mixt.

In diesem Buch werfen wir Raum für Raum einen Blick auf Interieurs, die den modernen Landhaus-Look neu definieren, – von rot gestrichenen Holz-Cottages an der skandinavischen Küste bis hin zu umgebauten Heuböden mitten in der freien Natur. In den einzelnen Kapiteln werden inspirierende Häuser, ansprechende Farbkonzepte und Tipps für die Umsetzung dieses Looks in den eigenen vier Wänden präsentiert.

Ob stylish umgebaute Scheune mit Glasfront oder Ferienhütte samt bunter Mischung aus zeitlosem Mobiliar: Allen in diesem Buch vorgestellten Häusern gemeinsam ist ihr Fokus auf Komfort und einen ganz persönlichen Stil. Deswegen wirken sie so überzeugend. Wie das heißgeliebte Paar Stan Smiths oder ein luxuriöser Kaschmirpulli ist der New-Country-Look etwas, wovon man nie genug bekommen kann.

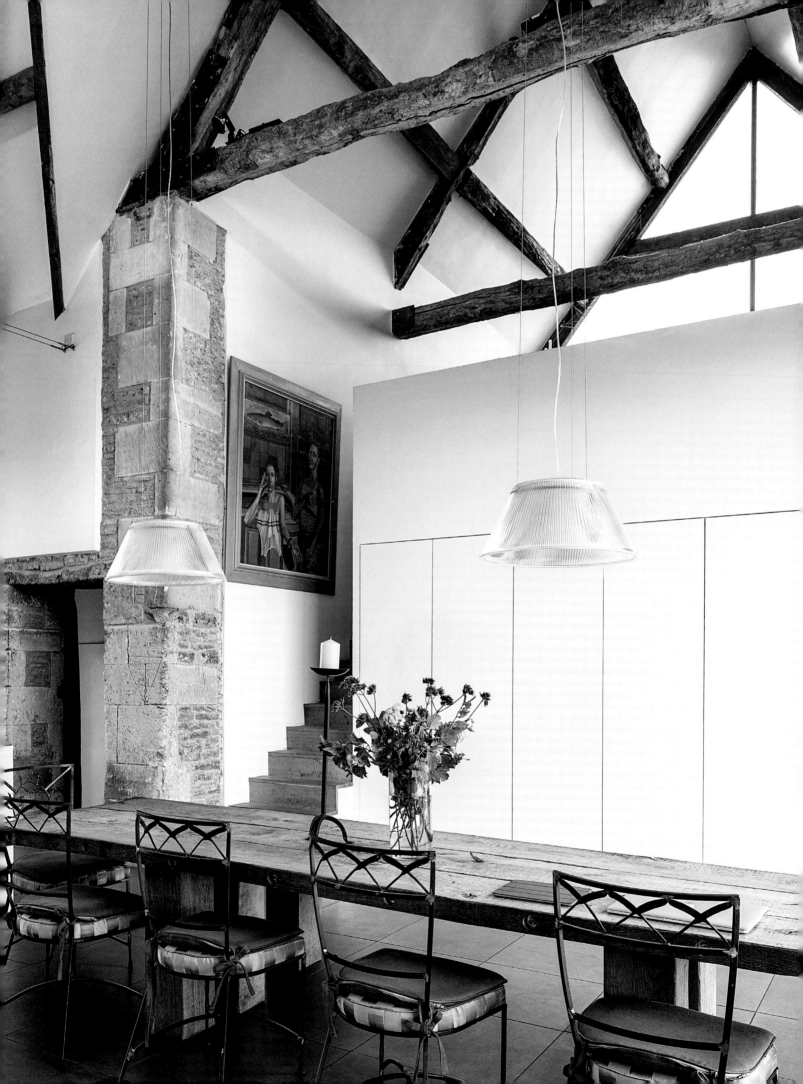

01

THE MODERN BARN

Once a run-down outbuilding or maybe a former mill, the modern barn conversion is light, open, and inviting. Capped by a vast timber roof, walls are knocked down to embrace the interior space, and floor-to-ceiling windows make the most of the high ceilings. This isn't a polite renovation, but a theatrical, architect-designed dream. Full of life-enhancing tech—floors are heated, the walls are insulated, and speakers are built in—it is the antithesis to the traditional country cottage with space to swing several cats.

Inside, the look is less rustic and more an opportunity to relish the industrial space. Think wraparound mezzanine areas that look down over a medieval-style hall and glass partitions that make a subtle room divide. Keeping the feeling of an open-plan space, doors slide on tracks or are done without, varying the floor or ceiling heights instead. Bare of curtains, the windows frame the views of the garden so they form part of the interior decoration.

Yet, this austerity is just an illusion. A wood-burning stove makes things cozy, and the enormous feather-filled sofas make it the perfect party pad. This look— the minimal-but-not-monastic décor accessorized with comfortable furniture—is what New Country looks like when you pare down the fuss. Frilly, floral sofas are swapped for low-level modular types with toe-sinking, shaggy carpets in front. Key points to note: original features of the building are retained and there are a lot of natural materials—craft is very much in favor here.

DIE MODERNE SCHEUNE

Was früher mal ein Wirtschaftsgebäude oder eine Mühle war, wird nun zu einer hellen, offenen und einladenden Behausung umgebaut. Unter der gewaltigen Konstruktion aus Deckenbalken werden Wände eingerissen und raumhohe Fenster eingesetzt, um die beeindruckenden Dimensionen des Raums voll zur Geltung zu bringen. Dies ist keine nette kleine Renovierung, sondern ein spektakulärer Architektentraum. Hinter und unter den Oberflächen pulsiert Hi-Tech: Fußbodenheizung, eingebaute Lautsprecher, isolierte Wände. Das Ganze ist die Antithese zum traditionellen Häuschen auf dem Lande. Hier kann man Luftsprünge machen, ohne sich den Kopf zu stoßen.

Das Interieur ist eher industriell als rustikal. Man stelle sich umlaufende Emporen vor, die auf eine mittelalterlich anmutende Halle blicken, und Trennwände aus Glas als unauffällige Raumteiler. Um den Eindruck des offenen Raums nicht zu zerstören, gleiten Türen entweder auf Schienen auf und zu oder fehlen ganz. Vorhanglose Fenster rahmen die Aussicht auf den Garten ein, der so zum Bestandteil der Innendekoration wird.

Der strukturellen Strenge wird mit Gemütlichkeit verbreitenden Einrichtungsstücken wie einem Holzofen und riesigen mit Daunen gepolsterten Sofas entgegengesteuert. Ein minimalistisches, aber nicht komfortfeindliches Dekor mit bequemem Mobiliar: Das ist New Country. Die im Landhausstil üblichen rüschigfloralen Sofas werden durch niedrige modulare Sitzelemente ersetzt. Davor liegen dicke, weiche Teppiche, in denen man knöcheltief versinkt. Die Grundprinzipien des modernen Scheunenstils: Originalteile des Gebäudes erhalten und viele Naturmaterialien einsetzen. Traditionelles Handwerk wird dabei großgeschrieben.

STYLE IN BRIEF

From exposed stone, large wooden dining tables to light and bright open-plan spaces, the modern rustic barn evokes a relaxed yet stylish mood. Go sleek with the kitchens, dreamy with the sofas, and bold with the lighting—all generously proportioned to fill up the space.

STIL KURZ GEFASST

Freiliegende Steinmauern, ein großer Esstisch aus Holz, helle, offene Räume: Die moderne Scheune verströmt eine entspannte und gleichzeitig stylishe Atmosphäre. Die Küche ist elegant und funktional, die Sofas verträumt, die Beleuchtung gewagt – und alle Proportionen sind großzügig bemessen, um den Raum auszufüllen.

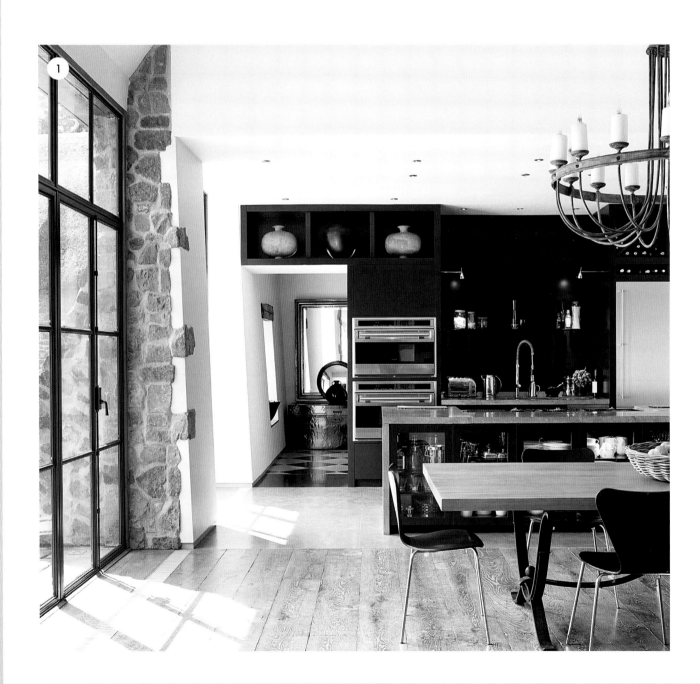

1 | *Lots of natural light showcases this sleek, state-of-the-art kitchen.* 2 | *Floor-to-ceiling windows make the most of the high ceilings.* 3 | *This bold, folding door opens up to create a dramatic indoor/outdoor space.*

1 | *Die hochmoderne Küche mit glänzenden Fronten wird von viel natürlichem Licht in Szene gesetzt.*
2 | *Raumhohe Fenster nutzen die Deckenhöhe optimal aus.*
3 | *Wenn diese ungewöhnliche Schwenktürkonstruktion offen steht, fließen Innen- und Außenbereich harmonisch ineinander.*

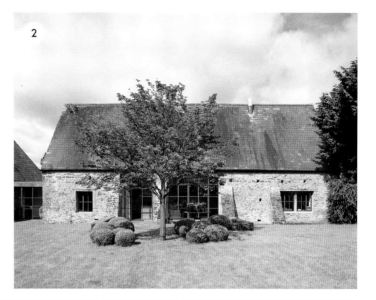

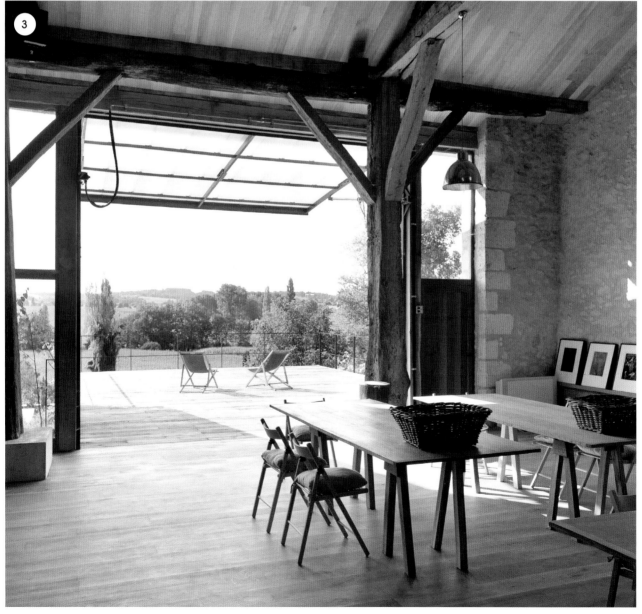

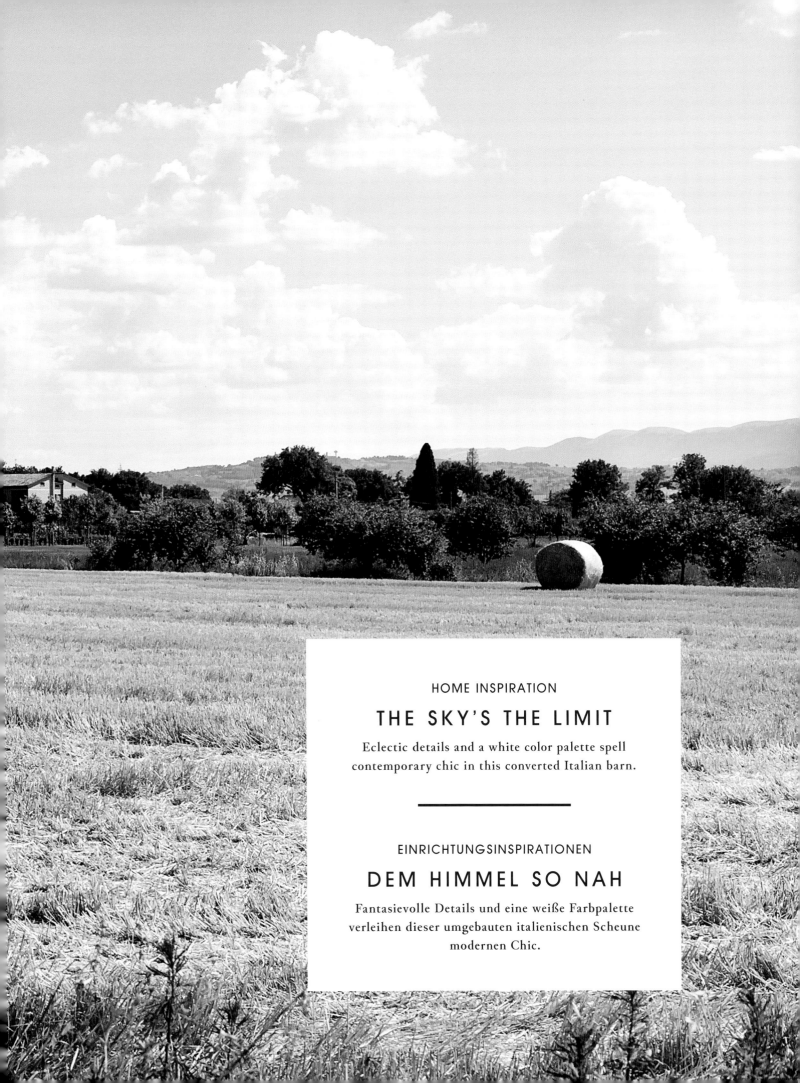

HOME INSPIRATION

THE SKY'S THE LIMIT

Eclectic details and a white color palette spell
contemporary chic in this converted Italian barn.

———

EINRICHTUNGSINSPIRATIONEN

DEM HIMMEL SO NAH

Fantasievolle Details und eine weiße Farbpalette
verleihen dieser umgebauten italienischen Scheune
modernen Chic.

Andrea Falkner-Campi's home is a fabulous place in which to relax. Everything about it oozes comfort and luxury from the Ergofocus fireplace suspended from the ceiling to the swathes of Indian voiles that surround the slipper bath. The summery white and pale gray color scheme is the perfect backdrop that makes the most of this unusual, vaulted space.

This 200-year-old former tobacco factory in Spello, a small Umbrian town about 90 miles from Rome, is the clever transformation by Italian architect and interior designer Paola Navone. Known for marrying modern design with a quirky touch, the biggest challenge for Navone was how to put all the functions of a house in just one room. The only space that remains separate is the kitchen. For the rest, Navone utilized the structure of the building, using curtains and glass partitions to divide the living areas and also laid a carpet of Moroccan tiles on the floor.

Everything inside has character from the row of Design House Stockholm pendant shades over the massive dining table designed by Mario Botta to the hexagonal tiles on the floor below. "I didn't want to have this old wood sitting on top of parquet," says Navone. An assortment of chairs completes the vignette. "The table is so big, so important," explains the architect. "You can't make a statement with a chair."

In Andrea Falkner-Campis Zuhause kann man sich hervorragend entspannen. Alles strahlt Komfort und Luxus aus – vom von der Decke hängenden Ergofocus-Kamin bis hin zu den luftigen Voile-Gardinen, die die freistehende Badewanne umgeben. Das sommerliche Farbschema aus Weiß und Hellgrau ist der perfekte Hintergrund für diesen außergewöhnlichen, überwölbten Wohnraum.

Der intelligente Umbau der 200 Jahre alten ehemaligen Tabakfabrik in Spello, einem kleinen, etwa 90 km von Rom entfernten Ort in Umbrien, ist das Werk der italienischen Architektin und Designerin Paola Navone. Sie ist bekannt dafür, dass sie modernes Design mit ausgefallenen Elementen kombiniert. Ihre größte Herausforderung in Spello war, alle Funktionen eines Wohnhauses in nur einem Raum unterzubringen. Der einzige separate Wohnbereich ist die Küche. Für den Rest nutzte Navone die Struktur des Gebäudes und setzte Vorhänge und Glastrennwände ein, um die einzelnen Wohnbereiche abzugrenzen. Auf den Boden legte sie einen „Teppich" aus marokkanischen Fliesen.

Alles hier hat einen ganz eigenen Charakter: von der Hängelampenreihe von Design House Stockholm über den von Mario Botta entworfenen massiven Esstisch bis hin zu den sechseckigen Bodenfliesen. „Ich wollte nicht, dass das alte Holz des Tisches auf Parkettboden trifft", sagt Navone. Bunt zusammengewürfelte Stühle komplettieren das Bild. „Der Tisch ist so groß, so wichtig", erklärt die Architektin. „Daneben kann man mit keinem Stuhl ein Statement setzen."

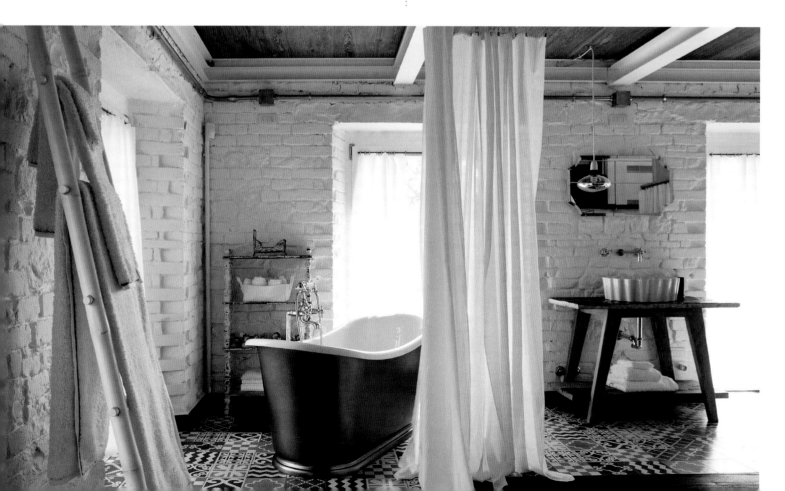

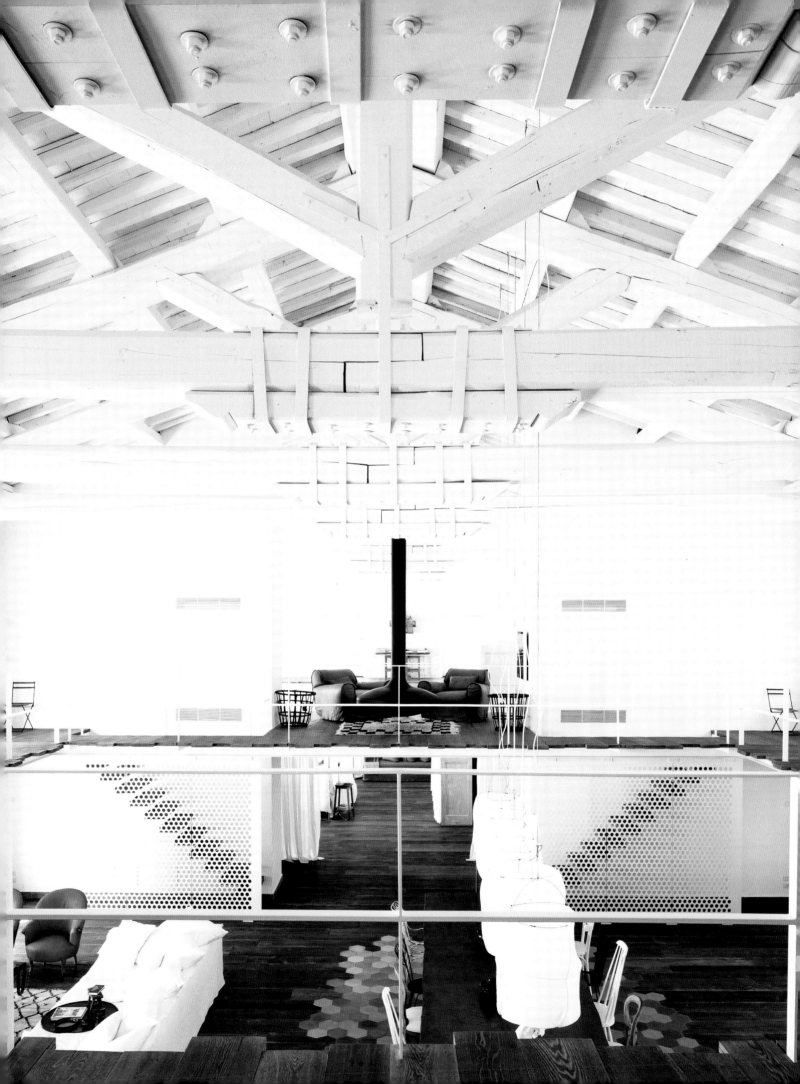

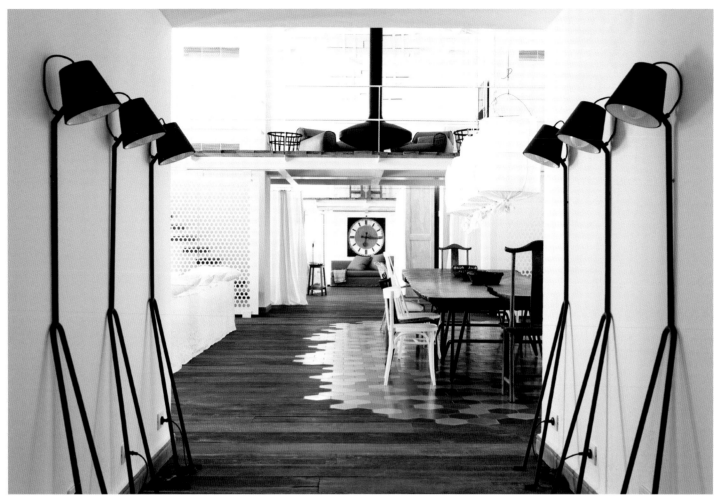

THE COLORS

This simple, fresh scheme is a Scandi style blend of black, white, and lots of wood. The soft-gray blue of the tiles work well with the neutrals and softens the monochrome palette. To liven things up, accents of jade green are also used. Paired with plants, it is a nod to the countryside location. The interior may be modern but the home is linked to nature and a love of the outdoors.

..

DIE FARBEN

Das einfache, frische Farbschema ist eine Scandi-Style-Mischung aus Schwarz, Weiß und jeder Menge Holz. Das sanfte Graublau der Fliesen passt gut zu den neutralen Farben und macht die monochrome Farbpalette weicher. Um das Ganze lebendiger wirken zu lassen, werden Akzente in Jadegrün gesetzt, die zusammen mit Zimmerpflanzen eine Brücke zur ländlichen Umgebung schlagen. Das Interieur ist zwar modern, zeugt aber dennoch von der Liebe zur Natur.

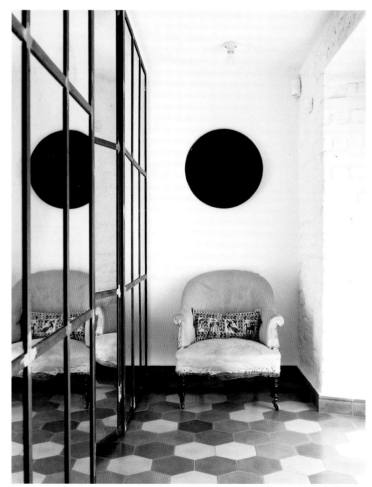

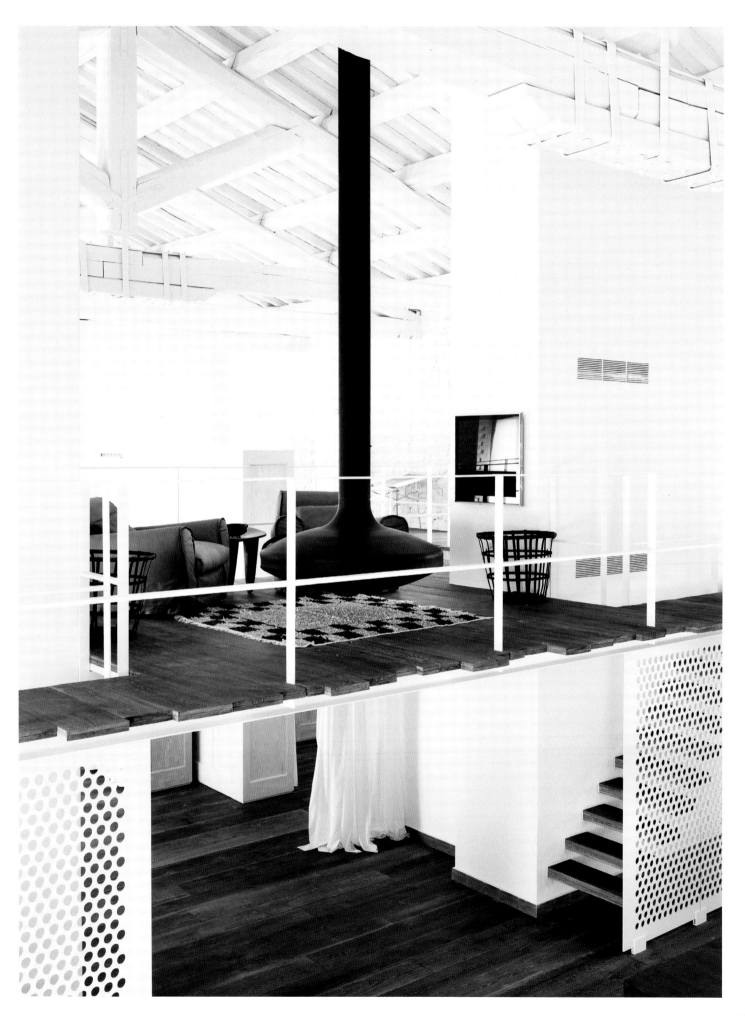

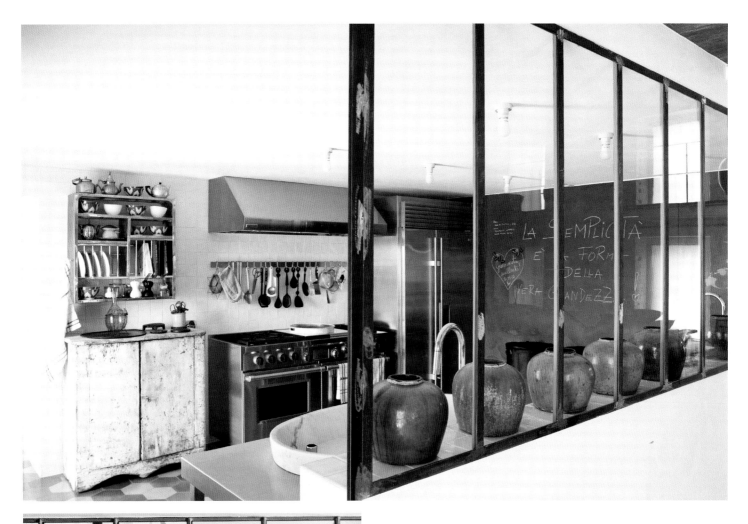

THE MATERIALS

Indian cotton drapes the vintage iron-framed bed and closet in the master bedroom. The double-height cabinets hold the homeowners' clothes. In the living room, white linen slipcovers give the sofa a lived-in look, and in the kitchen, the stainless steel units are practical and add to the industrial vibe. Enjoying pattern, throughout the house tiles are mixed with floorboards to separate different living areas. Who says timber widths or parquet patterns have to be conventional?

DIE MATERIALIEN

Indische Baumwolle verhüllt das Eisengestell des Vintage-Betts und den Schrank im Hauptschlafzimmer. Weitere Kleidungsstücke finden in den weißen Schrankaufsätzen Platz. Im Wohnzimmer verleihen abnehmbare Leinenbezüge dem Sofa einen gemütlich-knautschigen Look und in der Küche finden sich praktische Elemente aus Edelstahl, die einen Industrial Vibe erzeugen. Im ganzen Haus wechseln sich Holzdielen mit Fliesen ab, um die unterschiedlichen Wohnbereiche zu kennzeichnen. Und wer behauptet, dass die Dielenbreiten oder das Parkettmuster immer gleich sein müssen?

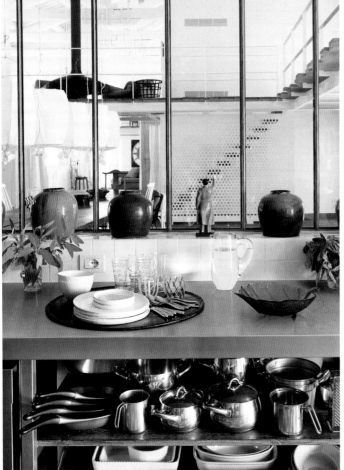

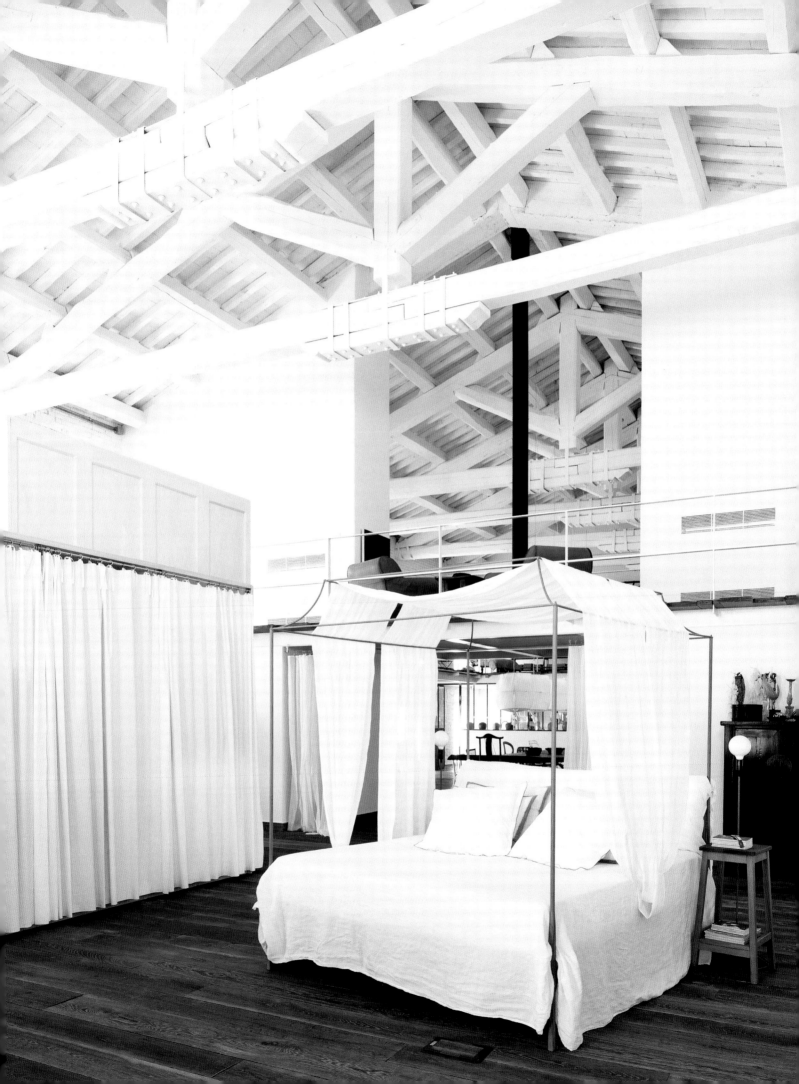

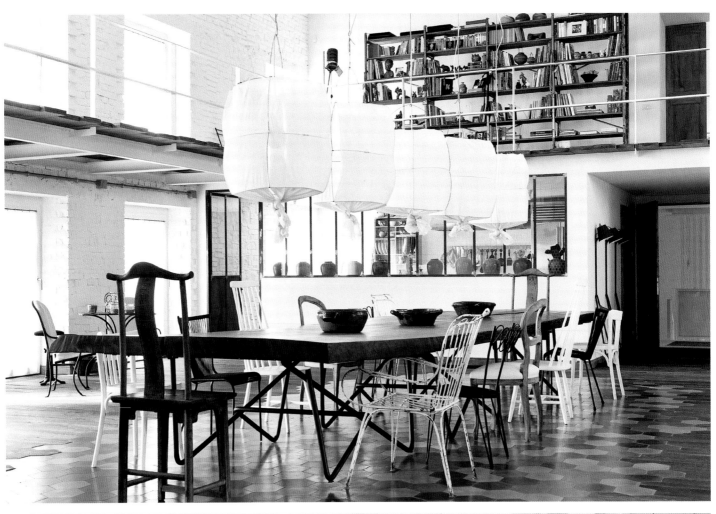

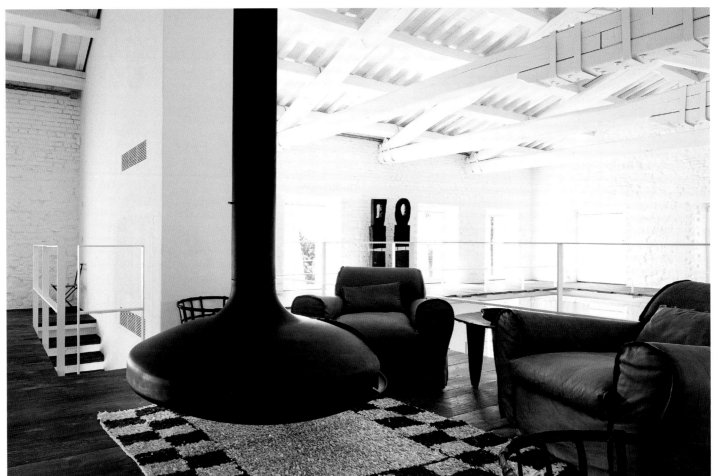

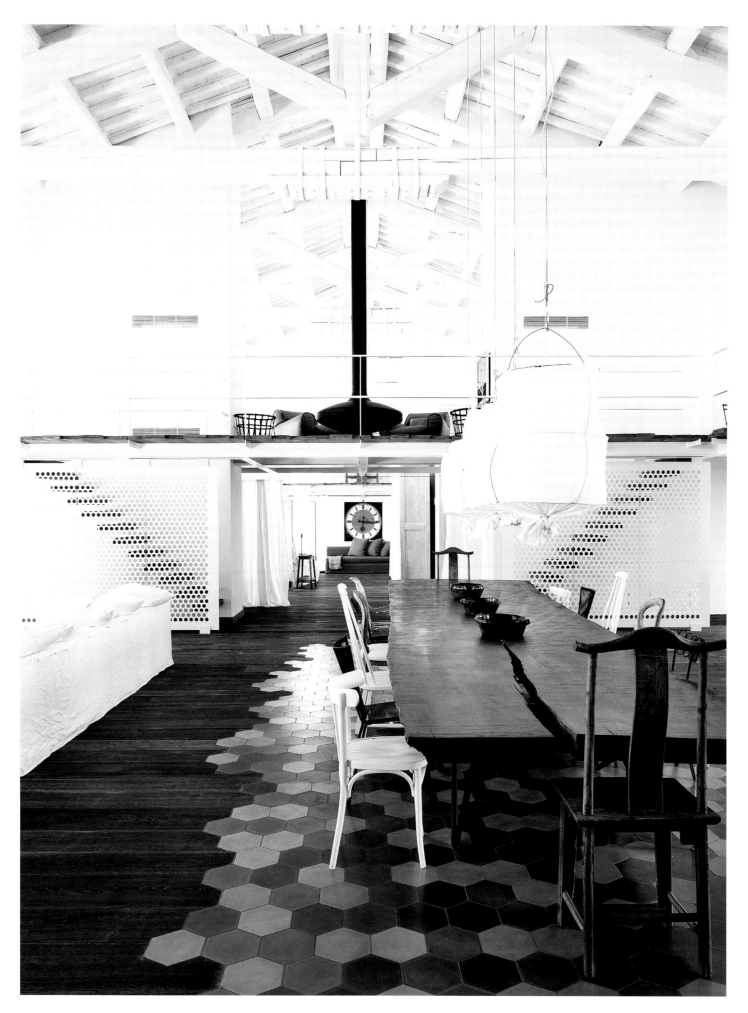

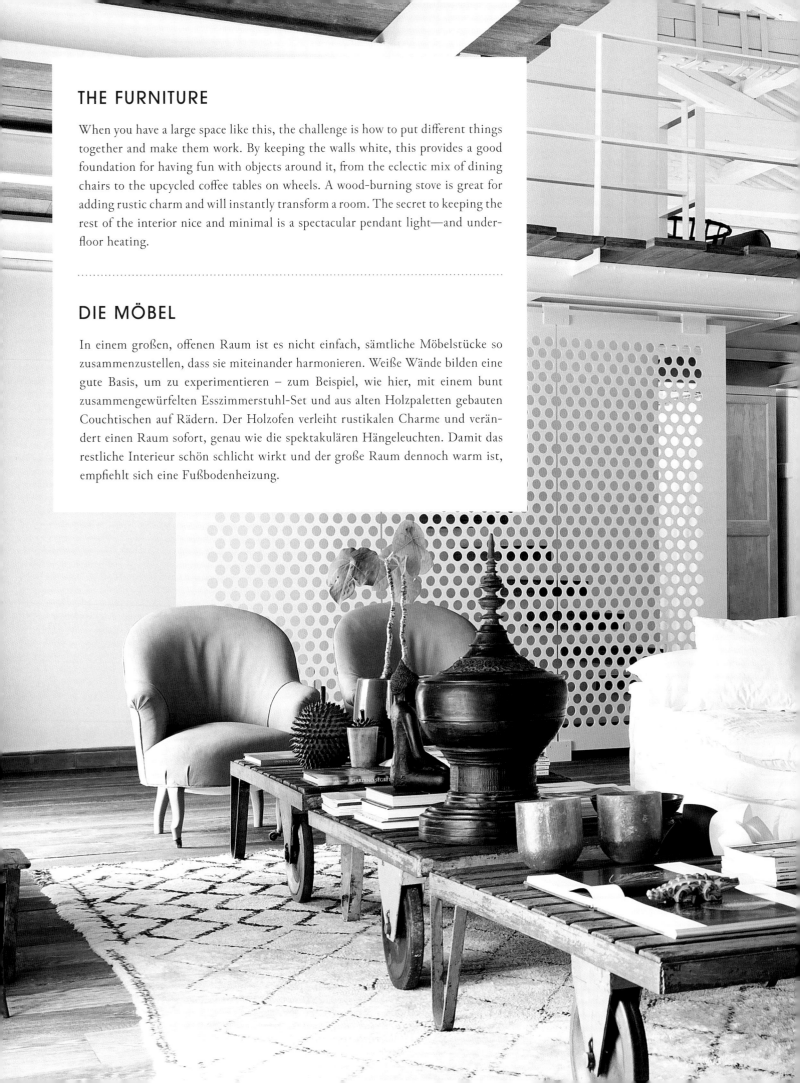

THE FURNITURE

When you have a large space like this, the challenge is how to put different things together and make them work. By keeping the walls white, this provides a good foundation for having fun with objects around it, from the eclectic mix of dining chairs to the upcycled coffee tables on wheels. A wood-burning stove is great for adding rustic charm and will instantly transform a room. The secret to keeping the rest of the interior nice and minimal is a spectacular pendant light—and under-floor heating.

DIE MÖBEL

In einem großen, offenen Raum ist es nicht einfach, sämtliche Möbelstücke so zusammenzustellen, dass sie miteinander harmonieren. Weiße Wände bilden eine gute Basis, um zu experimentieren – zum Beispiel, wie hier, mit einem bunt zusammengewürfelten Esszimmerstuhl-Set und aus alten Holzpaletten gebauten Couchtischen auf Rädern. Der Holzofen verleiht rustikalen Charme und verändert einen Raum sofort, genau wie die spektakulären Hängeleuchten. Damit das restliche Interieur schön schlicht wirkt und der große Raum dennoch warm ist, empfiehlt sich eine Fußbodenheizung.

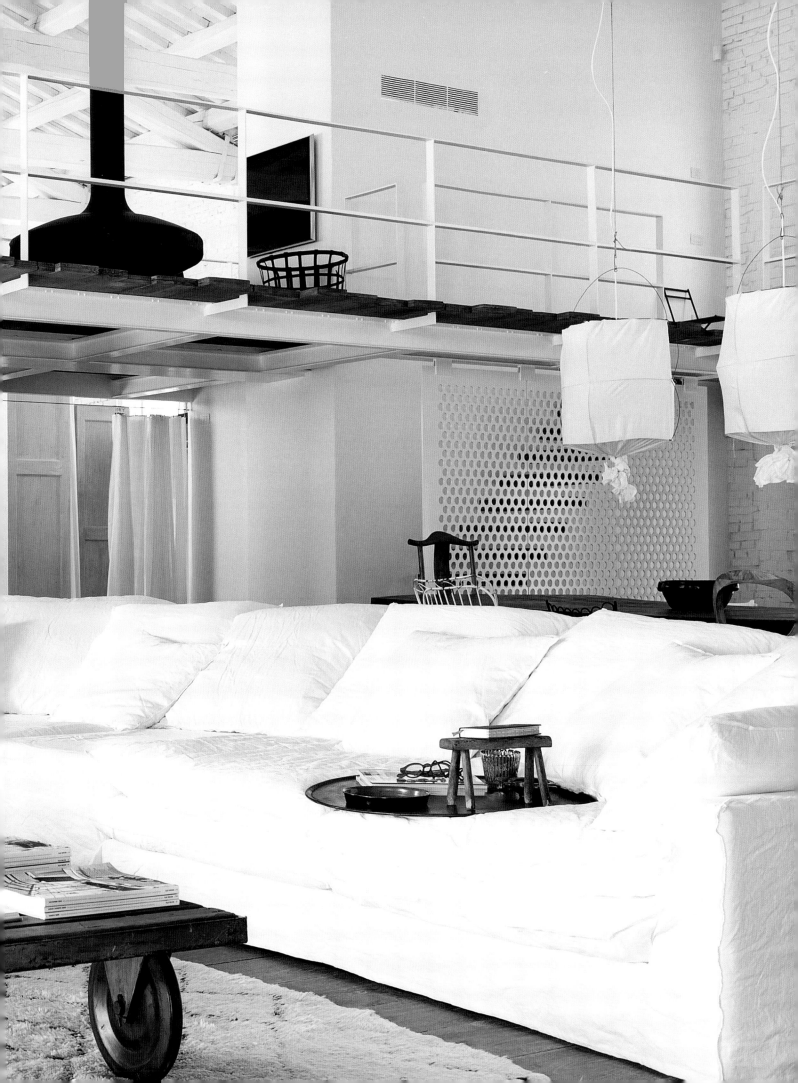

HOW TO PLAN
FOR A LIGHT, OPEN SPACE
EINEN HELLEN OFFENEN RAUM EINRICHTEN

———————

Keep costs down with a practical, high street kitchen, but spend more on luxurious materials and floors.

Entscheiden Sie sich für praktische und preiswerte Küchenelemente und geben Sie das eingesparte Geld lieber für luxuriöse Materialien und Böden aus.

Open-plan spaces should allow for an element of privacy. Pivoting walls or curtains will keep the interior feeling open but can be closed to create a separate room, as and when required.

Auch in offenen Wohnflächen sollte es Rückzugsmöglichkeiten geben. Schwenkbare Wände, Schiebetüren oder Vorhänge erhalten das Gefühl von Offenheit und Weite, können aber bei Bedarf einen abgetrennten Raum erzeugen.

Stick to a minimal palette of colors and materials throughout the house. This will give the illusion of even more space and keep things looking sharp.

Beschränken Sie sich im ganzen Haus auf einige wenige Farben und Materialien. Das lässt den Raum (fast) immer aufgeräumt und noch größer wirken.

Work out how you want to arrange the kitchen, bathroom, and larger pieces of furniture at the outset. This will determine where the lighting and electrics need to be.

Überlegen Sie schon im Vorfeld, wo Küche, Bad und größere Möbelstücke hinkommen sollen. Das bestimmt die Platzierung von Lichtquellen und elektrischen Leitungen.

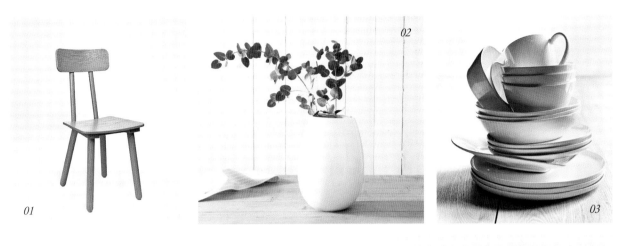

01

02

03

04

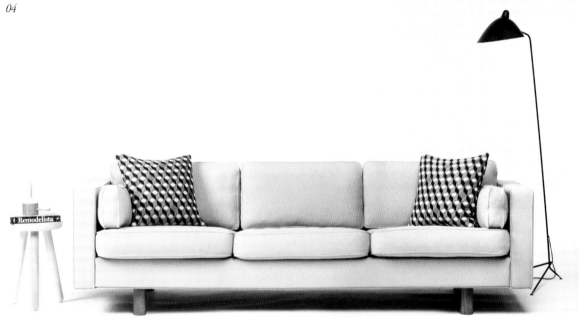

06

GET THE
LOOK

01. *Another Chair in Stone Gray by Another Country*
02. *Ceramic Artisan Vase by The White Company*
03. *Artisan Stoneware Collection by The White Company*
04. *Soren Lund SL60 by Another Country*
05. *3-oven AGA Total Control in*
 Duck Egg Blue by AGA Rangemaster
06. *Trepied floor lamp by Ligne Roset*
 (available at Heal's)

01. *Another Chair in Stone Gray von Another Country*
02. *Ceramic Artisan Vase von The White Company*
03. *Artisan Stoneware Kollektion von The White Company*
04. *Soren Lund SL60 von Another Country*
05. *3-Ofen AGA Total Control in*
 Duck Egg Blue von AGA Rangemaster
06. *Trepied floor lamp von Ligne Roset*

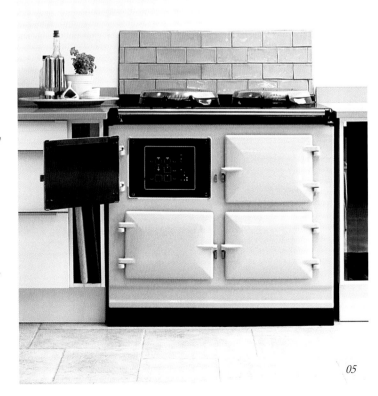

05

02

A CHARMING CABIN

Stone floors, wood-burning stoves, comfy sofas, layers of wool, and incredibly pretty views—is there anything more inviting than a cabin? A humble, stylish refuge in the middle of nowhere, it is a place to put your feet up and dream. Simply furnished with a day bed, kitchen range, breakfast table and large, glass doors to admire the view—when an interior is stripped back to the fundamentals of living (eat, bathe, sleep), it is amazing how little space you actually need.

To work this handsome, rugged look at home, opt for soft textures and calm colors. Layer up linens, rugs, and sheepskins in earthy shades—inky blues, rusty oranges, and chocolate browns all look good against a backdrop of wood. Choose worn items that get better with character and age. Mixing eras and styles, the cabin is filled with quality, utilitarian, as well as beautiful things. Open shelving is used to display handmade ceramics. It's nice to be able to see everything that's been collected and makes an interesting feature in a sparsely decorated room. When choosing pieces, new or old, the key is to start with quality. If something is well designed with good scale and proportions, then it naturally finds a home.

Lighting is also important in the timber-walled cabin, as the planks of wood absorb so much light. Industrial or midcentury designs in either metal or glass work particularly well and add to the cozy atmosphere at night. No televisions allowed—just books. Given the heirloom, cast-off quality of the objects and the cabin's reason for being, if there is ever a placc for stories, then this is it.

EINE CHARMANTE FERIENHÜTTE

Rustikale Steinböden und glimmende Holzöfen, gemütliche Sofas, kuschelige Wollstoffe und atemberaubende Ausblicke – eine Hütte ist der ideale Rückzugsort für gestresste Städter. In einer solch bescheidenen und doch stylishen Unterkunft mitten in der Natur kann man die Füße hochlegen und träumen. Die Einrichtung ist einfach: ein Schlafsofa, eine Küchenzeile, ein Esstisch. Und dazu riesige Glastüren, um die Aussicht zu genießen. Es ist erstaunlich, mit wie wenig Platz man auskommt, wenn ein Interieur auf das Wesentliche (essen, baden, schlafen) reduziert wird.

Wenn Sie diesen ungeschliffen-attraktiven Look bei sich zu Hause kreieren wollen, sollten Sie auf weiche Stoffe und ruhige Farben setzen. Schichten Sie Leinenstoffe, Teppiche und Schaffelle in Erdtönen übereinander – Tintenblau, Rostorange und Schokoladenbraun machen sich gut vor Holz. Dazu passen vom Zahn der Zeit bereits polierte oder patinierte Einrichtungsobjekte, die mit zunehmendem Alter noch schöner und charaktervoller werden. In der Hütte herrscht ein bunter Mix aus Epochen und Stilrichtungen, aus funktionalen und dekorativen Dingen. Auf offenen Regalen stapelt sich handgemachte Töpferware, die im ansonsten kaum dekorierten Raum einen hübschen Blickfang bildet. Egal, ob alt oder neu: Achten Sie bei der Auswahl der Teile auf gutes Design und ausgewogene Proportionen.

Die Beleuchtung ist in der mit Holz verkleideten Hütte besonders wichtig, da die Paneele viel Licht absorbieren. Glas und Metall im schlicht-modernen Stil der 1940er- bis 1960er-Jahre machen sich hier gut und tragen zur gemütlichen Atmosphäre nach Einbruch der Dunkelheit bei. Flimmernde Bildschirme sind nicht erlaubt – nur Bücher. Inmitten der Vintage-Objekte, von denen jedes eine eigene Geschichte erzählt, taucht man gerne in fremde Welten ein.

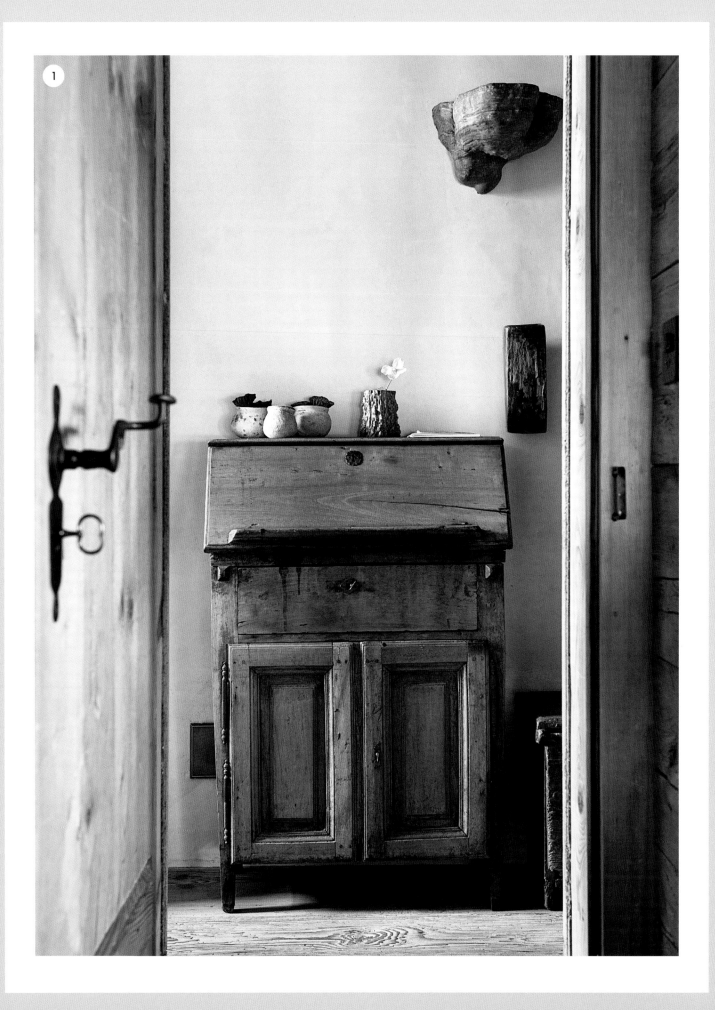

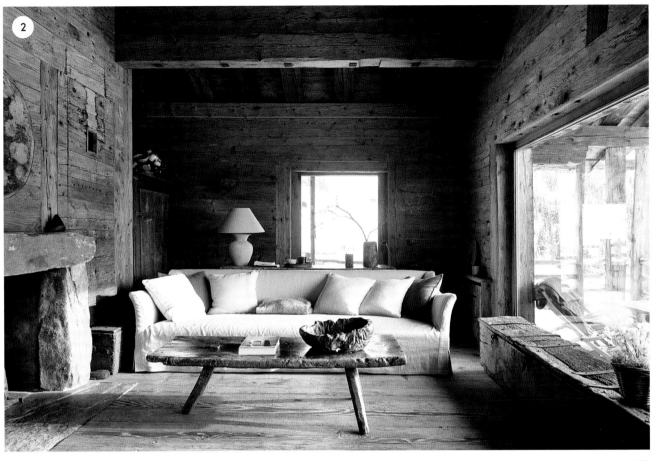

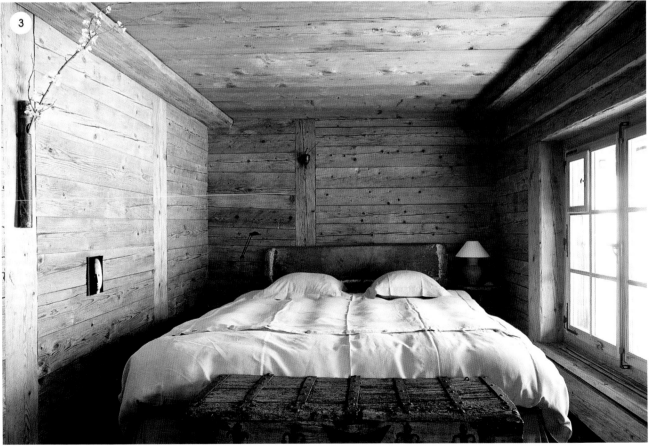

STYLE IN BRIEF

With a respect for natural materials and traditional craft techniques, this "back-to-basics" look seeks solace in the rituals that surround an object's use. Stone, cast-iron, and wood are de rigueur. A large pottery vessel, woven basket, or a graphic striped quilt—these artisanal, color-splashed pieces should feel as though they have been around for a hundred years.

STIL KURZ GEFASST

Dieser ursprüngliche Look respektiert natürliche Materialien genauso wie traditionelles Handwerk und bevorzugt Objekte, die an alte Rituale erinnern. Stein, Gusseisen und Holz sind ein Muss. Kunstgewerbliche Details wie ein großer Keramiktopf, ein geflochtener Korb oder ein gemusterter Quilt sollten so wirken, als wären sie schon ewig hier.

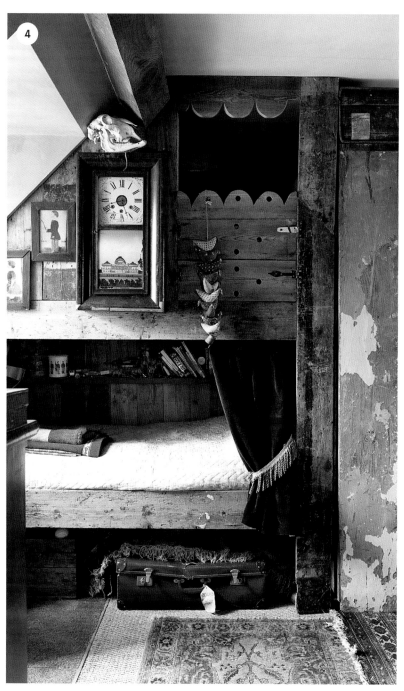

1 | *This rustic bureau feels lived-in and loved.*
2 | *An imposing stone fireplace and timber-clad walls set the tone in this chalet by Axel Vervoordt.*
3 | *Simple furnishings allow raw materials to shine through in this no-frills bedroom.* 4 | *A velvet curtain creates a cozy den for this cabin bunk.*
5 | *Wood paneling, canvas paintings, and an old bath all add texture.*

1 | *Der rustikale Sekretär sieht aus, als wäre er oft benutzt und sehr geschätzt worden.* 2 | *Ein imposanter Kamin und holzgetäfelte Wände geben in diesem Chalet von Axel Vervoordt den Ton an.*
3 | *Die schlichte Möblierung des Schlafzimmers stellt die Materialien in den Mittelpunkt.* 4 | *Der Samtvorhang macht aus der Schlafkoje eine gemütliche Höhle.* 5 | *Holzpaneele, bemalte Leinwände und eine alte Wanne fügen sich zu einem einheitlichen Bild.*

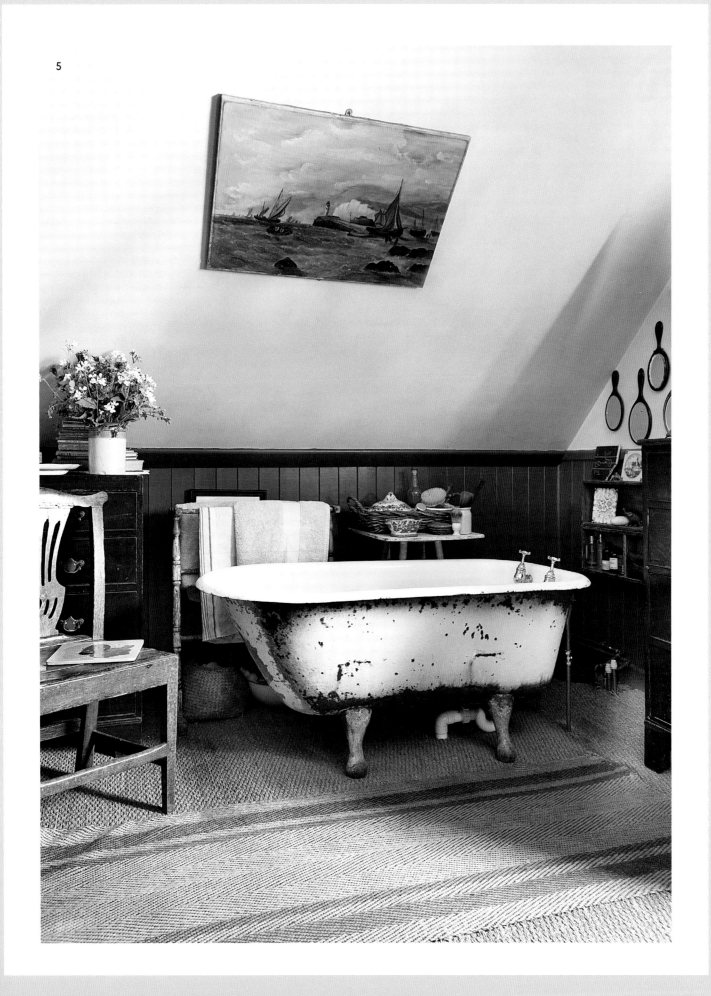

HOME INSPIRATION

LITTLE IDYLL

Simplicity, utility, and comfort make a beautiful
combination in this contemporary family retreat.

————————

EINRICHTUNGSINSPIRATIONEN

KLEINES IDYLL

Einfachheit, Funktionalität und Gemütlichkeit
bilden in diesem Familien-Ferienhäuschen
ein perfektes Dreigestirn.

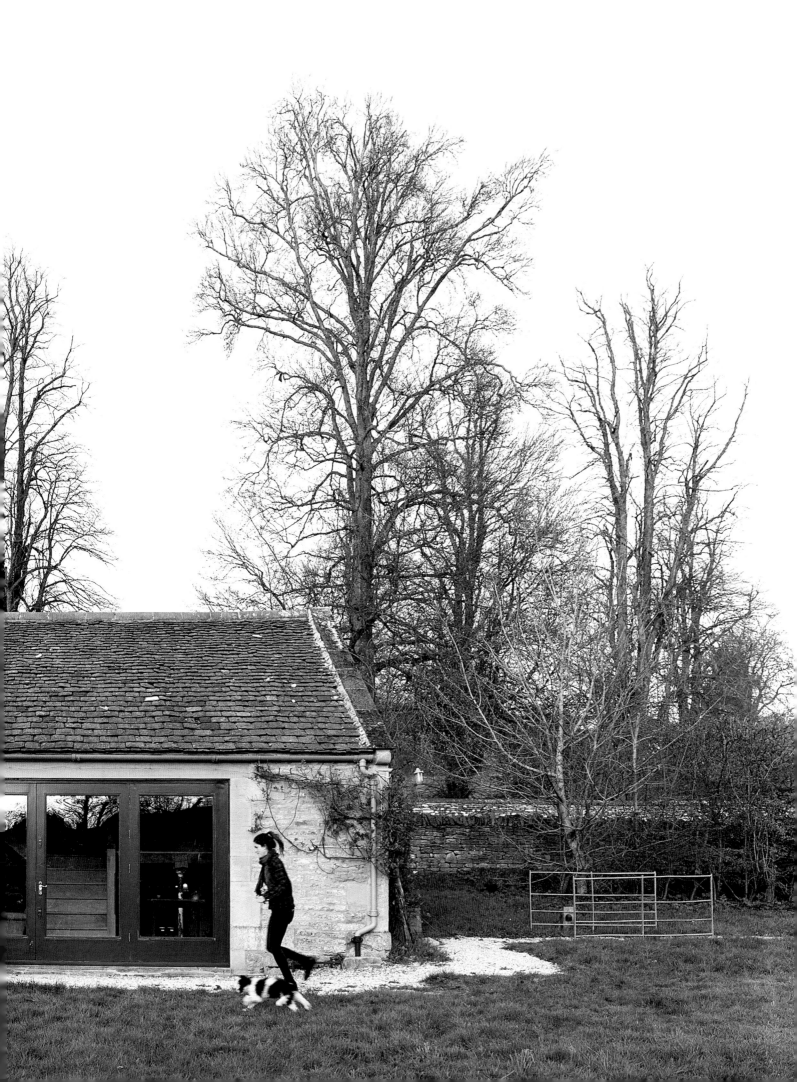

Set in the middle of a wild flower meadow, this 19th-century stone barn is located in the Cotswolds, a picture-postcard spot in southwest England. It is an inviting home-from-home for London antiques expert and interior designer Christopher Howe who uses it as a weekend escape. Breathing new life into the bones of this former sheep shed, the clever design exemplifies all that is so attractive about the New Country style.

An amazing open plan space with four clearly differentiated levels—when you look through the large glass doors, you can see every space in the house—the ground floor comprises the living room, which leads out to the stunning meadow; upstairs there is a mezzanine level and bedroom. The basement kitchen is sunk into the floor. The finishing of the workman-like space is far from refined but that was precisely the intention. "I wanted to make it as humble and straightforward as possible," Christopher explains.

Piecing together the interior with a variety of beautiful things, Christopher furnished the place to look as though it might have been given to someone that worked on the estate, or for one of the kids to live in. Local materials were used for the floor and walls, while the pieces, such as Moroccan carpet at the door to the 1950s Serge Mouille three-pronged light fixture that extends across the second floor, go some way to illustrate the eclectic mix. "I love the fact that these things have been taken from one extreme and placed into another. They still look appropriate and at home," he says.

This mix of high-end design with down-at-heel finds is symbolic of Christopher's signature style. "It is interesting how so many things, that are so different, can exist in harmony," Christopher remarks. "With objects, we're encumbered with preconceived ideas about things. If we didn't know where things were from, when they were made, or which King happened to be reigning at the time, we wouldn't know whether or not these things were supposed to live side-by-side. If we didn't have that knowledge, what would govern how we put things together? It is this lack of preconception that is part of the charm of the barn. It's more of a dream."

...

Dieser ehemalige Schafstall aus Stein steht mitten in einer naturbelassenen Blumenwiese in den Cotswolds, einer pittoresken Region im Südwesten Englands. Hierhin zieht es den Londoner Antiquitätenspezialisten und Innenarchitekten Christopher Howe, wenn er am Wochenende ausspannen will. Christopher hat der alten Struktur neues Leben eingehaucht und sein intelligentes Design vereint exemplarisch alles, was den New Country Style so attraktiv macht.

Die offene Raumaufteilung besticht durch vier klar voneinander abgegrenzte Ebenen – wenn man durch die großen Glastüren hineinschaut, kann man sie alle sehen. Im Erdgeschoss befindet sich das Wohnzimmer, durch das man in die wildromantische Wiese hinaustritt. Oben gibt es eine Zwischenempore und ein Schlafzimmer. Die Küche liegt ein paar Stufen tiefer im Souterrain und geht vom Wohnzimmer ab. Beinahe unfertig wirken die grob belassenen Oberflächen, aber genau dieser Effekt ist gewollt. „Ich wollte es so bescheiden und gradlinig wie möglich", erklärt Christopher.

Liebevoll hat er eine Reihe von schönen Gegenständen zusammengetragen und das Häuschen so eingerichtet, als würde dort eines der Kinder wohnen oder jemand, der auf dem Anwesen arbeitet. Für Wände und Böden wurden heimische Materialien verwendet, die den Hintergrund für einen ungewöhnlichen Mix aus Einzelstücken bilden, darunter zum Beispiel an der Tür ein marokkanischer Teppich und im Obergeschoss eine dreiarmige Leuchte von Serge Mouille aus den 1950er-Jahren. „Mir gefällt, dass diese Dinge von einem Extrem in ein anderes transportiert wurden", sagt Christopher. „Sie sehen trotzdem so aus, als würden sie hierher gehören."

Die Kombination aus High-End-Designobjekten und alltäglichen Gegenständen ist typisch für Christophers Stil. „Es ist interessant, dass so viele unterschiedliche Sachen harmonisch nebeneinander existieren können", bemerkt er. „Wir haben vorgefasste Vorstellungen über Dinge. Doch wenn wir nicht wüssten, wo etwas herkommt, wann es hergestellt wurde oder welcher König zufällig damals regierte, hätten wir gar keine Vorstellung davon, womit es zusammenpassen sollte. Was würde dann bestimmen, wie wir Dinge kombinieren? Dieses Ablegen von Schubladendenken macht einen Teil des Hüttencharmes aus. Es ist ein bisschen wie im Traum."

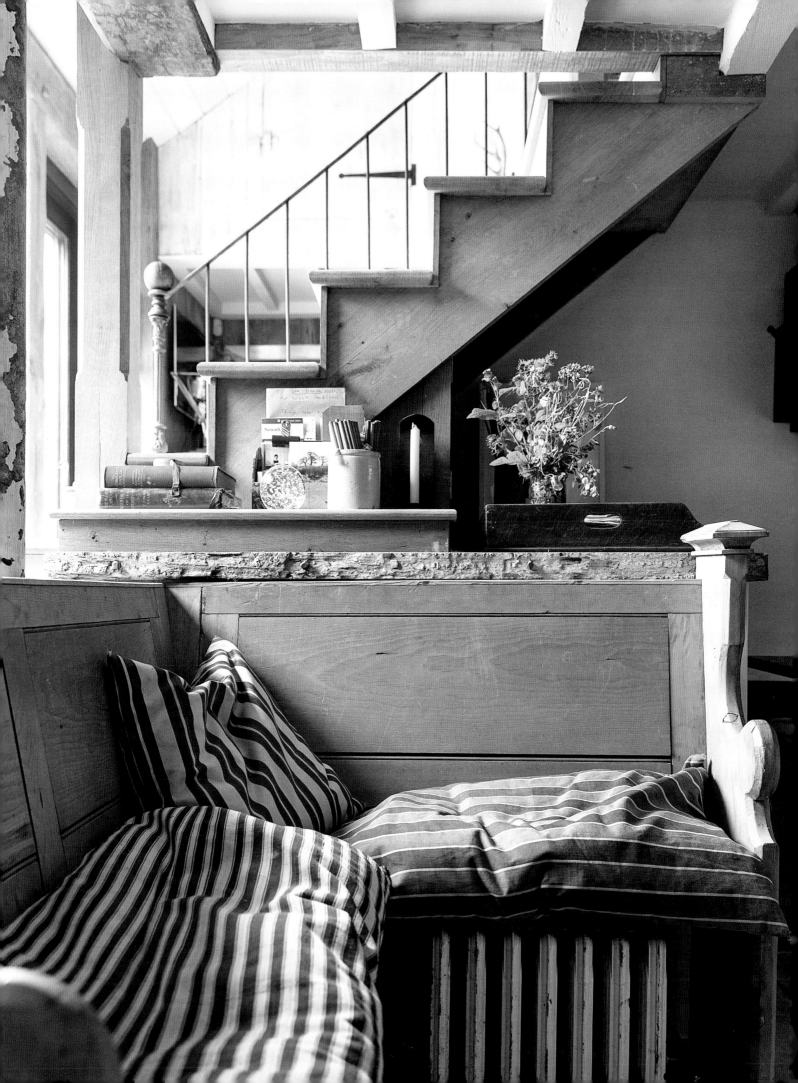

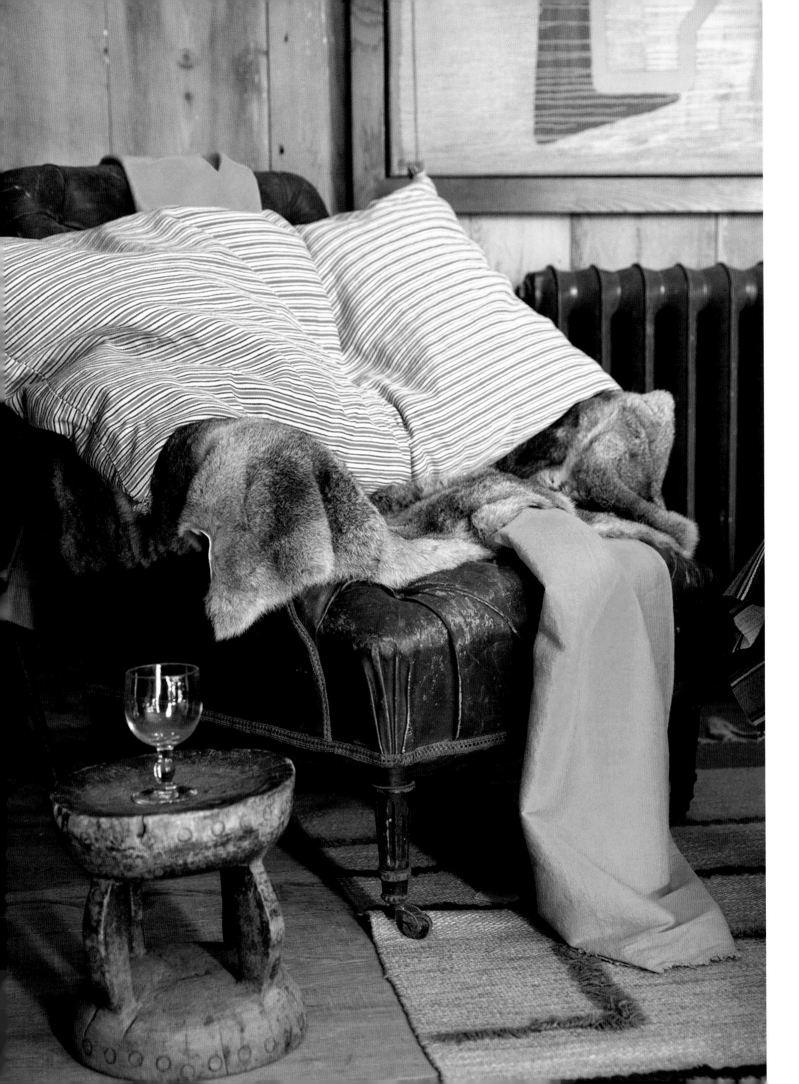

ABOVE *This 19th-century stone barn is located at the edge of a wildflower meadow.* **LEFT** *In the corner of the living room a 19th-century arm-chair is covered with timeworn leather, ticking striped pillows, and a rabbit throw.* **RIGHT** *From the galvanized metal bucket to an old tripod stool, each object was chosen for its timeless beauty—and utility.*

OBEN *Diese Steinhütte aus dem 19. Jahrhundert liegt am Rande einer Wiese.* **LINKS** *In einer Ecke des Wohnzimmers steht ein Sessel aus dem vorletzten Jahrhundert mit abgewetztem Lederbezug, darauf drapiert sind ein gestreiftes Baumwollkissen und eine Kaninchenfelldecke.* **RECHTS** *Ob Eimer aus verzinktem Eisen oder alter Holzschemel: Jedes Objekt wurde wegen seiner zeitlosen Schönheit – und seiner Funktio- nalität – ausgewählt.*

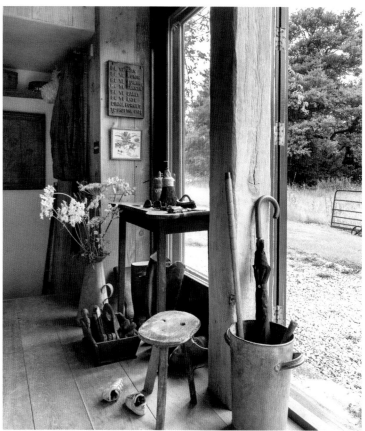

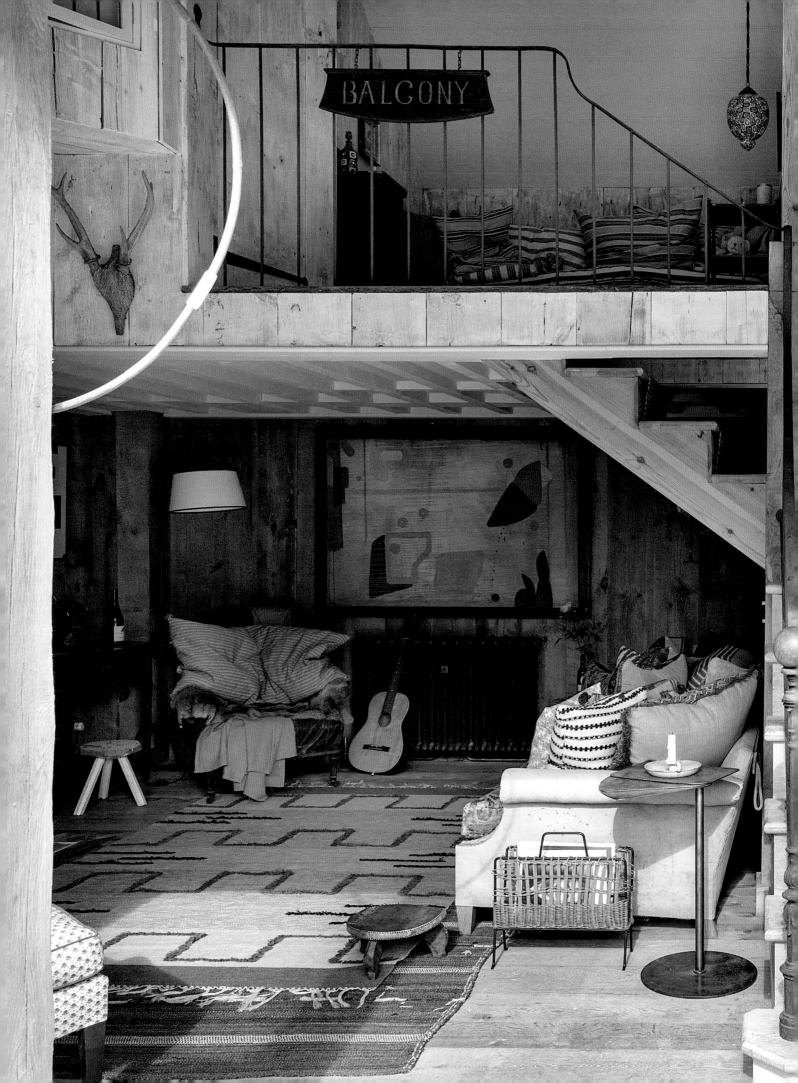

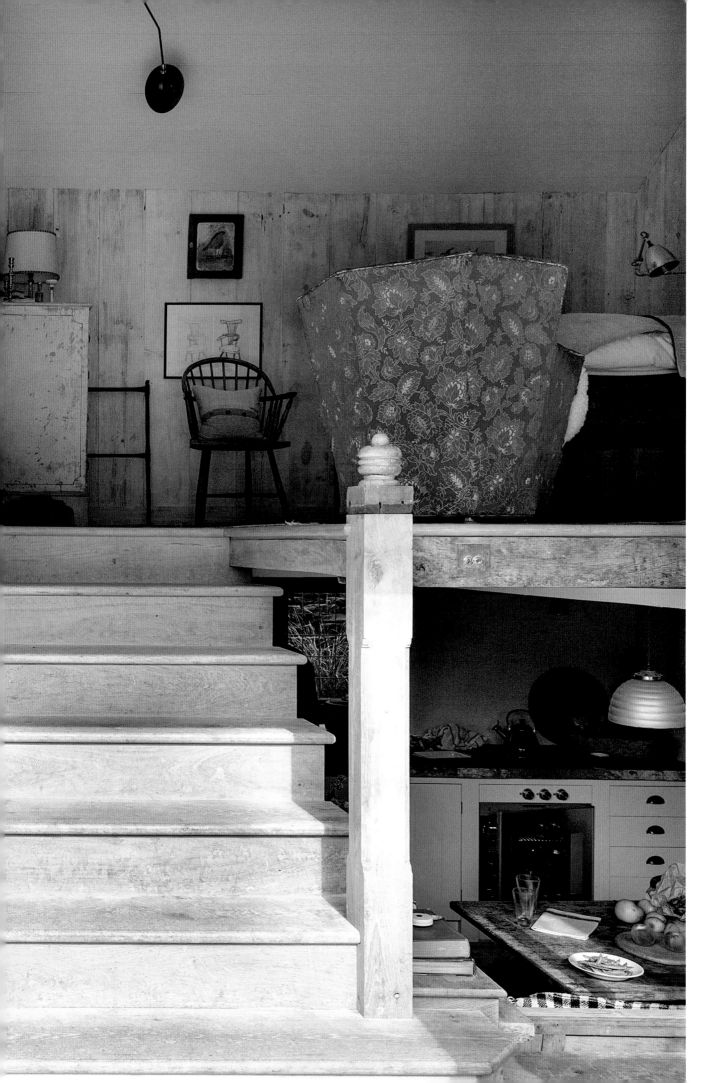

THE COLORS

Dominated by wood, natural materials form the basis of the color scheme. In tune with the soul of the building, by reigning in the colors, you can mix different furniture styles to your heart's content. Upstairs, pine walls have been lime-washed, and in the living room, modern art decks the walls. Additional flashes of color, such as the red Art Deco chair plus the blue and white rugs in the bedroom, help to brighten the space.

DIE FARBEN

Naturmaterialien bestimmen das Farbkonzept des von Holz dominierten Ambientes. Vor einem Hintergrund aus gedeckten Tönen lassen sich die Möbelstile nach Herzenslust kombinieren. Oben wurden die Pinienwände weiß getüncht und im Wohnzimmer hängt moderne Kunst. Farbakzente wie der rote Art-déco-Stuhl und die blau-weißen Teppiche im Schlafzimmer beleben den Raum.

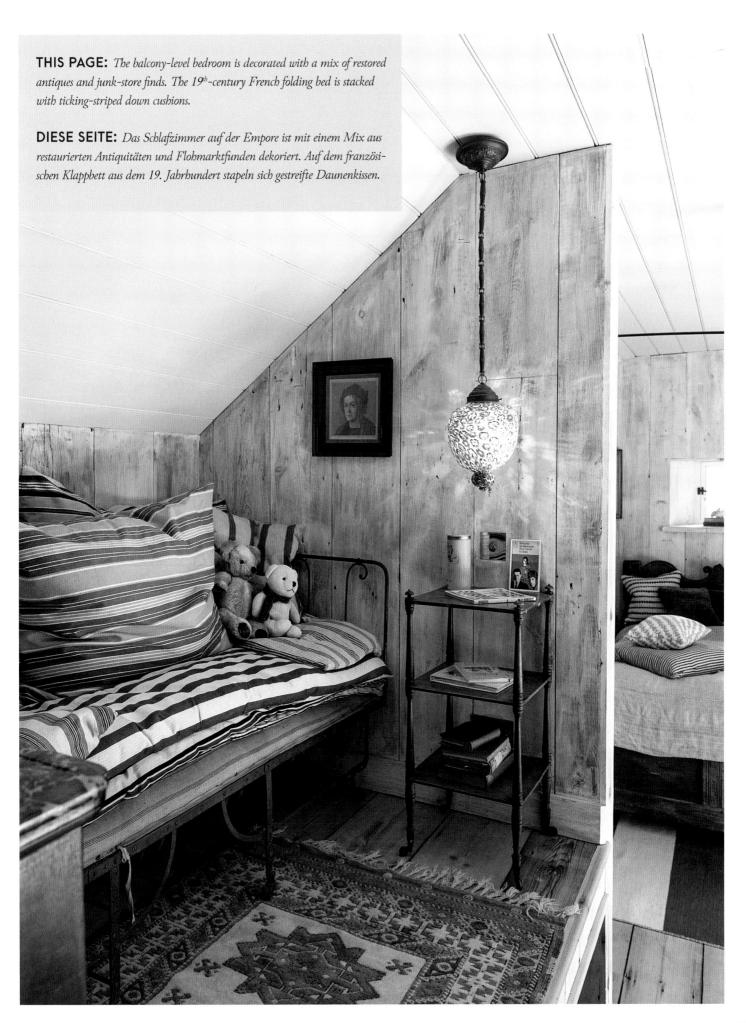

THIS PAGE: *The balcony-level bedroom is decorated with a mix of restored antiques and junk-store finds. The 19th-century French folding bed is stacked with ticking-striped down cushions.*

DIESE SEITE: *Das Schlafzimmer auf der Empore ist mit einem Mix aus restaurierten Antiquitäten und Flohmarktfunden dekoriert. Auf dem französischen Klappbett aus dem 19. Jahrhundert stapeln sich gestreifte Daunenkissen.*

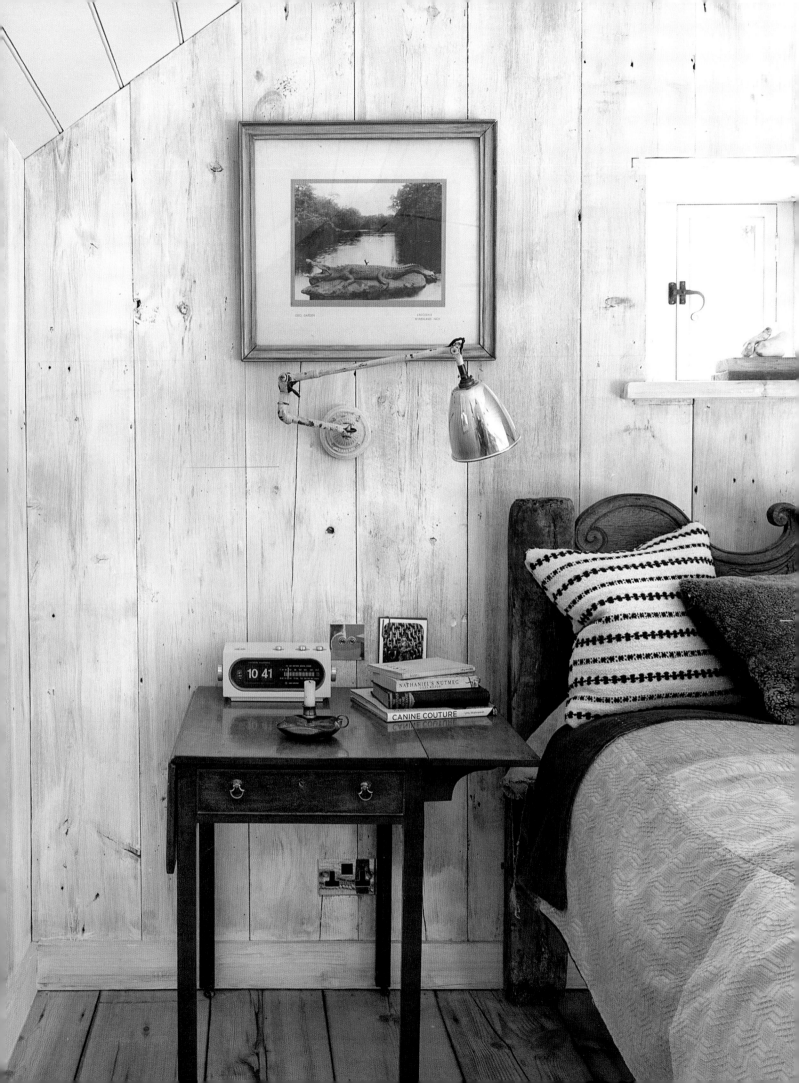

THE FURNITURE

Putting his stamp on the place, Christopher furnished the space with a variety of unique pieces sourced from his store. From the painted Norwegian dresser in the kitchen to the custom-made sofa covered in an old tent canvas and stuffed with kilim cushions—these are all of a character that suit the straightforward, simplicity of the shed. Combining Swedish rugs from the 1940s with a mahogany 18th-century card table results in a harmonious mix.

DIE MÖBEL

Christopher hat der Hütte mit einigen ausgewählten und sehr unterschiedlichen Stücken aus seinem Laden seinen Stempel aufgedrückt. Von der handbemalten norwegischen Anrichte in der Küche bis hin zum extra angefertigten Sofa, das mit altem Zeltplanstoff bezogen und mit Kelim-Kissen ausgestattet ist: Alle Teile passen zur bodenständigen Schlichtheit des Stalls. Die schwedischen Vorleger aus den 1940er-Jahren gehen sogar mit einem Mahagoni-Kartentischchen aus dem 18. Jahrhundert eine harmonische Verbindung ein.

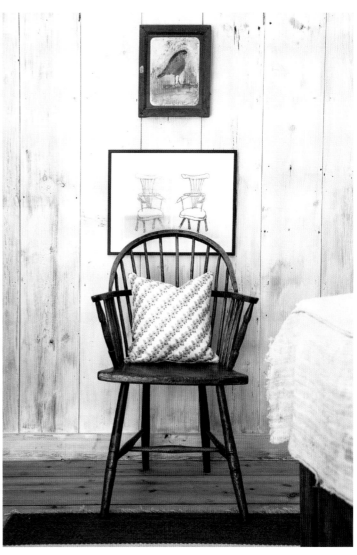

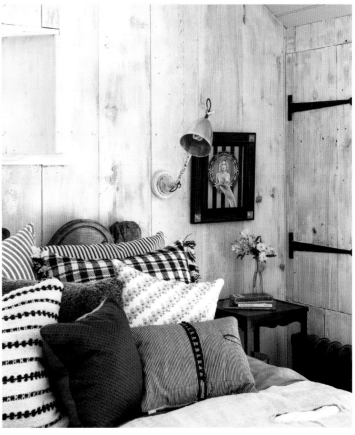

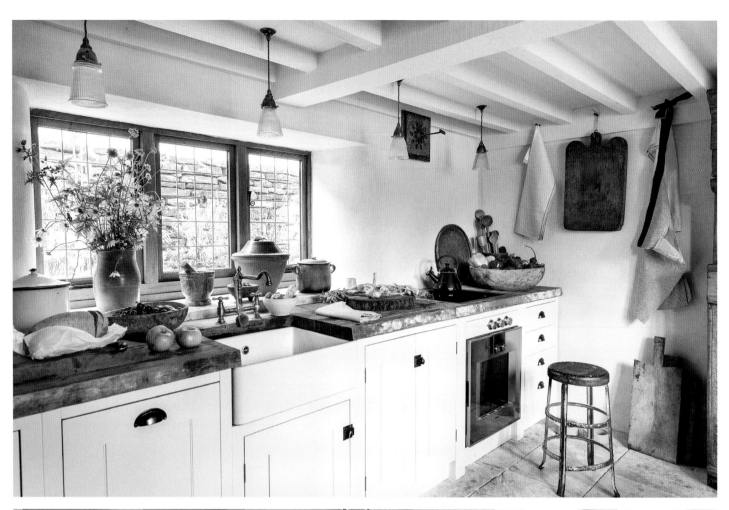

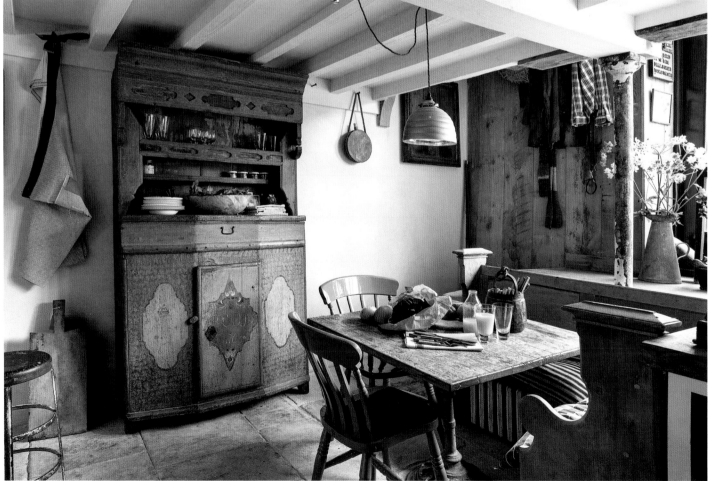

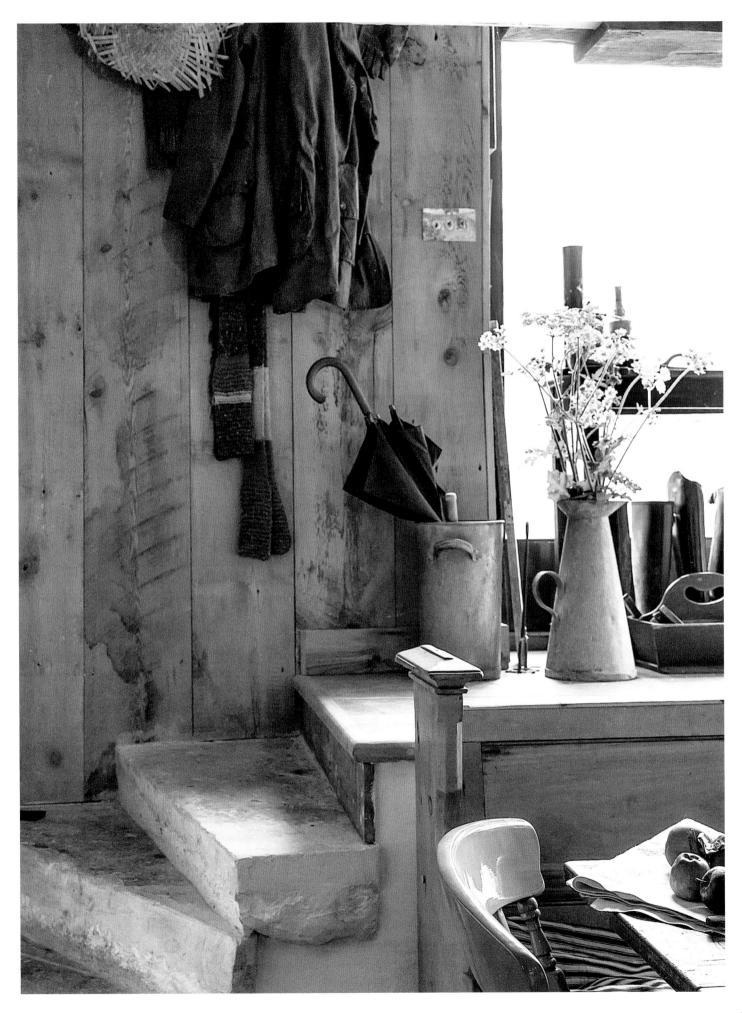

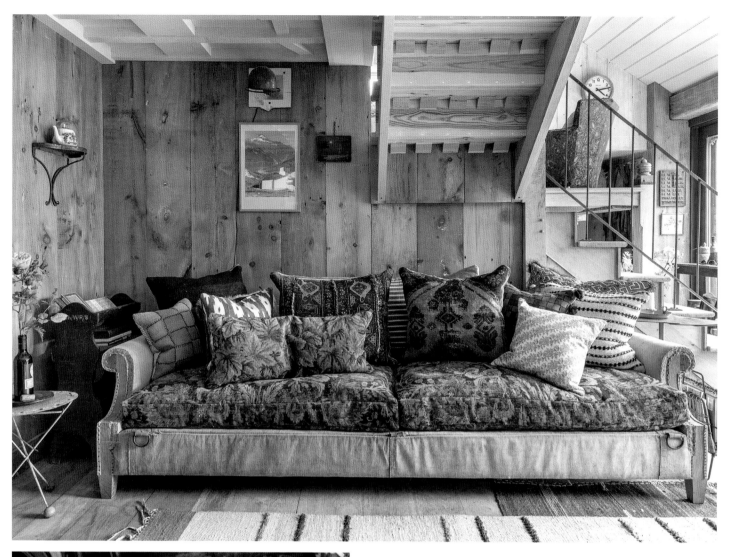

THE MATERIALS

Oak floorboards, sheepskins, slubby linens, and worn leather chairs—the materials are rich and cocooning. The flagstone floor, waney kitchen countertop, and burnished iron handrail reflects the barn's history, contrasted with details such as an opulent Murano glass lamp. The subdued color palette makes layering easy—the more texture and materials, the more contrast, the better.

DIE MATERIALIEN

Eichenparkett, Schaffelle, grobe Leinenstoffe und abgenutzte Ledersessel – die Materialien, die hier zum Einsatz kommen, strahlen Substanz und Gemütlichkeit aus. Der Steinfliesenboden, die raue Küchenarbeitsplatte und das an den oft berührten Stellen glänzende Eisengeländer verweisen auf die Geschichte des einstigen Stalls und stehen im Kontrast zu Details wie der opulenten Lampe aus Muranoglas. Die reduzierte Farbpalette macht das Layering leichter – je mehr unterschiedliche Texturen und Materialien, desto besser.

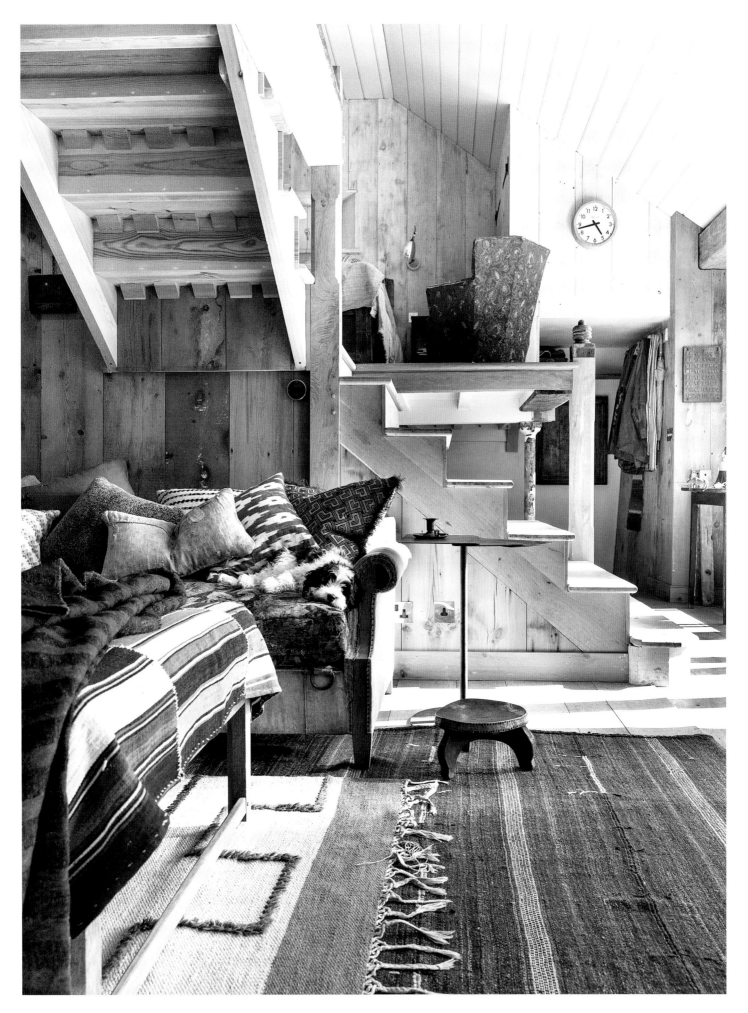

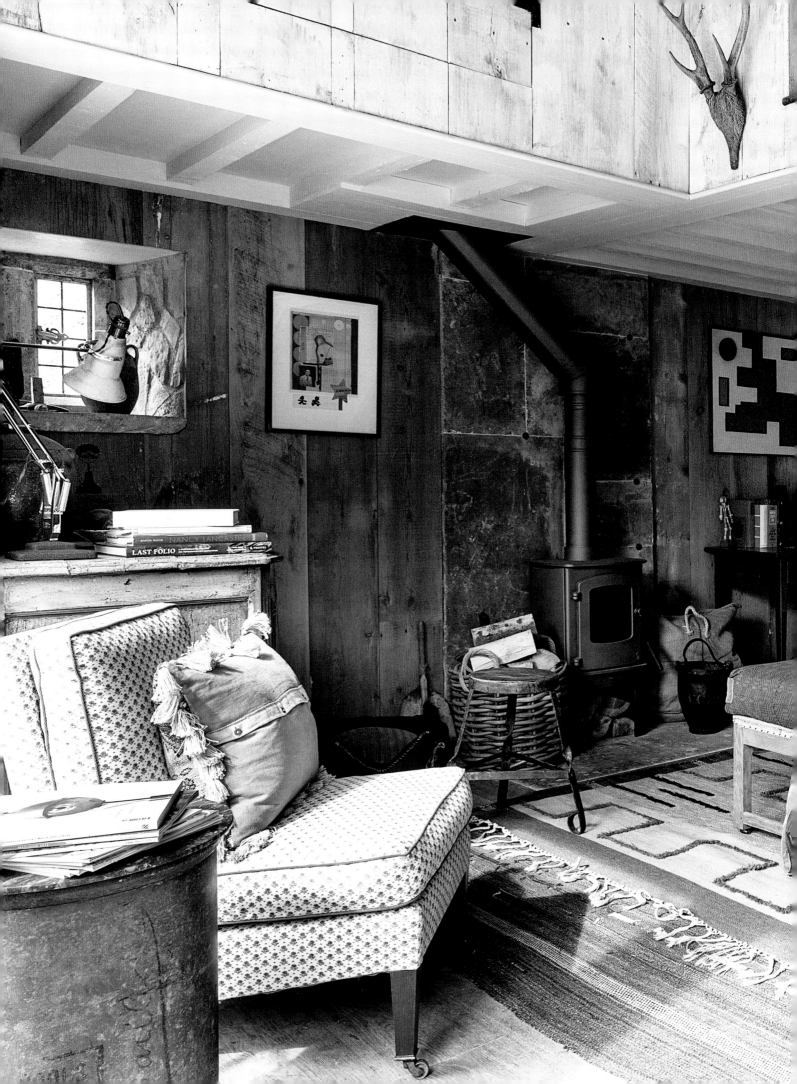

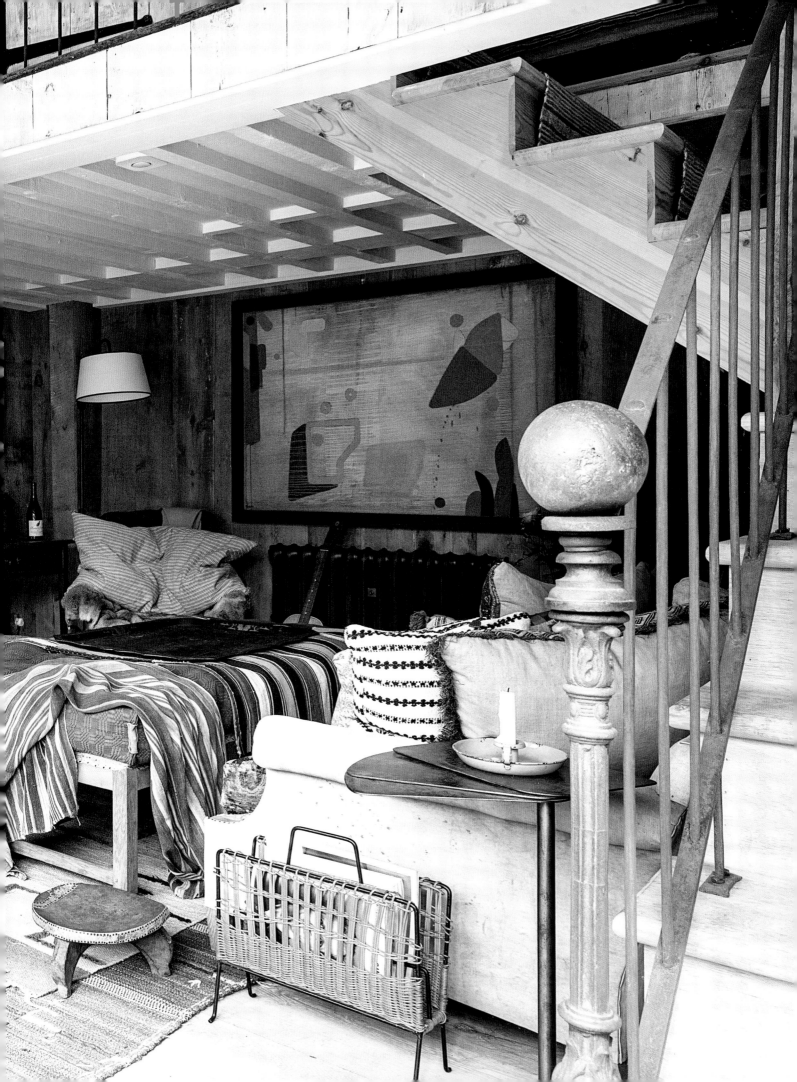

LESSONS IN LAYERING
TIPPS FÜRS LAYERING

Let the bare bones of the building shine through. Flagstone flooring and pine-clad walls are the foundations of this style.

Machen Sie das Skelett des Gebäudes sichtbar. Steinfliesenböden und Pinienholzwände sind die Fundamente dieses Stils.

Contrast the rough with the smooth. Metallics and glass stand out against the raw surfaces and bounce around light. Soft textiles offset the roughhewn.

Kontrastieren Sie das Raue mit etwas Glattem. Metall und Glas heben sich schön von den unpolierten Oberflächen ab und reflektieren das Licht. Weiche Textilien bringen Grobgewebtes und -gestricktes zur Geltung.

Repurpose unusual furnishings. Old Persian rugs make brilliant cushions, and industrial pieces can be adapted for the home.

Setzen Sie einzelne Elemente auf ungewöhnliche Weise neu ein. Aus alten Perserteppichen werden fantastische Kissen und auch für industrielle Teile ergeben sich oft verblüffende neue Aufgaben.

Combine old, worn pieces with sleek, midcentury design. An angular wall light from the 1940s or 1950s is a cool way to inject a touch of glamour in among the grit.

Kombinieren Sie alte, abgenutzte Teile mit schicken Designerobjekten aus der Mitte des 20. Jahrhunderts. Eine geometrische Wandleuchte aus den 1940er- oder 1950er-Jahren bringt etwas Glamour ins sonst eher schlichte Ambiente.

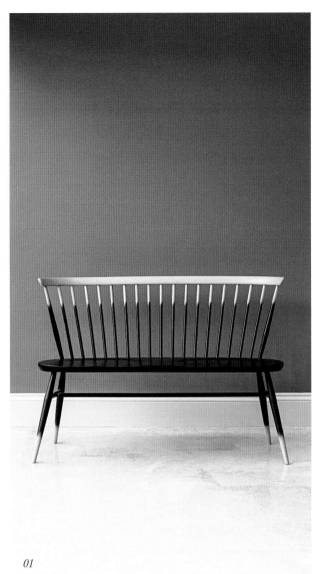

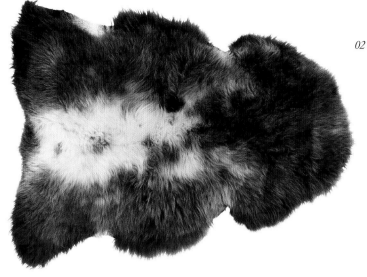

02

03

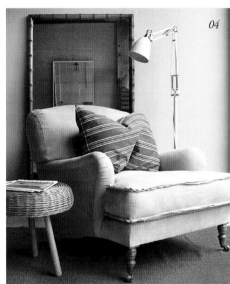

04

01

GET THE
LOOK

01. Originals Love Seat by Ercol
02. Herdwick Sheepskin Rug by TOAST
03. The Fan Table by HOWE
04. The Elveden Armchair by HOWE
05. Gateway Japan kettle, design Sori Yanagi, by David Mellor Design
06. Country 4 stove by Charnwood

01. Originals Love Seat von Ercol
02. Herdwick Sheepskin Rug von TOAST
03. The Fan Table von HOWE
04. The Elveden Armchair von HOWE
05. Gateway Japan kettle, Design Sori Yanagi, von David Mellor Design
06. Country 4 Kamin von Charnwood

05

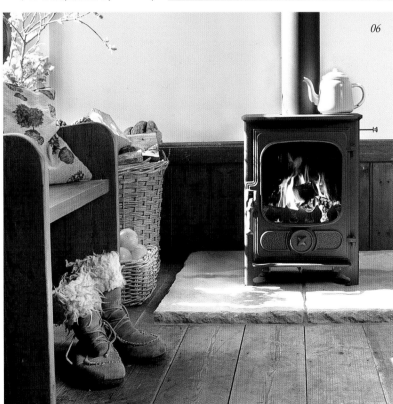

06

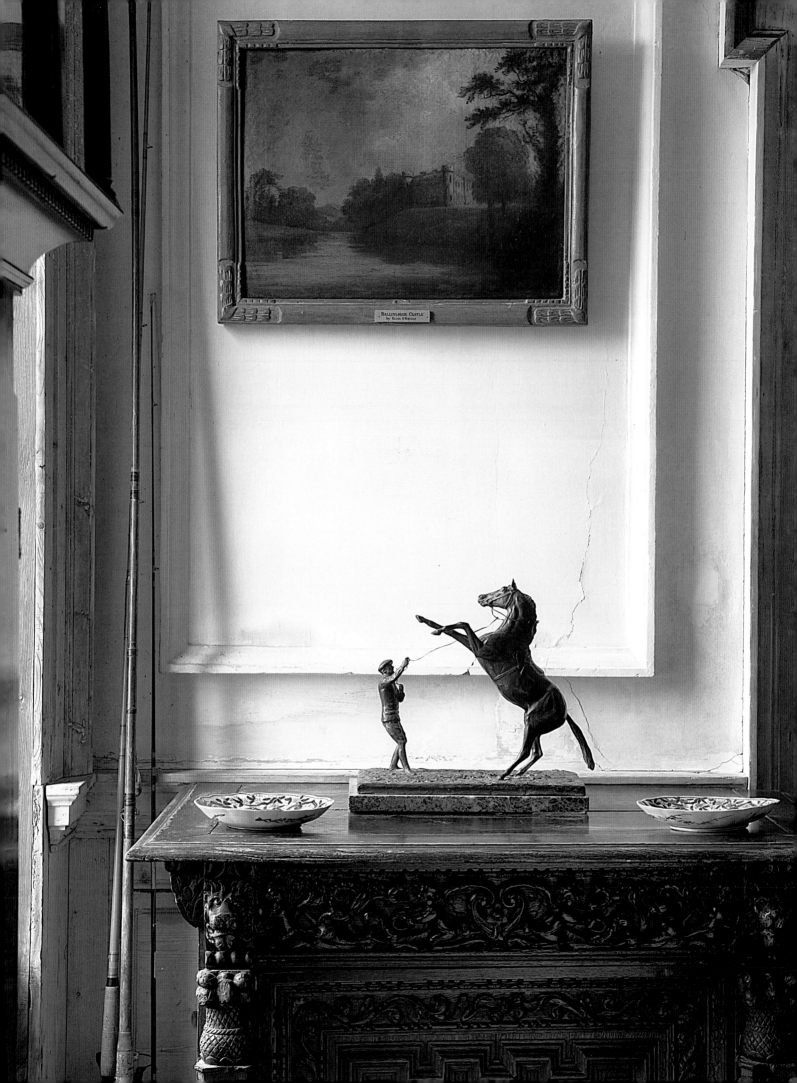

BALLINLOUGH CASTLE
by Eliza O'Reilly

03

THE GRAND CHÂTEAU

Picture the scene: a fairy tale chateau, Italian palazzo, or stately manor house perched on an exquisite piece of land. In terms of New Country style, this grand old duke/duchess is much more on the fancy side than the other décor situations. But that's simply down to the sheer size of the space and the intricate features of the period build. Opulent yet relaxed, ancient yet fearlessly modern, today's New Country château is an artful mix.

How to make it classic and contemporary? Think eclectic. Think rough luxe. Inside, plaster walls are left bare after stripping the rooms of wallpaper. Antique pieces are countered with design classics in the ilk of Verner Panton et al., and 19th-century canvases are casually leaning against the marble mantelpiece or propped on the floor. There is always lots of patina and lots of antiques.

However, the secret to making it chic, not stuffy, is to temper the old with modern materials and furniture, too. So, the velvet Louis XV cane bergére is paired with a modern painting, and the fat Chinoiserie lamp bases are teamed with sleek spotlights. Likewise, a Michael Anastassiades suspension light looks incredible against a frescoed palazzo interior and a modern kitchen—granite countertops, lacquered cabinets—creates a brilliant tension when it sits on a herringbone parquet floor. Here, when you place something modern next to the old, theatrics start to happen.

DAS PRÄCHTIGE CHÂTEAU

Stellen Sie sich ein märchenhaftes französisches Château, einen charmanten italienischen Palazzo oder ein stattliches Herrenhaus auf einem traumhaften Anwesen vor. Allein schon von den Dimensionen her und auch wegen der früher vorherrschenden Vorliebe für Ornamentik muss der eher schlichte New Country Style sich hier zur (Stuck-) Decke strecken, ohne jedoch den grundlegenden Pfad der Unaufgeregtheit zu verlassen. Opulent, aber entspannt, antik, aber mit Mut zum Modernen: New Country im Château ist eine besonders kunstvolle Mischung.

Ein Interieur, das zugleich klassisch und zeitgemäß ist? Ein Ambiente, das die Historie würdigt, ohne muffig zu wirken? Eklektizismus ist hier das Zauberwort. Ein Konzept von „rauem Luxus". Nachdem die Tapeten abgezogen wurden, bleibt nur der blanke Putz zurück. Antike Stücke werden mit modernen Designklassikern wie etwa von Verner Panton kontrastiert und Ölgemälde aus dem 19. Jahrhundert leger auf dem marmornen Kaminsims abgestellt oder auf dem Boden gegen die Wand gelehnt. Hier gibt es viel Patina und jede Menge Antiquitäten.

Ein weiteres Geheimnis besteht darin, die alten Teile mit neuen Materialien und sogar mit modernen Möbelstücken zu kombinieren. So wird die samtgepolsterte Louis-XV-Bergère direkt neben einem avantgardistischen Gemälde platziert und den breiten Lampensockeln im Chinoiserie-Stil werden schlanke Spotlights aufgesetzt. Eine Hängeleuchte von Michael Anastassiades fühlt sich auch in einem Palazzo mit Fresken zu Hause und eine zeitgemäße Küche – Granitplatten, Hochglanz-Schrankfronten – erzeugt eine aufregende Spannung, wenn sie auf Fischgrätenparkett steht. Wenn etwas Modernes auf etwas Altes trifft, ist die Theatralik nicht weit.

STYLE IN BRIEF

Ornately furnished with lots of eclectic charm, the interiors of these palatial homes feature faded antiques, opulent accessories, and statement chandeliers. Paneled walls and rich architectural details combine with a rich color palette and threadbare Persian rugs on the floors.

STIL KURZ GEFASST

Die Interieurs dieser mit viel eklektischem Charme ausgestatteten Häuser warten mit verblichenen Antiquitäten, opulenten Accessoires und Statement-Lüstern auf. Holzgetäfelte Wände und ornamentale architektonische Details werden mit einer kräftigen Farbpalette und fadenscheinigen Perserteppichen kombiniert.

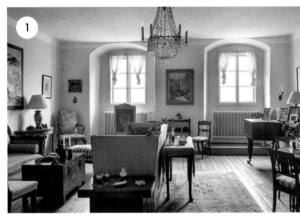

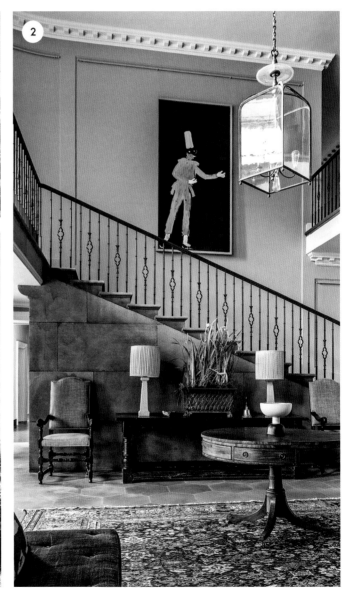

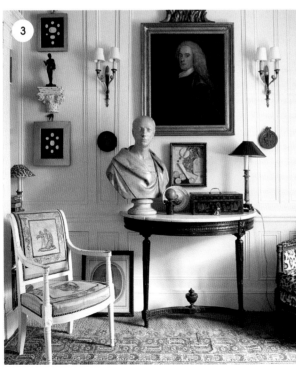

1 | *The living room is furnished with an assortment of antique furniture and art.* 2 | *A glass lantern and circular table are the main features in this entrance.* 3 | *A modern sense of classicism is created with an arrangement of dark paintings set against geometric wall paneling.* 4 | *Art Deco fabrics and furniture pep up a traditional vintage rug.* 5 | *An historic French estate.*

1 | *Das Wohnzimmer ist mit bunt zusammenge-würfelten antiken Möbelstücken und Kunstwerken eingerichtet.* 2 | *Eine Glaslaternen-Leuchte und ein runder Tisch sind die Hauptakteure des Eingangs-bereichs.* 3 | *Durch die Hängung von dunklen Gemälden vor einer geometrischen Wandvertäfelung entsteht eine moderne Version des Klassizismus.* 4 | *Art-déco-Stoffe und -Möbel peppen einen antiken Teppich auf.* 5 | *Ein historisches Anwesen in Frankreich.*

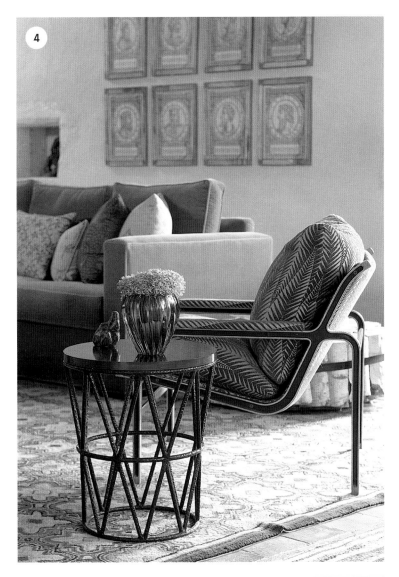

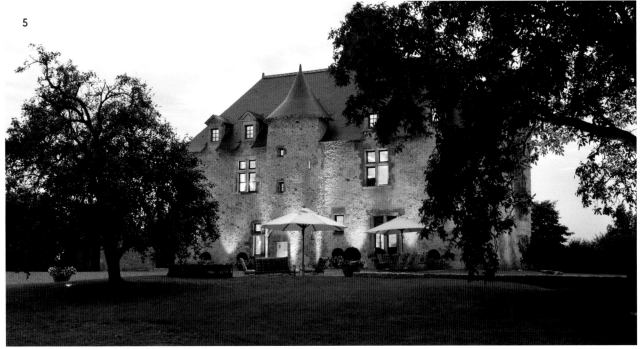

HOME INSPIRATION

GRANDEST DESIGNS

Château fantasies don't come more majestic
than this modernized pile in rural France.

EINRICHTUNGSINSPIRATIONEN

IM GROSSEN STIL

Dieses modernisierte französische Landschloss
lässt royale Träume wahr werden.

Built between the 15th and 18th centuries in the heart of the Bordeaux wine lands, Château Rigaud packs a lot of punch. The magnificent estate is decorated in a classic scheme to display the homeowners' collection of timeless design and pieces picked up from their travels.

The English family who took on the massive job of renovating the château employed the help of design-savvy friends and teams of Australian and South African traveling builders. They stripped the enormous rooms back to their basic structure, retaining the old tiled and wooden floors, fireplaces, and beams. They removed all the windows, repaired them, re-wired, and installed plumbing in the entire house. A friend created the 13-foot (four-metre) drop silk and velvet curtains, and in French gastro style, the kitchen is practical with a focus on the stove.

Despite the grandeur of the château, the mood is understated and serene. There's a sense of the past throughout. The original stonework walls are painted in a soothing palette of duck-egg blues and soft browns, along with the richer shades of aubergine and darkest blue-green in the bedrooms. Because the scale of the rooms demanded large pieces of furniture, the owners looked east to Java for custom-sized reclaimed teak beds, tables, and chairs. Bathrooms feature contemporary, freestanding baths, and a cave-like wet room with rainforest shower adds an indulgent feel. The result is a beautiful interior that balances a building's history with a gentle, modern touch.

Das imposante Château Rigaud wurde zwischen dem 15. und dem 18. Jahrhundert im Herzen des Bordeaux-Anbaugebiets erbaut. Das prächtige Anwesen ist vorwiegend klassisch eingerichtet, um die von den Besitzern zusammengetragenen Designstücke und Reisemitbringsel hervorzuheben.

Die englische Familie, die die Mammutaufgabe der Restaurierung in Angriff nahm, holte sich Hilfe bei befreundeten Designern sowie australischen und südafrikanischen Handwerkern auf Wanderschaft. Sie kernsanierten die riesigen Räume bis auf die Grundstrukturen, wobei sie die alten Fliesen und Holzböden, die Kamine und die Dachbalken erhielten. Außerdem lösten sie alle Fenster heraus, um sie zu reparieren, legten elektrische Leitungen und installierten moderne Sanitäranlagen im ganzen Haus. Ein Freund nähte vier Meter lange Gardinen aus Seide und Samt. Die praktisch gestaltete Küche im französischen Gastrostil ist ganz auf den Herd ausgerichtet.

Trotz der Pracht ist die Atmosphäre im umgebauten Château ruhig und von Understatement geprägt. Der Geist der Vergangenheit durchzieht das Gebäude. Das Original-Mauerwerk ist in einer beruhigenden Palette aus Entenei-Blau und weichen Brauntönen gestrichen; in den Schlafzimmern kommen warmes Aubergine und dunkles Blaugrün hinzu. Weil die schiere Größe der Räume nach ausladenden Möbelstücken verlangt, ließen die Besitzer in Indonesien alte Betten, Tische und Stühle aus Teakholz auf- und umarbeiten. Die Badezimmer sind up to date mit freistehenden Wannen ausgestattet und ein höhlenartiger Waschraum mit Regendusche verbindet Ursprünglichkeit und Luxus. Das Ergebnis ist ein wunderschönes Interieur, das dem geschichtsträchtigen Gebäude mit Feingefühl einen modernen Touch verleiht.

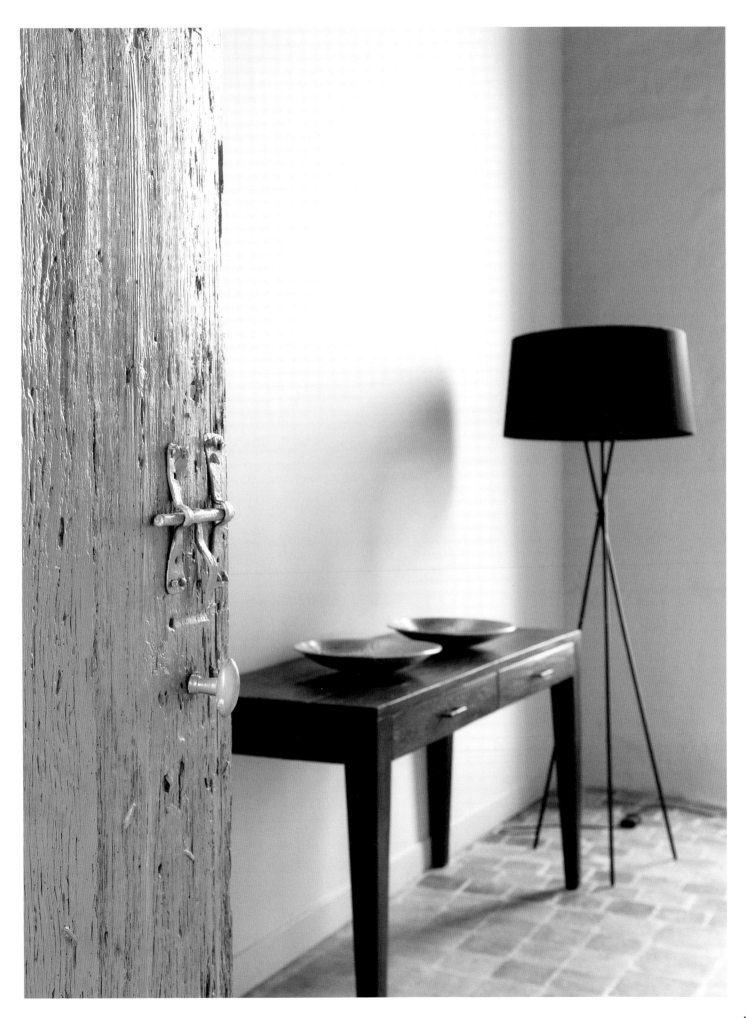

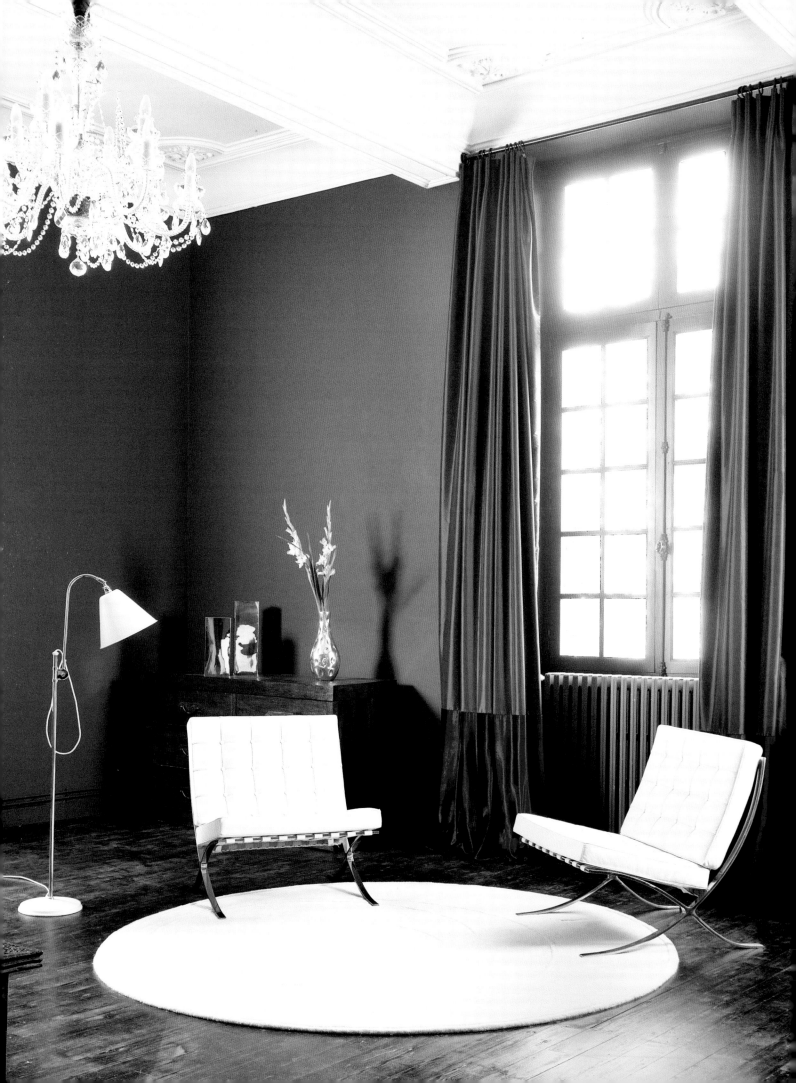

THE COLORS

Color plays a bolder role in this interior as the massive rooms can carry a petrol blue, sage green, dark gray, or mousey brown with ease. Matte is where it is at: the chalkier, the velvet-ier, the better. It adds softness to the interior and frames items beautifully. With these ancient buildings, there is enough drama going on with the architecture, so the matte finish adds the comfort.

DIE FARBEN

Die Farbauswahl ist hier etwas kühner als sonst bei New Country üblich, da die gewaltigen Raumdimensionen ohne weiteres Töne wie Petrolblau, Salbeigrün, Dunkelgrau oder Lehmbraun vertragen. Matt ist Trumpf: je kreidiger und samtiger, desto besser. Gedämpfte Farben machen das Interieur weich und rahmen ausgewählte Objekte schmeichlerisch ein. In solch alten Gemäuern steckt in der Architektur schon genug Dramatik; der Mattanstrich liefert dazu die Behaglichkeit.

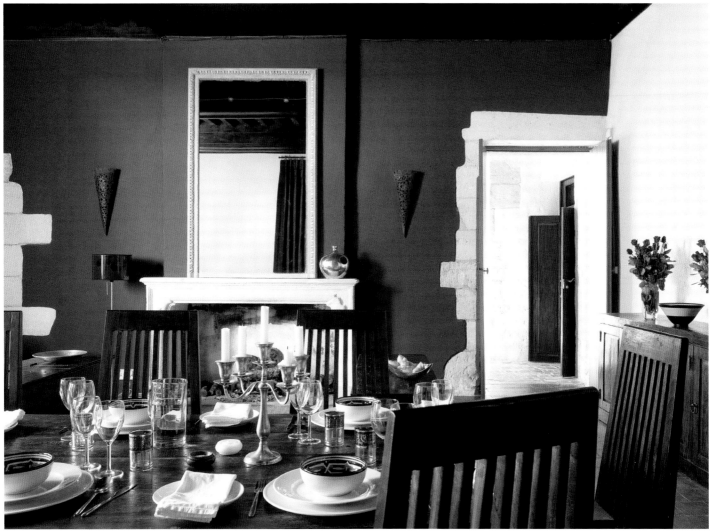

THE FURNITURE

The interior scheme is eclectic with influences ranging from the Orient through to traditional French country. The furniture includes large, contemporary sofas and a rustic coffee table in the living room. For the kitchen, Arne Jacobsen Series 7 chairs surround the pine refectory table. Industrial elements are added to the mix. Lighting makes this easy with a stainless steel drum shade in the kitchen and vintage chandeliers elsewhere. Always go for drama when it comes to lighting. Hang a chandelier lower than you dare to make it really catch the eye. The overall effect will define the space and make it feel cooler.

DIE MÖBEL

Die Möblierung mischt verschiedenste Einflüsse, die vom Orient bis zum französischen Landhausstil reichen. Das Wohnzimmer ist mit großen modernen Sofas und einem rustikalen Couchtisch ausgestattet, in der Küche umrahmen Arne Jacobsens Serie-7-Stühle einen mächtigen Esstisch aus Pinienholz. Auch Elemente im Industrial Style sind Teil des Wohnensembles, zum Beispiel in Form eines trommelförmigen Lampenschirms aus Edelstahl in der Küche. In anderen Räumen erhellen wiederum prächtige Vintage-Kristalllüster die Szenerie. Überhaupt: Bei der Beleuchtung darf es auch mal dramatisch werden. Hängen Sie einen Kronleuchter ruhig tiefer als üblich, damit er ins Auge fällt und zum Raummittelpunkt wird.

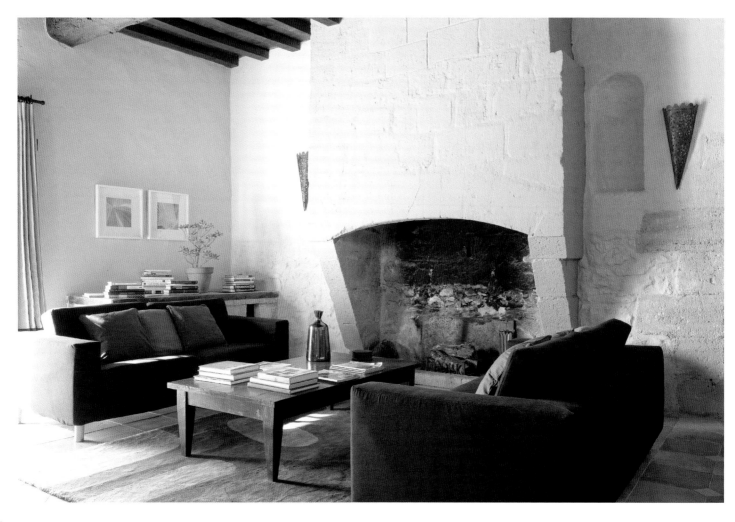

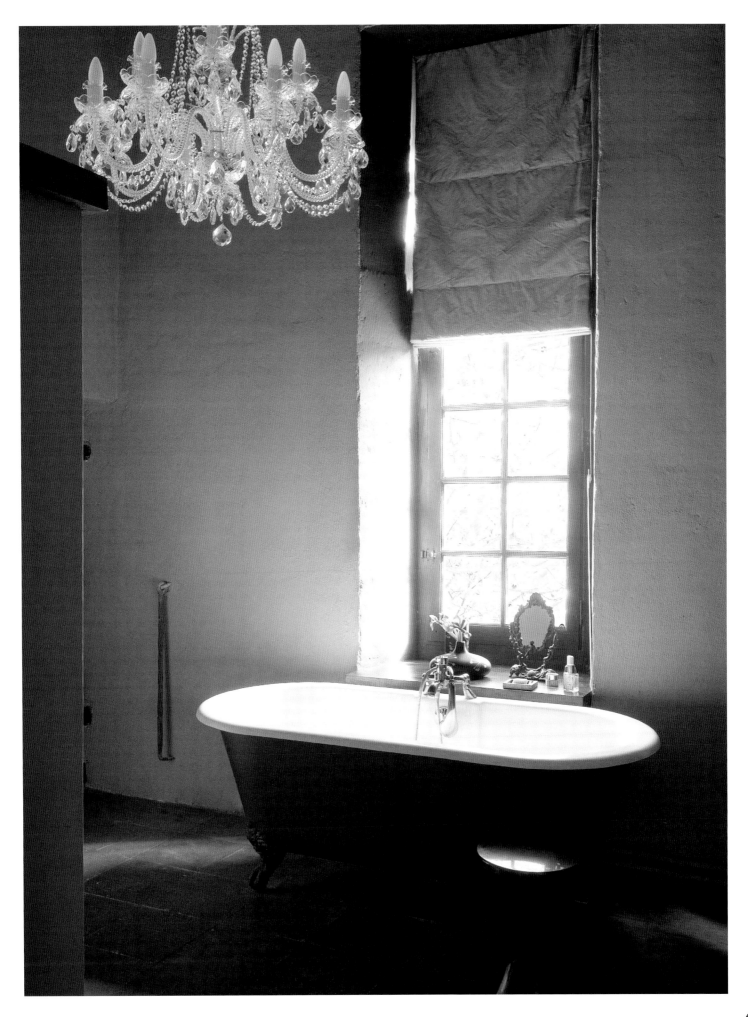

THE MATERIALS

Ultimately, this is a modern home inside an old shell. Throughout the house, original terra-cotta tiles or wide, treacle-stained floorboards deck the floor. The walls are bare, and the spa-like wet room marries rough stone with a polished plaster floor. Flashes of chrome and white leather add a contemporary element and stand out against the dark wood and moody tones. All the while admiring the cool furniture and stunning original floors, there may be an intricate stucco ceiling. Don't forget to look up.

DIE MATERIALIEN

Letztendlich handelt es sich hier um ein modernes Zuhause in alter Schale. Im ganzen Gebäude bedecken original Terrakotta-Fliesen oder breite, sirupfarben gebeizte Holzdielen den Boden. Die Wände sind kahl und der Wellness-Duschraum vereint grobes Mauerwerk mit einem Boden aus poliertem Beton. Akzente aus Chrom und weißem Leder bilden ein zeitgenössisches Element und heben sich vom dunklen Holz und den eher gedeckten Tönen ab. Vergessen Sie nicht, den Blick nach oben zu richten, nachdem Sie das coole Mobiliar und die wunderschönen Originalböden bewundert haben: Dort erfreut eine üppige Stuckdecke das Auge.

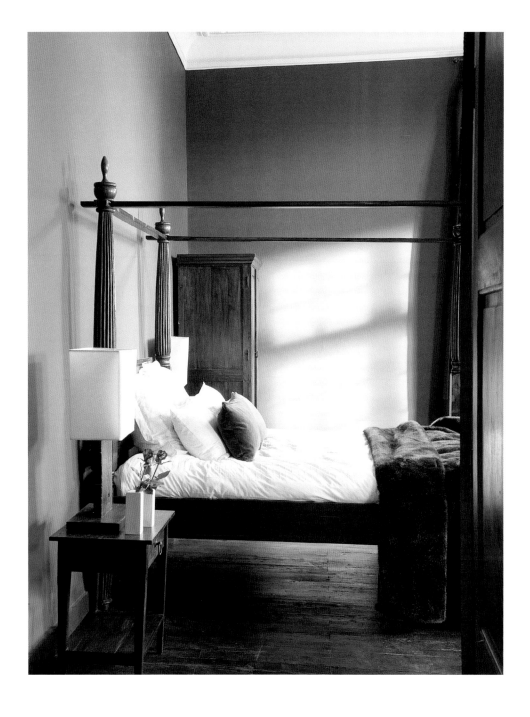

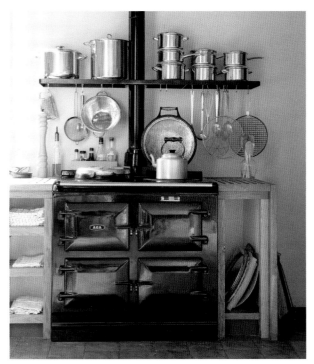

LEFT *A traditional cooking range suits the utility of the kitchen.*
BELOW *Contemporary dining furniture and lighting softens up the imposing stone fireplace.* LEFT PAGE *In the bedroom, a dark molasses-stained floor makes a striking combination with the blue walls.*

LINKS *Eine traditionelle Küchenzeile passt zur Funktionalität der Küche.* UNTEN *Moderne Esszimmermöbel und Leuchten mildern die Strenge des imposanten Steinkamins ab.*
LINKE SEITE *Im Schlafzimmer geht der dunkel gebeizte Holzboden eine harmonische Verbindung mit den blauen Wänden ein.*

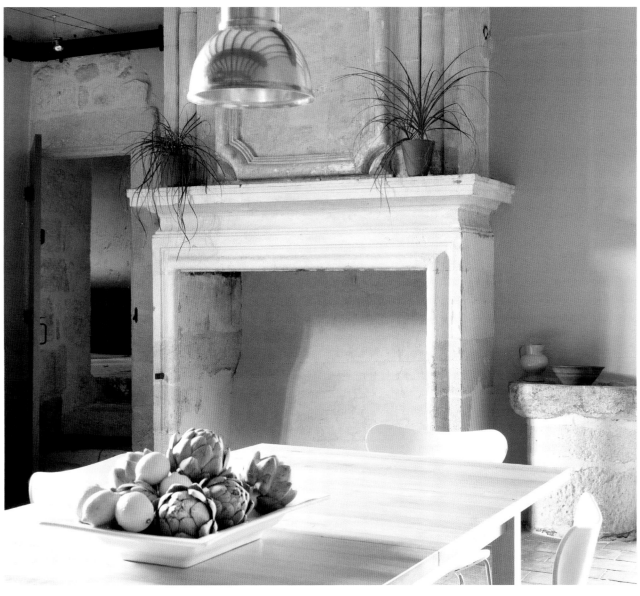

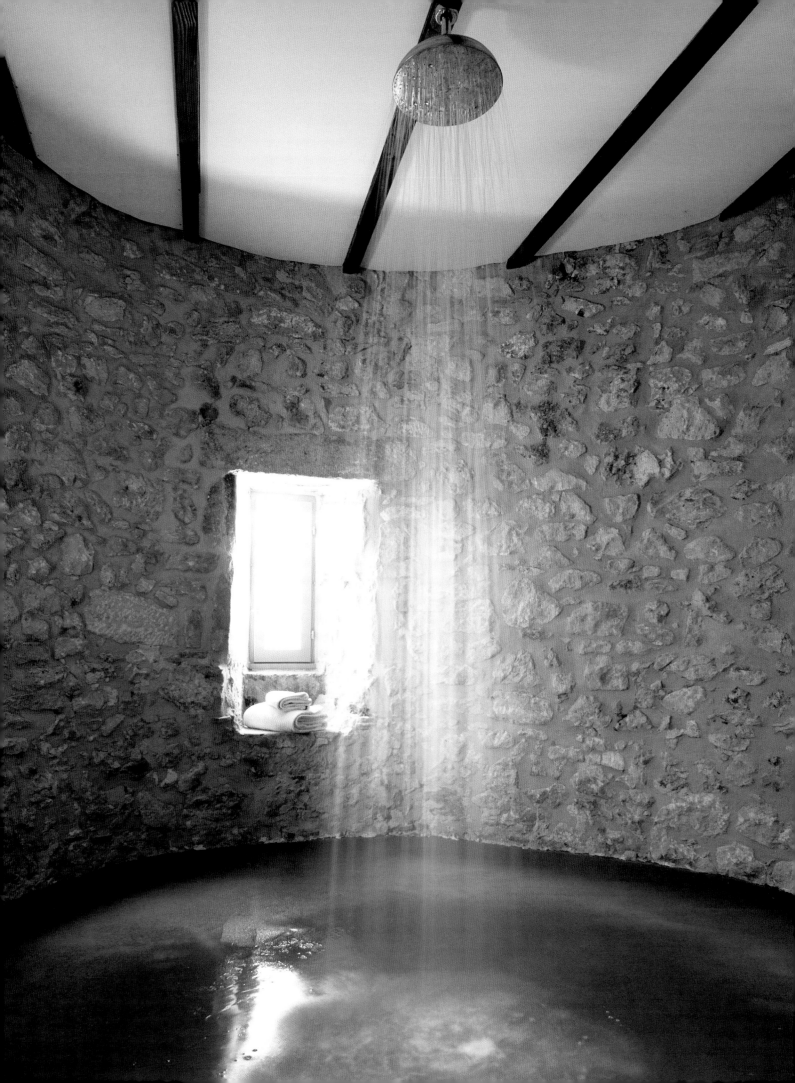

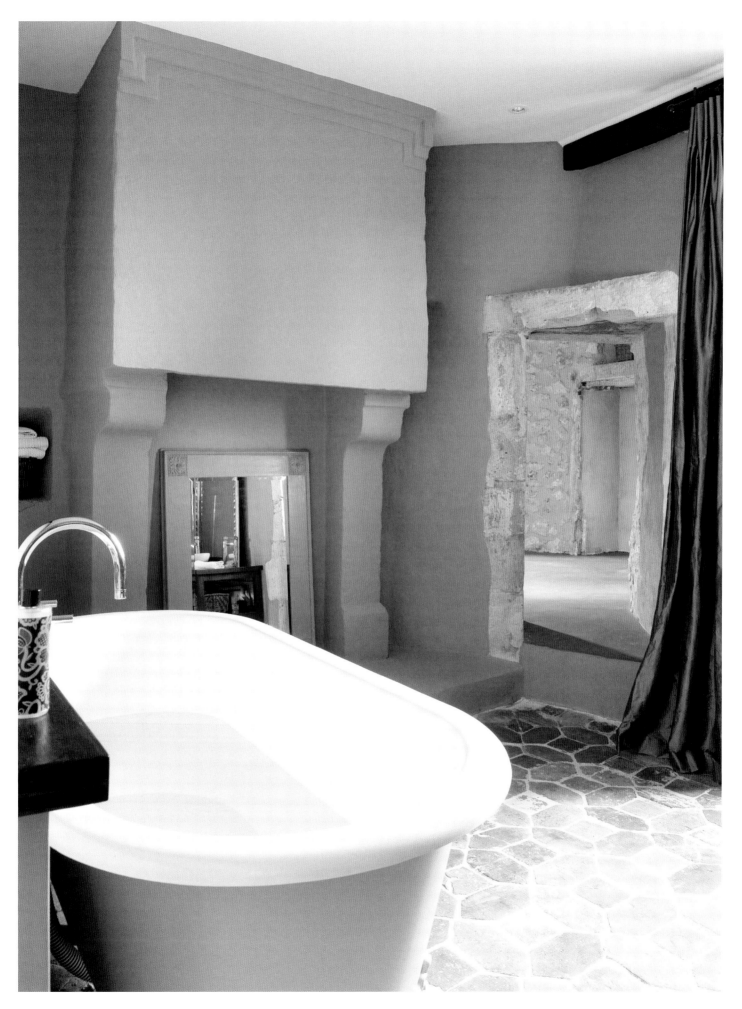

MIXING AND MATCHING CHAIRS WITH FLAIR

STÜHLE MIT FLAIR KOMBINIEREN

Rule number one is to try and match chairs in pairs. If a chair is part of a couple, then the end result has a more cohesive feel.

Versuchen Sie, eher Stuhlpaare als Einzelstücke miteinander zu kombinieren. Der Gesamteindruck wird dadurch harmonischer.

For color, there are two options. If the chairs are matching, then it's good to go rainbow. If there is a mix of styles, then tie them together with a single shade.

In Sachen Farbe gibt es zwei Optionen: Wenn die Stühle zusammen passen, können sie unterschiedliche Farben haben. Bei einem Stilmix sollten sie durch einen Farbton miteinander verbunden werden.

Consider proportions. You can mix old and new, industrial with rustic but stick to the same seat heights to avoid the overall effect looking odd.

Achten Sie auf die Proportionen. Sie können problemlos alt und neu, industriell und rustikal mixen, sollten dabei aber immer die gleiche Lehnenhöhe beibehalten, damit Ihr Sitzsortiment nicht einfach nur seltsam aussieht.

If in doubt, stick to the classics. You can't go far wrong with an Eames or Ercol chair. They are at home around any manner of table styles.

Bleiben Sie im Zweifel bei den Klassikern. Mit einem Stuhl von Eames oder Ercol kann man nicht viel falsch machen, sie passen eigentlich zu allen Tischstilen.

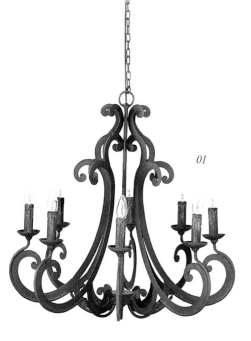

GET THE LOOK

01. *Curlicue Chandelier by OKA*
02. *Savage Couture Fabric Collection by de Le Cuona*
03. *Scented candle by Cire Trudon*
04. *Diana Bust & Stately Screens by The French Bedroom Co*
05. *Lit d'Amour bed by The French Bedroom Co*
06. *The Copper Bateau by Catchpole & Rye*

01. *Curlicue Chandelier von OKA*
02. *Savage Couture Stoffkollektion von de Le Cuona*
03. *Duftkerze von Cire Trudon*
04. *Diana Bust & Stately Screens von The French Bedroom Co*
05. *Lit d'Amour Bett von The French Bedroom Co*
06. *The Copper Bateau von Catchpole & Rye*

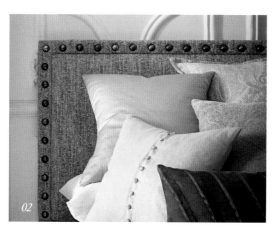

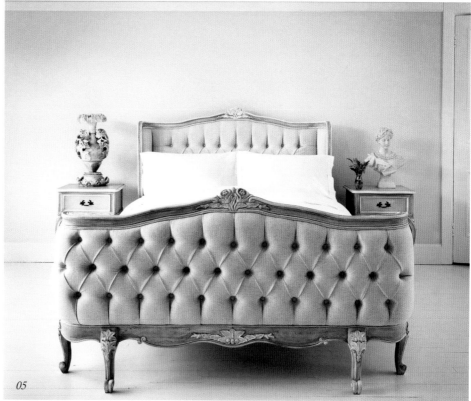

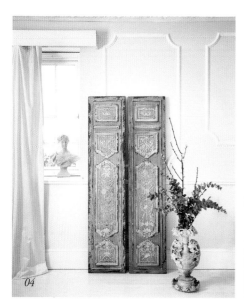

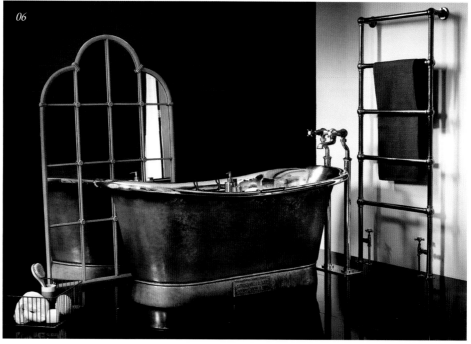

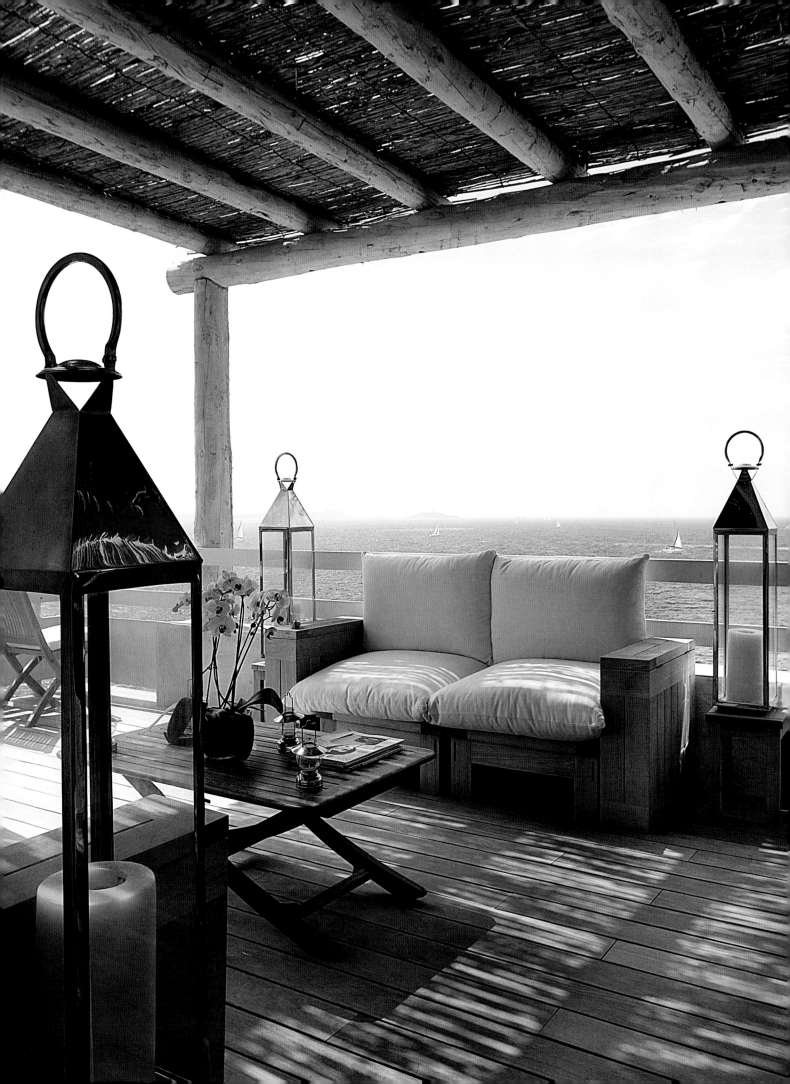

04

THE HOUSE AT THE SEA

There's an ethereal beauty to a weather-boarded cottage perched on the ocean. A fisherman's cottage with only one bedroom, the frame of mind is as breezy as the location. These are the love at first sight houses where you can literally breathe in the salt air—if we were to include some little sample bags with sand and seashells, you would get the full effect.

Wood takes center stage. So does space. There's a desire to open up the interior as much as possible. By heightening the ceiling to expose the beams, the structure of the building is showcased. This also enhances the feeling of openness that echoes the beauty of its surroundings. A monochrome palette in this open-plan shell provides a perfect backdrop to display vintage furniture and driftwood finds—the black and white giving a modern edge to the otherwise neutral tones.

The interior suits the chaos of the ocean. It's full of character. At times calm, at times messy, it goes in many different directions with a mixture of antique and contemporary design. In some areas, the cupboards might be concentrated with magpie finds. In other areas, space reigns with furniture kept to a minimum. Too much and a small space would feel cluttered. At its basic, a living room needs only a massive sofa to curl up on and a fire to sit in front. The bedroom needs to feature little more than an old wrought-iron bed, a folding chair, and a superb modern lamp.

Fixed with a veranda to the front with French windows that swing out to the ocean, the appeal is a washed-up and sea-faded charm. Domestic happiness here is the calm, the quiet, birds singing, sunsets, and the wind in the grass. Bliss.

DAS HAUS AM MEER

Ein Haus am Meer, das Wind und Wetter trotzt, hat etwas Zartes, Ätherisches an sich. Hier wird der Kopf durchgepustet von der frischen Brise; die Gedanken wandern frei umher. Man kann das Salz in der Luft förmlich riechen – es ist Liebe auf den ersten Blick!

Holz steht bei der Einrichtung an oberster Stelle. Und Weite. Der Raum soll so groß und offen wie möglich wirken, weshalb die Dachbalken freigelegt werden. Eine monochrome Farbpalette bildet den perfekten Hintergrund für Vintage-Möbel und Treibgutobjekte. Ein schwarz-weißes Einrichtungskonzept verleiht den neutralen Tönen einen modernen Touch.

Das Interieur passt zum Chaos des Ozeans. Es hat viel Charakter. Mal ruhig, mal stürmisch, schwappt es mit seinem Mix aus antikem und zeitgenössischem Design in viele verschiedene Richtungen. In manchen Bereichen sind die Schränke mit skurrilen Zufallsfunden vollgestopft, während in anderen in Sachen Möblierung Minimalismus herrscht, um kleine Wohnflächen nicht zu überladen. Letztendlich braucht man im Wohnzimmer nur ein massives Sofa zum Einkuscheln vor dem prasselnden Kamin. Und im Schlafzimmer reichen ein altes Eisenbett, ein Klappstuhl und eine sorgfältig ausgewählte moderne Lampe.

Zur Veranda mit Meerblick öffnen sich bodentiefe Glastüren. Insgesamt strahlt dieses Zuhause einen von der Meeresluft ausgeblichenen Charme aus. Glück bedeutet hier Ruhe, Vogelzwitschern, Sonnenuntergänge und der Wind in den Dünen. Was will man mehr?

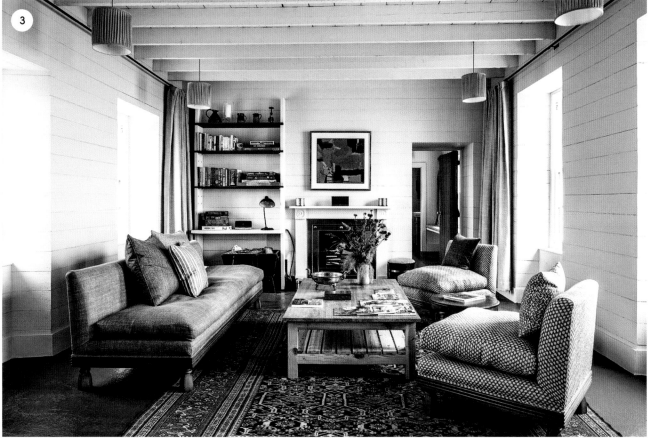

STYLE IN BRIEF

These waterside cabins—with their breezy, white interiors—are the perfect weekend retreat. Furnished with compact sofas, vintage finds, and nautical-inspired light fixtures, the key here is to keep things simple and make the most of the indoor/outdoor space.

STIL KURZ GEFASST

Mit ihren luftig-weißen Interieurs sind diese Häuschen am Wasser die perfekten Rückzugsorte fürs Wochenende. Die Ausstattung mit kompakten Sofas, Vintage-Accessoires und nautisch inspirierten Leuchten ist einfach und pflegeleicht und passt zu einem Konzept, bei dem sich ein Großteil des Lebens im Freien abspielt.

4

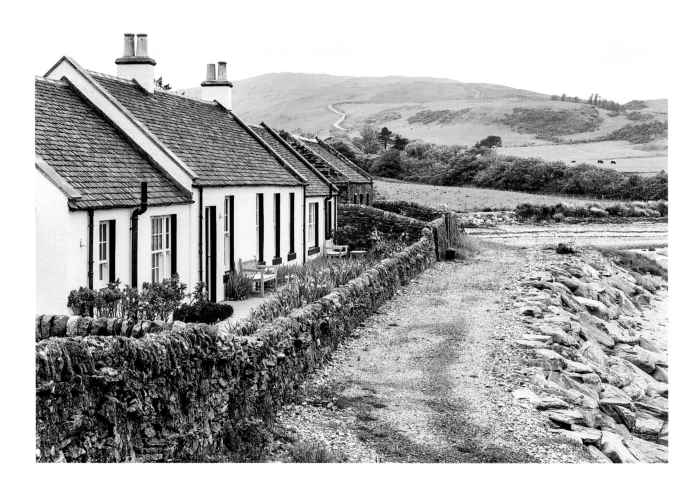

1 | *White-painted wood paneling adds to the charm.*
2 | *A red dresser adds a flash of color in this dining room.* **3 |** *Compact yet comfy, these down-filled chairs take up very little space.* **4 |** *Simple summer cottages.*
5 | *A white-and-blue color scheme gives a maritime feel to the bedroom.* **6 |** *Open shelving is spacious enough for the kitchen utensils.*

1 | *Weiß gestrichene Holzpaneele tragen zum Charme des Interieurs bei.* **2 |** *Eine rote Anrichte setzt im Esszimmer einen Farbakzent.* **3 |** *Kompakt und doch bequem: Diese mit Daunen gepolsterten Sessel nehmen nur wenig Platz ein.* **4 |** *Einfache Sommerhäuschen.*
5 | *Mit frischen Blau- und Weißtönen wird es auch im Schlafzimmer maritim.* **6 |** *Offene Regale bieten ausreichend Platz für Küchenutensilien.*

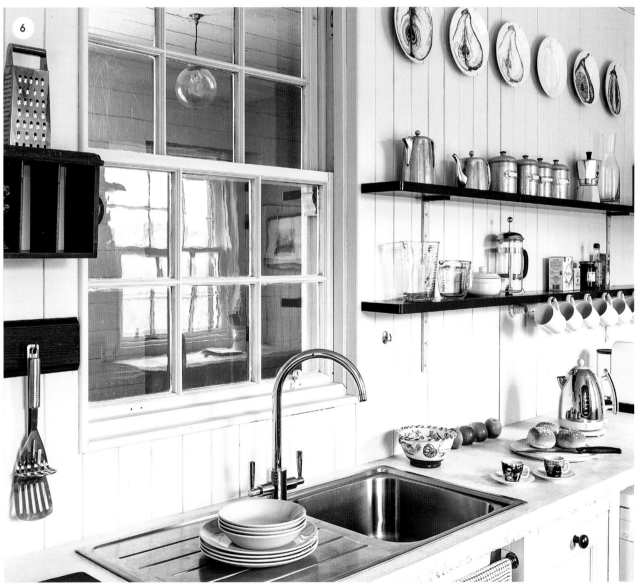

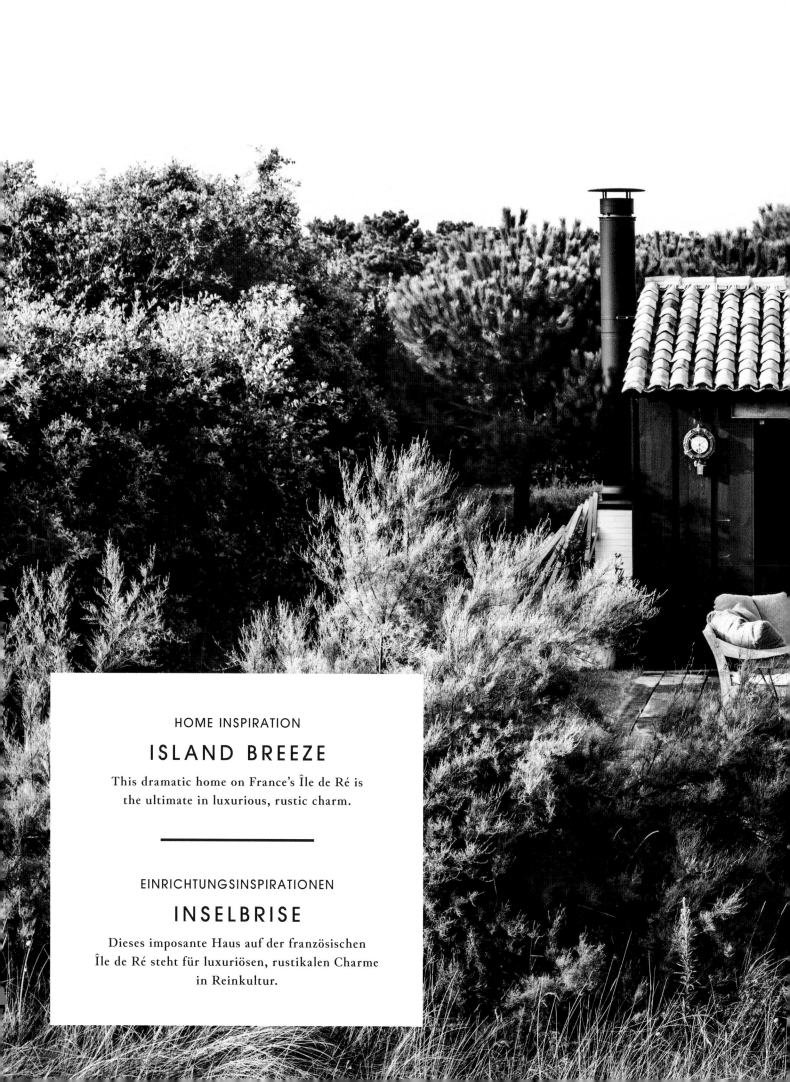

HOME INSPIRATION

ISLAND BREEZE

This dramatic home on France's Île de Ré is
the ultimate in luxurious, rustic charm.

———————

EINRICHTUNGSINSPIRATIONEN

INSELBRISE

Dieses imposante Haus auf der französischen
Île de Ré steht für luxuriösen, rustikalen Charme
in Reinkultur.

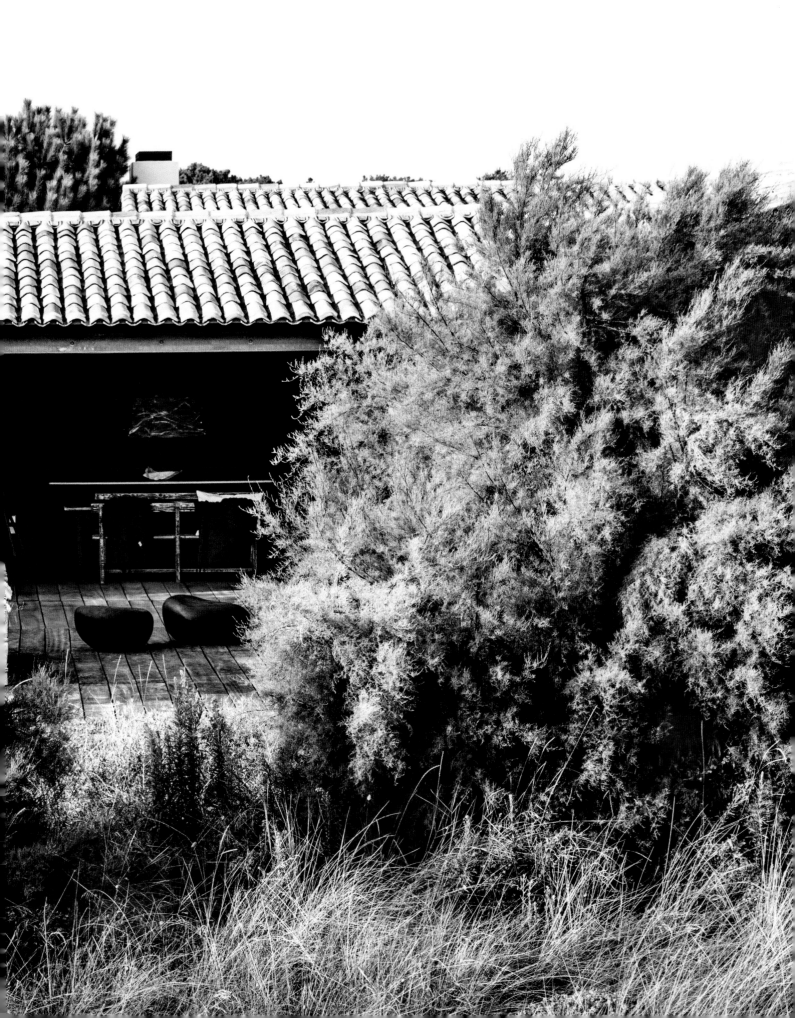

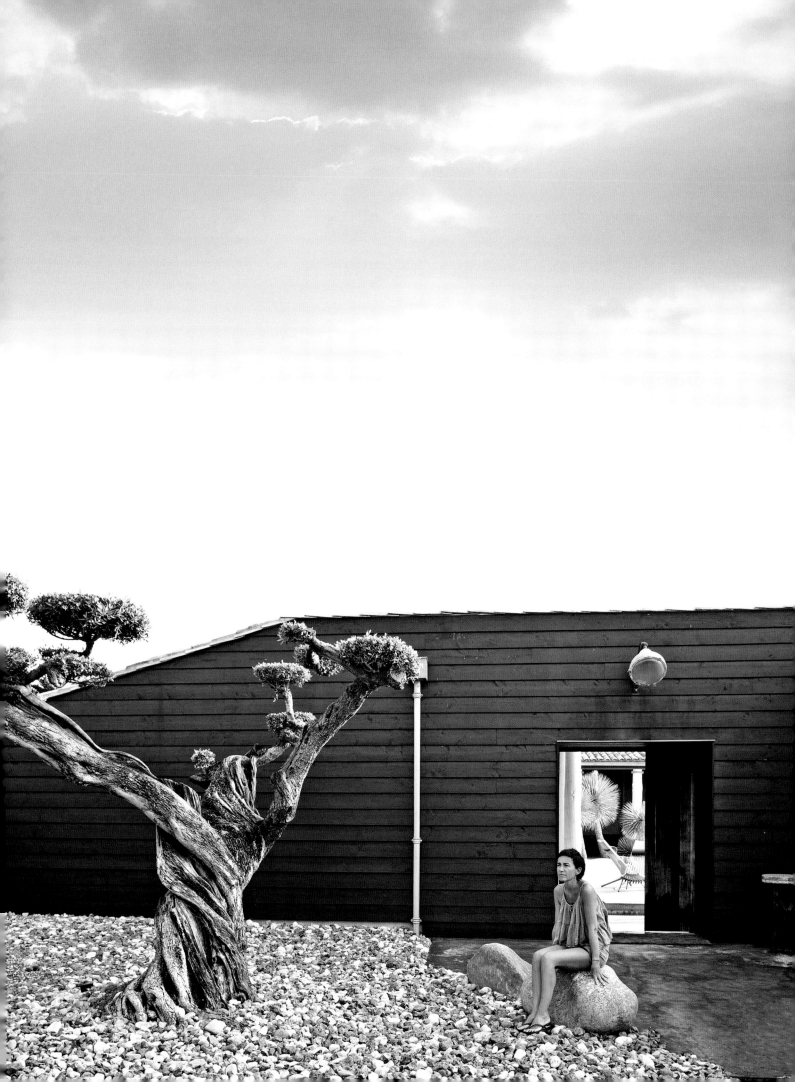

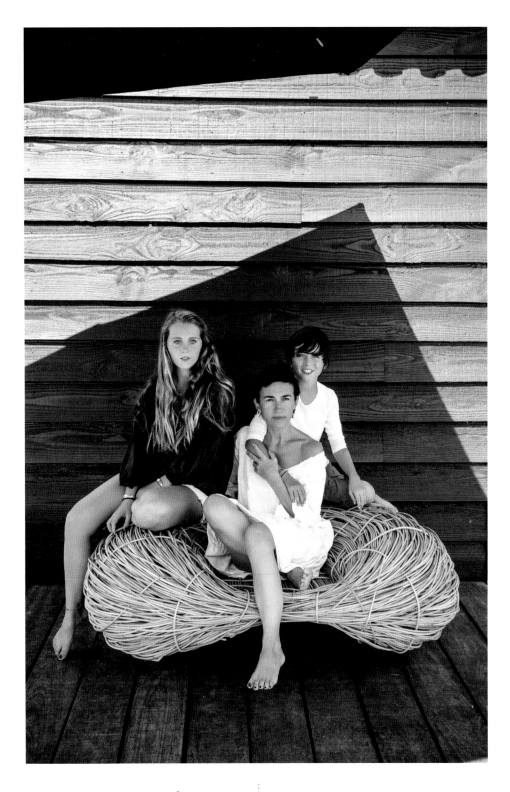

Situated on the west coast of France on the chic Île de Ré, Laurence Simoncini's holiday home is the essence of tranquility and natural beauty. Close to the beach and enjoying panoramic views, you can really sense the spot's wild and beautiful surroundings. The dark-stained wooden building sets the raw and elegant tone, while the ancient gnarled and twisted tree surrounded by pebbles gives the garden a desert-like feel. This laid-back and low-maintenance family retreat is characterized by the use of natural materials put together in a sophisticated, yet sensational way.

Laurence Simoncinis Ferienhaus auf der angesagten Île de Ré an der französischen Westküste ist von Ruhe und natürlicher Schönheit umgeben. Hier kann man in Strandnähe Panoramablicke genießen und die wildromantische Umgebung förmlich spüren. Das mit dunklem Holz verkleidete Gebäude wirkt rau und gleichzeitig elegant, während die uralten knorrigen Bäume und der von Kieseln bedeckte Boden dem Garten ein Wüstenflair verleihen. Dieses entspannte und pflegeleichte Ferienhaus wird vor allem durch den Einsatz von Naturmaterialien charakterisiert, die auf eine sehr geschmackvolle und besondere Weise zusammengestellt wurden.

Inside, chalky plaster walls and a high-beamed ceiling define the enormous living space. The muted color palette is balanced with sumptuous furniture: a deep linen sofa is made extra inviting with cushions, while the driftwood sculptures and metal coffee tables add contrasting textures. Without curtains, the many windows provide a spectacular view of the ever-changing sea and sky. This home is very much part of its outdoor surroundings, where you can experience nature and live both inside and out.

By keeping the walls free of ornamentation, the space appears larger than it is. There is so much wood throughout, items such as the dipped plaster sculptures and large pendant lights help to break up the scheme. In the bathroom, the chain-hung antique mirror and old metal basket complement the roughly finished stone used for the basin. In the bedroom, the copper drums used as bedside tables add a shimmering quality as the light shifts across the room and also combines beautifully with the warmth of the wood.

Rustic but far from shabby chic, this simple scheme is all about using color and materials that spring from the building and the environment. Chunky timber has been repurposed into sculptural furniture, and felted wool ottomans match the stone boulders and shingle of the beach outside. By using nature as your lead, you can create a haven and be as bold as you like.

Innen definieren weiß getünchte Wände und eine hohe Decke mit freigelegten Balken die riesige Wohnfläche. Die gedeckte Farbpalette bildet den ruhigen Hintergrund für das ausladende Mobiliar: Ein niedriges Sofa mit Leinenbezug wird durch große, bauschige Kissen besonders gemütlich, während die Skulpturen aus Treibholz und die Couchtische aus Metall kontrastierende Texturen beisteuern. Die vielen gardinenlosen Fenster geben einen spektakulären Blick frei auf Meer und Himmel, die sich ständig verändern. Dieses Haus verschmilzt fast mit seiner Umgebung. Man kann die Natur hautnah erfahren und gleichzeitig drinnen und draußen leben.

Die kahl belassenen Wände lassen den Raum größer wirken. Einzelne Elemente wie die Gipsfiguren und die große Hängeleuchte brechen die Vormachtstellung des Holzes auf. Im Badezimmer ergänzen ein an einer Kette hängender antiker Spiegel und ein alter Metallkorb den grob gehauenen Stein des Waschbeckens. Im Schlafzimmer strahlen die als Nachttischchen verwendeten Kupfertrommeln einen rötlichen Glanz aus, der wunderbar zur Wärme des Holzes passt.

Rustikal, aber kein Shabby Chic: In diesem Einrichtungs-konzept dreht sich alles um natürliche Farben und Materialien, die einen Bezug zum Gebäude und zur Landschaft haben. Aus groben Holzbalken entstanden mächtige Möbelstücke und Filzottomane erinnern an die Felsbrocken und Kieselsteine des Strands. Mit der Natur als Einrichtungswegweiser können Sie wild experimentieren und trotzdem ein gemütliches Refugium erschaffen.

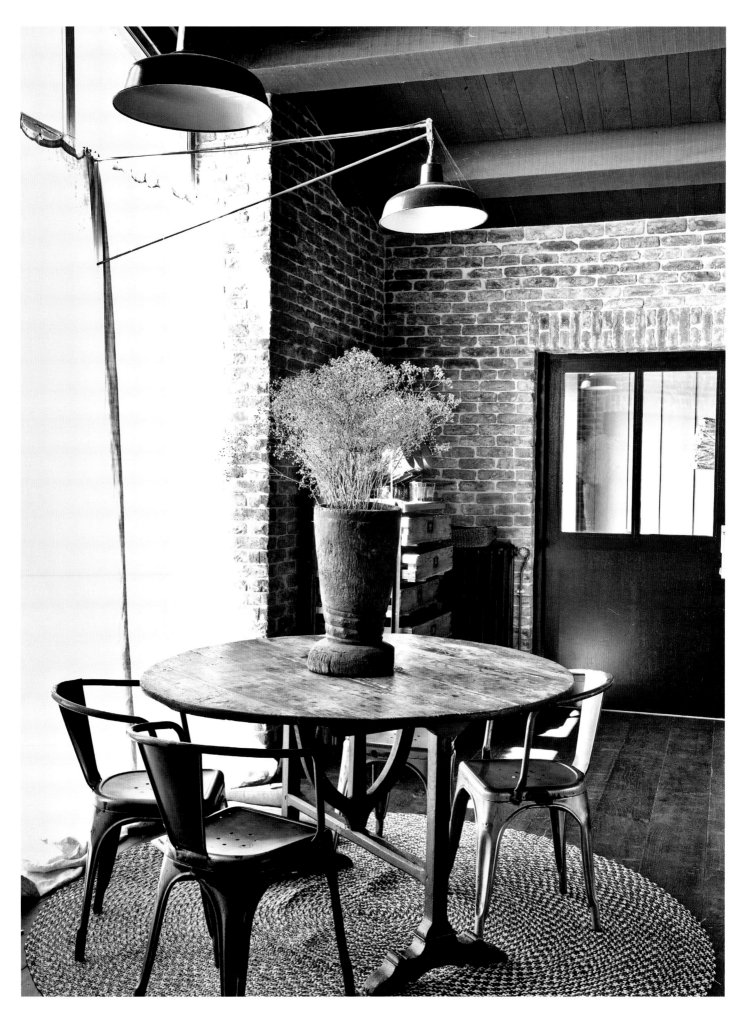

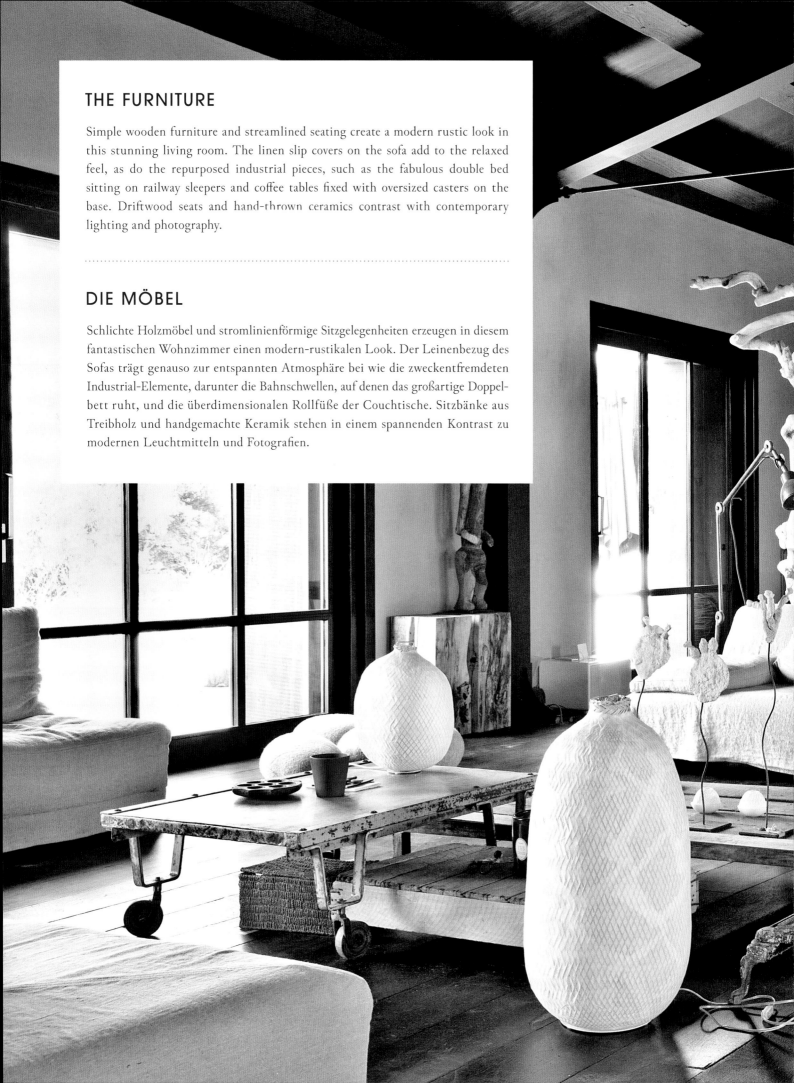

THE FURNITURE

Simple wooden furniture and streamlined seating create a modern rustic look in this stunning living room. The linen slip covers on the sofa add to the relaxed feel, as do the repurposed industrial pieces, such as the fabulous double bed sitting on railway sleepers and coffee tables fixed with oversized casters on the base. Driftwood seats and hand-thrown ceramics contrast with contemporary lighting and photography.

DIE MÖBEL

Schlichte Holzmöbel und stromlinienförmige Sitzgelegenheiten erzeugen in diesem fantastischen Wohnzimmer einen modern-rustikalen Look. Der Leinenbezug des Sofas trägt genauso zur entspannten Atmosphäre bei wie die zweckentfremdeten Industrial-Elemente, darunter die Bahnschwellen, auf denen das großartige Doppelbett ruht, und die überdimensionalen Rollfüße der Couchtische. Sitzbänke aus Treibholz und handgemachte Keramik stehen in einem spannenden Kontrast zu modernen Leuchtmitteln und Fotografien.

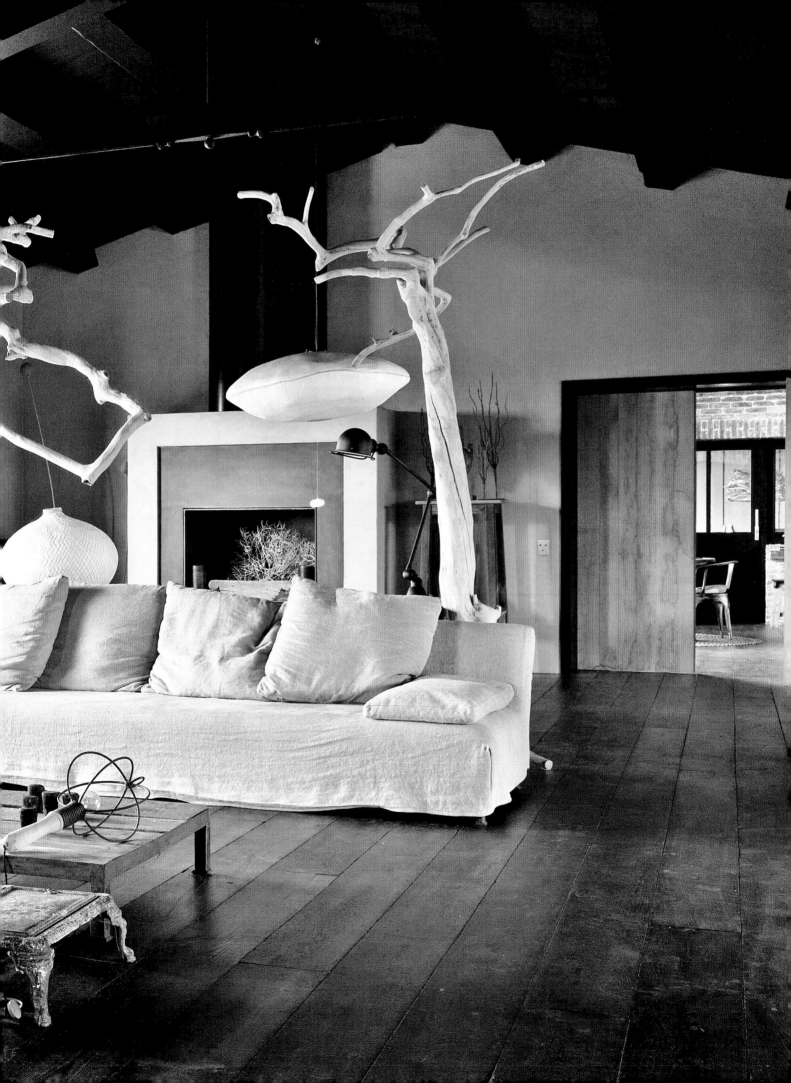

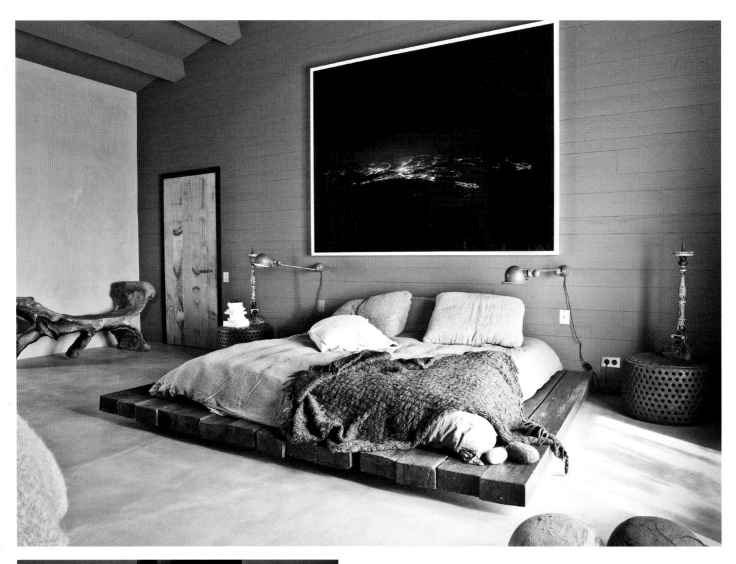

THE COLORS

A palette of browns and creams makes the interior feel warm and inviting, while the addition of black gives the space a modern edge. The dark wooden cladding merges beautifully with the landscape. To achieve a gray-weathered timber similar to the exterior of Laurence's home, treat wood with an iron sulfate wood preserver, which gives a building a brownish-gray tone.

DIE FARBEN

Eine Palette aus Braun- und Cremetönen macht das Interieur warm und einladend, die schwarzen Farbakzente verleihen dem Raum eine moderne Note. Die dunkle Holzfassade fügt sich nahtlos in die Umgebung ein. Den leicht verwitterten Look von Laurences Haus erhält man, wenn man Holz mit eisensulfathaltigem Schutzmittel behandelt. So entsteht ein braungrauer Farbton.

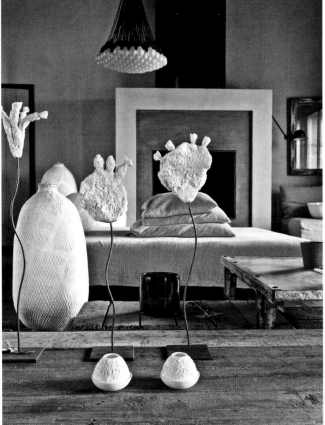

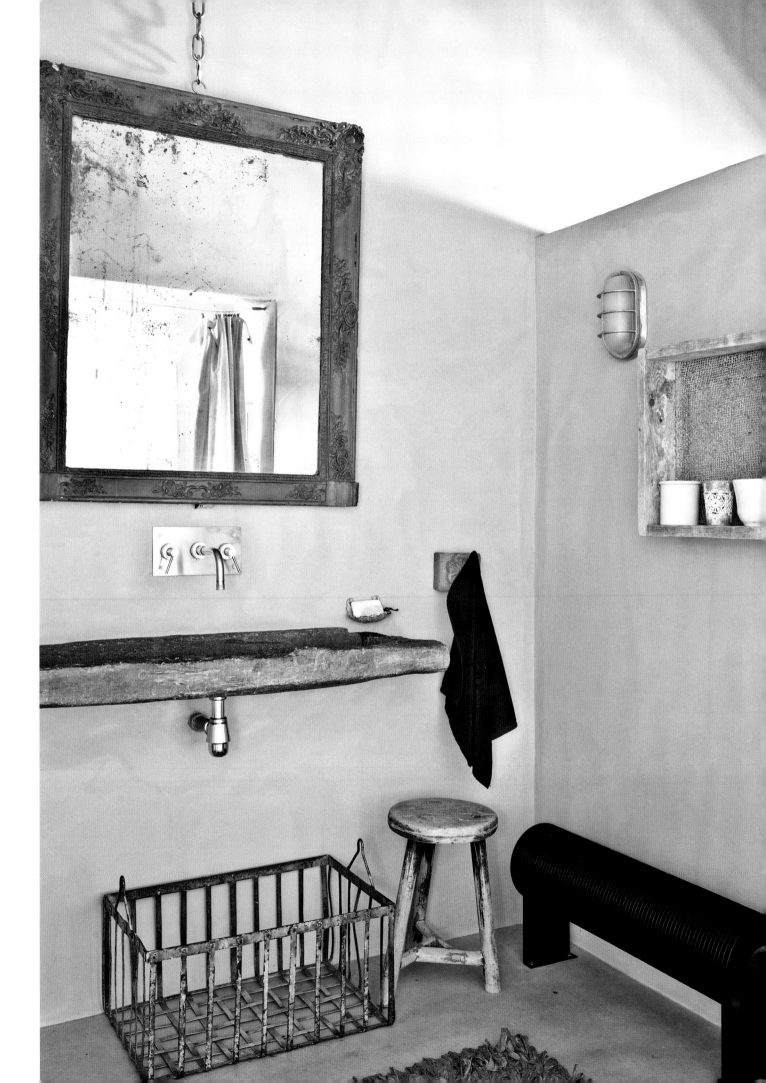

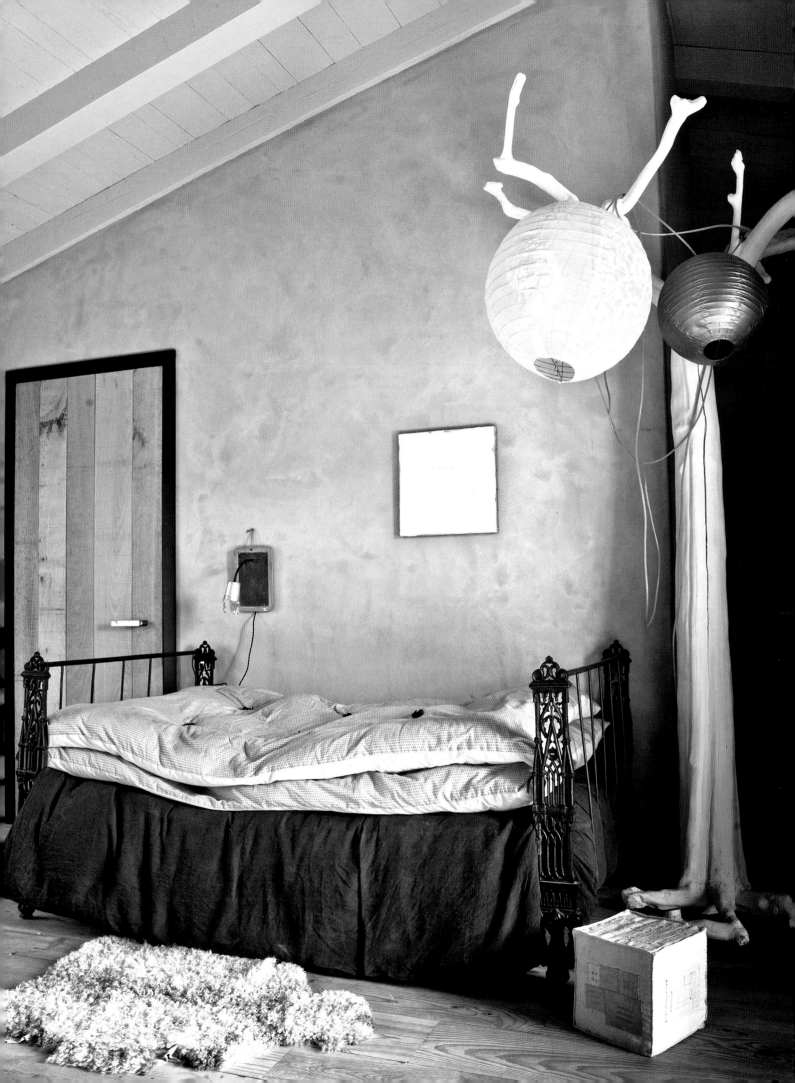

LEFT *This room features an old cast-iron bed strewn with feather-filled duvets, while paper lanterns are casually strung from the driftwood tree.* **ABOVE** *Beautifully wonky, hand-thrown ceramics stand out against the metal surrounds.* **RIGHT** *In the living room, a coffee table is made out of well-worn timber planks.*

LINKS *Auf dem alten Bett mit hübsch verziertem Eisengestell liegen Daunendecken. Papierlampen sind locker an einem Treibholzbaum drapiert.* **OBEN** *Wunderbar unregelmäßige handgetöpferte Keramik hebt sich vom Hintergrund aus Metall ab.* **RECHTS** *Der Tisch im Wohnzimmer wurde aus alten Holzplanken zusammengezimmert.*

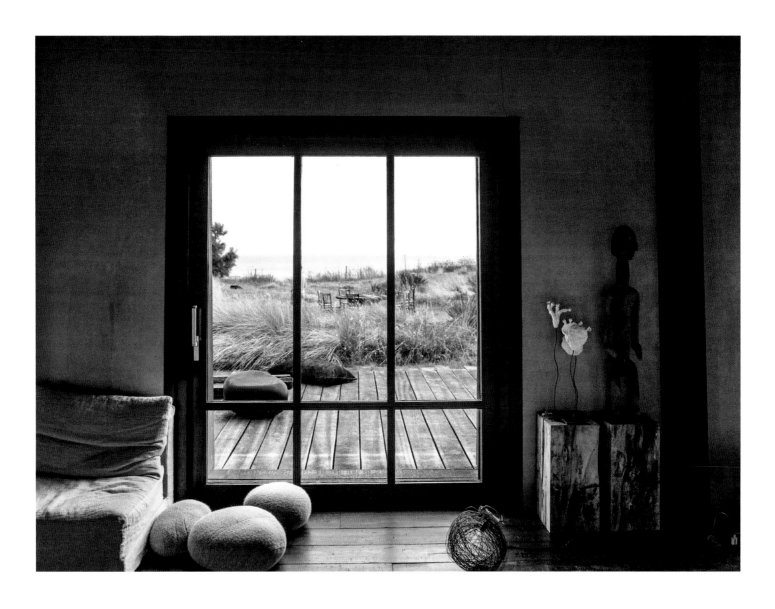

THE MATERIALS

Inside, there's a cool, harmonious mood where the focus is on raw and natural materials, textures, and fabrics. Polished concrete, plaster walls, wooden flooring, and soft, downy quilts—everything is kept in a wonderful brown, gray, and black palette with carefully selected art objects and woven, nest-like furniture adding to the eclectic mix of textures and shapes.

DIE MATERIALIEN

Innen liegt der Schwerpunkt auf natürlichen und unbearbeiteten Materialien, die ein kühles und harmonisches Ambiente erzeugen. Polierter Beton, verputzte Wände, Holzböden und weiche Daunendecken – alles ist in wunderbaren Schattierungen von Braun, Grau und Schwarz gehalten. Sorgfältig ausgewählte Kunstwerke, zum Beispiel nestartige Objekte aus Draht, erweitern den bunten Mix aus Texturen und Formen.

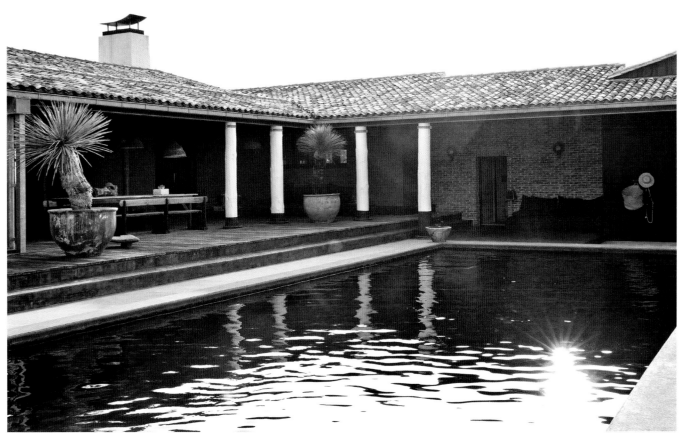

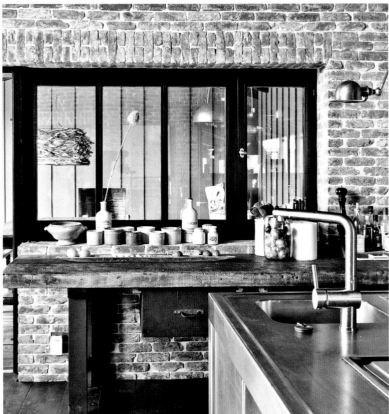

FAR LEFT *Floor-to-ceiling windows make the most of the spectacular view.* **ABOVE** *This court-yard pool provides the ultimate escape.* **LEFT** *In the kitchen, industrial metal units mix with exposed brick walls and thick wooden countertops.*

GANZ LINKS *Raumhohe Fenster setzen die spektakuläre Aussicht bestens ins Bild.* **OBEN** *Dieser Pool im Innenhof bietet Erholung pur.* **LINKS** *In der Küche werden industriell anmutende Metall-elemente mit freigelegten Ziegelsteinwänden und Arbeitsflächen aus dicken Holzplatten kombiniert.*

HOW TO CREATE
A SOOTHING MOOD

EINE ENTSPANNTE WOHNATMOSPHÄRE ERZEUGEN

Avoid too much white, as it can be bright, clean, and shiny. Instead choose earthy tones in brown, mossy green, and dirty rose.

Vermeiden Sie den Einsatz von zu viel Weiß, da dies grell und steril wirken kann. Wählen Sie stattdessen Erdtöne wie Braun, Moosgrün und Altrosa.

Good lighting is important to help create a calm mood. Go for adjustable wall lights instead of spotlights, which can be too harsh.

Die Beleuchtung ist der Schlüssel, wenn es um ein stimmungsvolles Ambiente geht. Verstellbare Wandleuchten sind besser als Spotlights, die oft zu direktes Licht geben.

Pearly or warm metal accessories are great for bouncing a light around and provide a lovely contrast to velvety matte finishes.

Warm schimmernde Metallaccessoires reflektieren das Licht und bilden einen schönen Kontrast zu samtig-matten Oberflächen.

Wood is good and lots of it. The feel of walking on it is so much nicer than cold tiles, and it generally has more character than carpet.

Holz ist Trumpf. Es läuft sich darauf so viel angenehmer als auf kalten Fliesen und es hat generell mehr Charakter als Teppichboden.

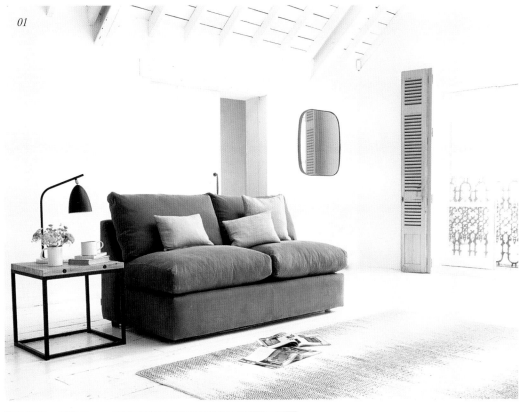

01

02

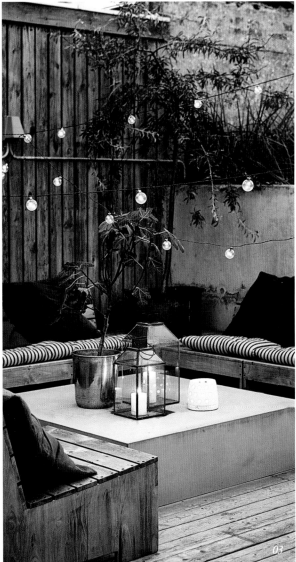

03

04

GET THE
LOOK

01. *Chatnap modular sofa by Loaf*
02. *Oceanic pendant in basalt gray*
 by Davey Lighting
03. *Outdoor inspiration by House Doctor*
04. *Glass vases by House Doctor*
05. *Striped Linen Beach Towel by TOAST*

01. *Chatnap modular sofa von Loaf*
02. *Oceanic pendant in basalt gray*
 von Davey Lighting
03. *Garteninspiration von House Doctor*
04. *Glasvasen von House Doctor*
05. *Striped Linen Beach Towel von TOAST*

05

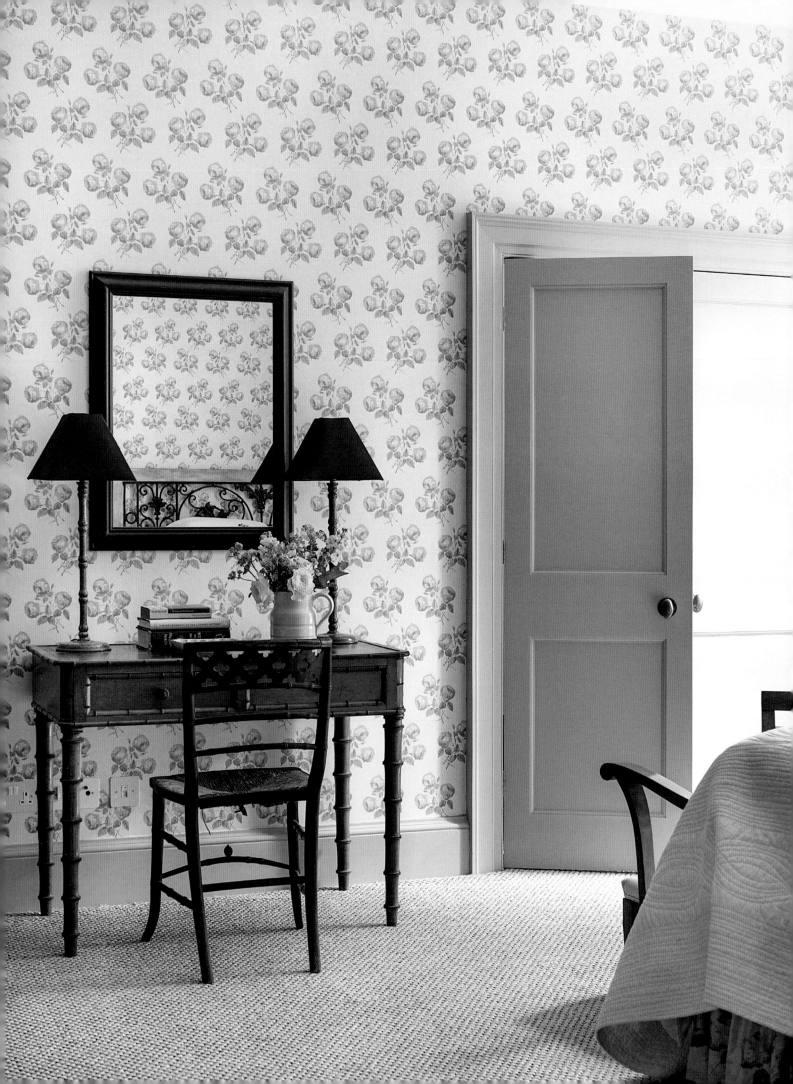

05

THE COZY COTTAGE

It's time to dust off your finest vintage and dress up your windows with lace. Like a large-scale doll house, this get-away-from-it-all bolt-hole serves up nostalgia by the heap. The mood is pretty, folksy, and heirloom—and the perfect antidote to today's design-savvy ways. Will you play tweedy woolen textures against glossy glazed earthenware or take coordination to the next level with matchy-matchy wallpaper and upholstered chairs? Whichever direction, this perky, petite interior is one-of-a-kind.

The key to this unique and unpretentious look is the use of authentic materials. Rustic wood, flaking paint, antique linen sacks, and old tin trays give a depth of character, casting off its fusty reputation. Traditional crafts such as embroidery or crochet are combined with worn items. Basically, anything with a palpable sense of the past is a shortcut to this New Country look.

The rooms are weeny, but lovely to live in. You're allowed a few chic knickknacks, too; this home knows all about the allure of a keepsake. Go for objects that make you feel happy and use it as an opportunity to create little vignettes, pockets of wonder that distract the eye from anything in need of repair. In short, this home has a textured, happy style that positively hums with life. Respect for faded damasks and shag pile rag rugs! It is beautiful here.

DAS GEMÜTLICHE COTTAGE

Stauben Sie Ihre besten Vintage-Objekte ab und holen Sie die Spitzengardinen raus! Dieses Refugium für jene, die gerne die Seele baumeln lassen, wirkt wie ein überdimensionales Puppenhaus und hat ein Herz für Nostalgie. Hübsche, folkloristische, Erbstücke dürfen hier ihren Charme entfalten – der totale Gegenpol zum zeitgenössischen Designwahn. Wie wäre es mit einer Kombination aus Tweedwolle und glasierter Töpferware? Oder Sie stimmen – Gipfel der Koordinationskunst! – Tapeten und Stuhlpolsterung aufeinander ab. Wofür Sie sich auch entscheiden: Dieses muntere, zierliche Cottage-Interieur ist originell und einmalig.

Der Schlüssel zu einem solch einzigartigen und unprätentiösen Look ist die Verwendung authentischer Materialien. Rustikales Holz, abblätternde Farbe, alte Leinensäcke und antike Blechtabletts verleihen dem Interieur charakterliche Tiefe, so streift es sein muffiges Image ab. Traditionelles Handwerk wie Stick- oder Häkelarbeiten wird mit abgetragenen Teilen kombiniert. Kurz gesagt: Diese Variante des Country-Looks liebt alles, was einen Hauch von Vergänglichkeit verströmt.

Die Zimmer sind winzig, aber entzückend. Trotz Platzmangels sind Sammelobjekte erlaubt, denn hier werden Andenken in Ehren gehalten. Auch verblichenen Damaststoffen und fadenscheinigen Teppichen wird Respekt gezollt. Wählen Sie Dinge aus, die Sie glücklich machen, und kreieren Sie damit kleine Wunderecken, die das Auge von reparaturbedürftigen Stellen ablenken. Die Grundatmosphäre dieses Stils ist fröhlich und sehr lebendig.

STYLE IN BRIEF

A mix of reclaimed furniture, vintage wallpapers, and collected kitsch create a home that's simple, quirky, and full of old-fashioned charm. With more than a large dose of nostalgia, here you can happily play with characterful antiques, color, and embroidered fabrics. The result will transport you back in time.

STIL KURZ GEFASST

Durch einen Mix aus Secondhand-Möbeln, Vintage-Tapeten und angesammeltem Kitsch entsteht ein Interieur, das einfach, lebendig und voll von alt-modischem Charme ist. Wer Nostalgie liebt, kann hier fröhlich mit ausdrucksstarken Antiquitäten, Farbe und bestickten Stoffen spielen. Das Resultat ist eine Zeitreise in die Vergangenheit.

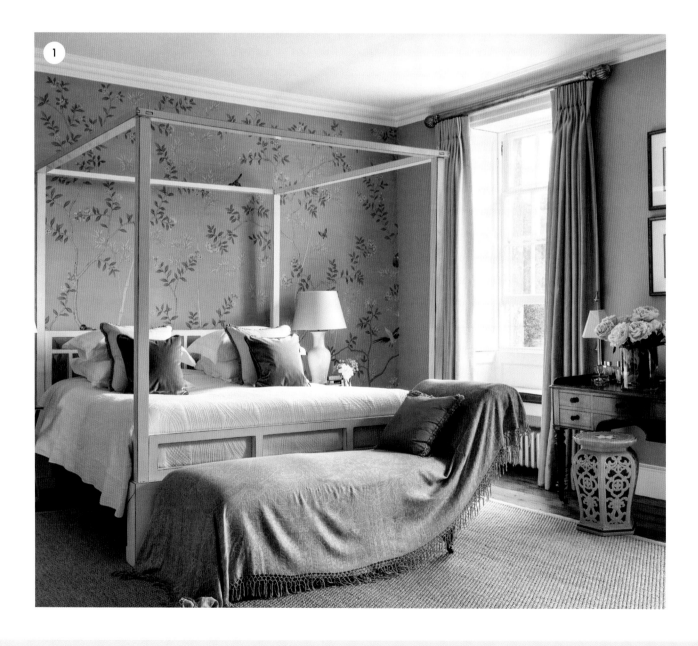

1 | *No country cottage bedroom is complete without a chaise longue.* 2 | *Rattan furniture, lace tablecloths, and antique paint-washed furniture sum up this look.* 3 | *In the hallway, the paneling is painted two-tone to add more color to the interior.*

1 | *Jedes Cottage auf dem Land braucht eine Chaiselongue.* 2 | *Korbstühle, Spitzentischdecken und weiß oder bunt gestrichene Antikmöbel prägen den Look.* 3 | *Im Eingangsbereich ist die Wandvertäfelung zweifarbig gestrichen, um das Interieur farbenfroher zu gestalten.*

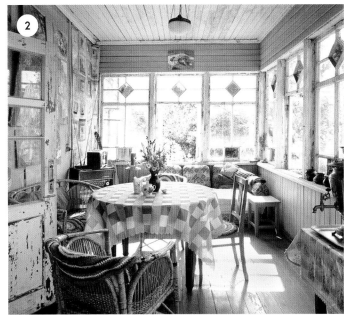

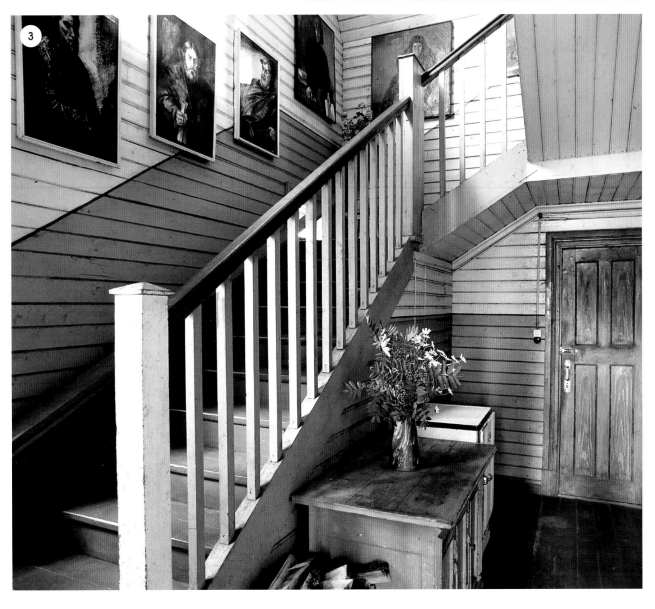

HOME INSPIRATION

HOME SWEDE HOME

Nostalgic, free and easy, this cute country cottage
fulfilled a dream for a family in southern Sweden.

———————

EINRICHTUNGSINSPIRATIONEN

VILLA KUNTERBUNT

Nostalgisch, frei und unbeschwert: Mit diesem
hübschen Cottage auf dem Lande erfüllte sich eine
Familie in Südschweden ihren Traum.

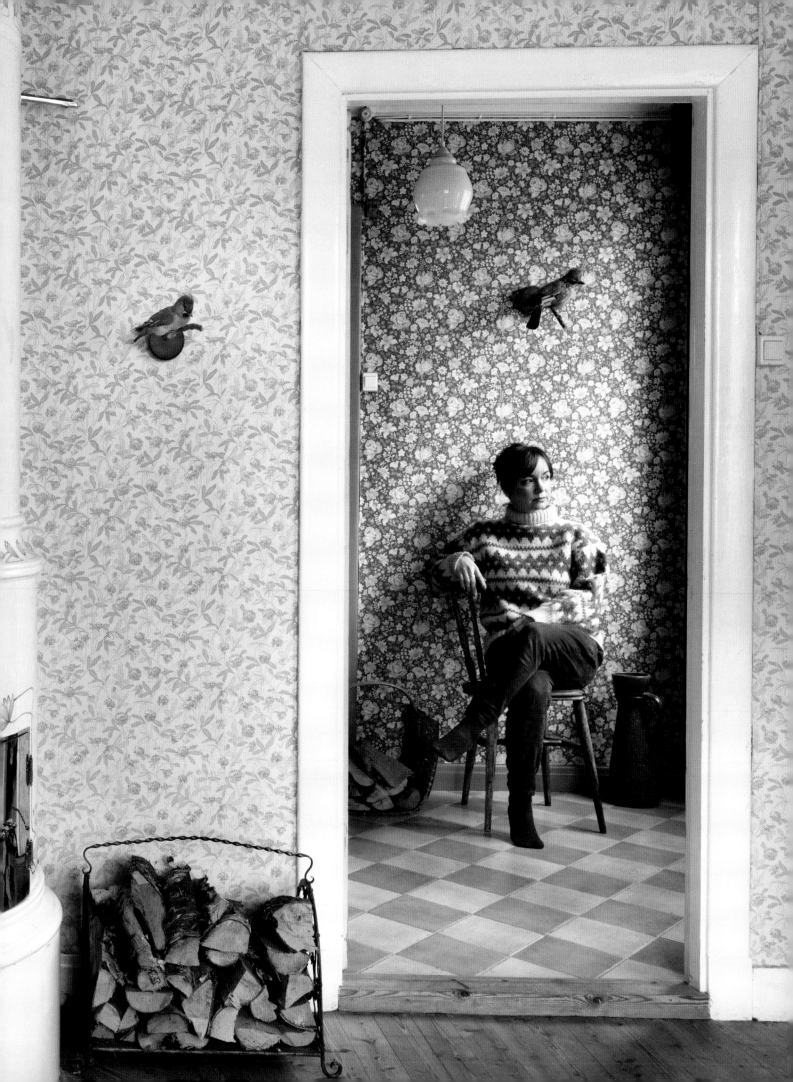

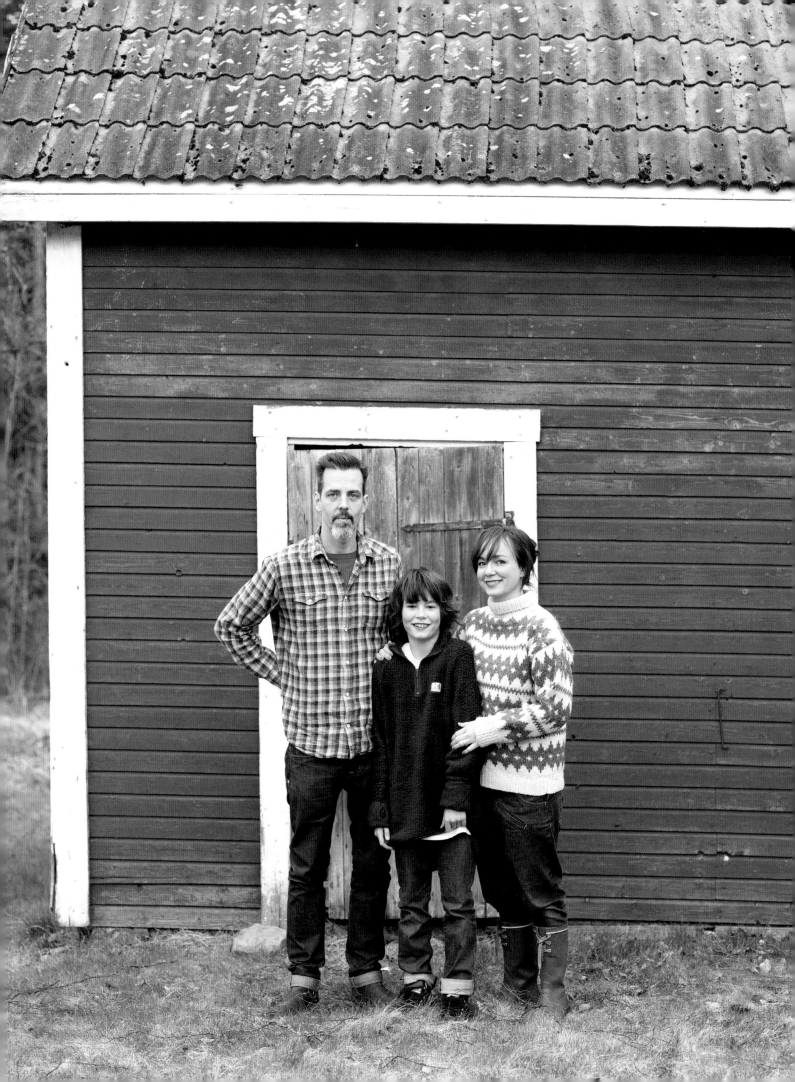

Elisabeth Dunker of design company Fine Little Day shares this 1930s wooden cottage and outbuildings in Småland, southern Sweden with her husband Dennis, their daughter Tovalisa, and son Otto. During the week the family is based in Gothenburg. This is their weekend home and summer retreat.

"I have dreamt of having a house in the country all my life," explains Elisabeth, "but we have always lived and worked in the city. It feels friendly and welcoming here, and I love the way it reminds me of the Swedish author Astrid Lindgren's Pippi Longstocking books. It is totally untouched."

"When we first viewed the house, we overheard another couple talking of their plans to strip it back and start again. So we decided we had to save it! The 1950s wallpaper was in good condition, so it didn't need to be replaced. Although the house reflects my personal style, I'm not usually into florals, nor quite as romantic. But I like things with a bit of character and places that have a sense of history. That's why I love this house. It feels like we've been here forever. We were lucky that the former owners had great style. We've just preserved what was here and then accessorized where we've needed to."

"In the summer we spend long periods at the house. During the winter we usually drive down on a Friday after work, so it's late when we arrive. We stop for a pizza takeout on the way and eat in front of the stove. Time spent here is about socializing and being relaxed—going for walks, cooking, playing board games. Yes, the barn does need painting and work needs to be done on the roof, but on the whole, we're here to have fun and basically not do a lot."

Elisabeth Dunker von der Designfirma Fine Little Day bewohnt das im südschwedischen Småland gelegene Holzhaus samt Nebengebäuden aus den 1930er-Jahren mit ihrem Mann Dennis und den gemeinsamen Kindern Tovalisa und Otto. In der Woche lebt die Familie in Göteborg. Dieses kleine Anwesen ist ihr Rückzugsort für Wochenenden und Ferientage.

„Ich träume schon mein ganzes Leben davon, ein Haus auf dem Land zu besitzen", erzählt Elisabeth, „aber wir haben immer in der Stadt gewohnt und gearbeitet. Der Ort hier fühlt sich freundlich und einladend an und erinnert mich an die Pippi-Langstrumpf-Bücher von Astrid Lindgren. Er ist völlig unberührt."

„Als wir das Haus zum ersten Mal besichtigten, mussten wir mitanhören, wie ein anderes Paar davon sprach, es bis auf die Grundmauern umzubauen. Also beschlossen wir, es zu retten! Die Tapeten aus den 1950ern waren noch in einem guten Zustand und mussten nicht ersetzt werden. Obwohl ich normalerweise nicht so auf Blümchenmuster und Romantik stehe, entspricht das Haus doch ganz meinem Geschmack. Denn ich mag Dinge mit Charakter und Orte, die von Geschichte umweht sind. Deswegen liebe ich dieses Haus. Es fühlt sich an, als würden wir hier schon ewig leben. Zum Glück hatten die Vorbesitzer einen guten Geschmack. Wir haben also nur erhalten, was schon da war, und dann hier und da die Einrichtung ergänzt."

„Im Sommer verbringen wir viel Zeit hier. Im Winter fahren wir meist freitags nach der Arbeit runter, kommen also erst spät an. Wir holen uns unterwegs Pizza zum Mitnehmen und essen sie vor dem Herd. Es geht darum, zu entspannen und Zeit miteinander zu verbringen – spazieren gehen, kochen, Brettspiele spielen. Ja, die Scheune müsste mal gestrichen und das Dach repariert werden, aber hauptsächlich sind wir hier, um Spaß zu haben, und nicht, um viel zu arbeiten."

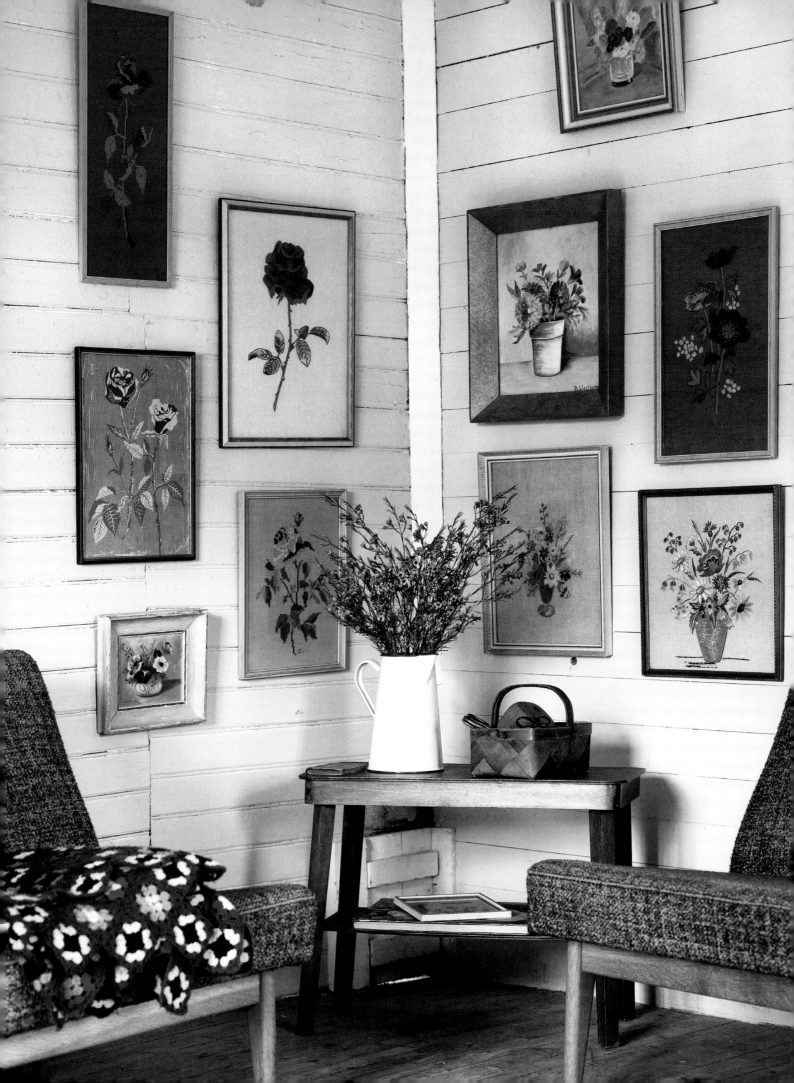

THE COLORS

There's no need to stray far from nature for the palette here. Taking its cue from meadow flowers, pink, and green is the main color combo. Just add some tan-stained wood and frame the rooms in white. Painted in a creamy sage green, the main building is set over two floors with four rooms and a kitchen. The red-painted timber cabin, originally a hen house, was converted into a guest bedroom with a lounge.

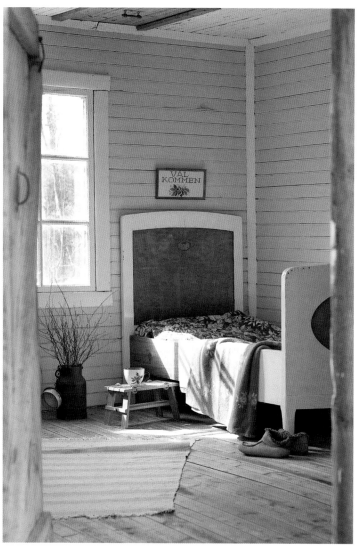

DIE FARBEN

Hier gibt es keinen Grund, von der Farbpalette abzuweichen, die die Natur vorgibt. Von einer Blumenwiese inspiriert, ist Grün mit Rosa hier die vorherrschende Kombination. Dazu passen hell gebeiztes Holz und weiß eingefasste Wände. Das in einem cremigen Salbeigrün gehaltene Hauptgebäude birgt auf zwei Etagen vier Zimmer und eine Küche. Der rot gestrichene ehemalige Hühnerstall wurde in ein Gästezimmer mit Lounge umgewandelt.

THE MATERIALS

Rustic is the look. Tongue-and-groove timber walls are painted in soft shades of green—this is the décor basic—however, in the living room, the homeowner added character with pattern, and lots of it. Elisabeth inherited the patterned 1950s wallpapers from the previous owners, and the gnarled floorboards, much of it salvage, is left untreated and bare. There's character in the wear and tear. Elisabeth made the lace curtains from old tablecloths, which look lovely when the light shines through.

DIE MATERIALIEN

Die Ausrichtung ist rustikal. Wandpaneele mit Nut-Feder-Verbindung wurden in sanften Grüntönen gestrichen und bilden die Basis des Dekors. Das Wohnzimmer bekommt mit Mustern Persönlichkeit – und zwar nicht zu knapp: Elisabeth übernahm die Tapeten aus den 1950er-Jahren von den vorherigen Besitzern. Die knorrigen Holzdielen, viele davon recycelt, wurden unbehandelt belassen. Der Zahn der Zeit verleiht Charakter. Die Spitzengardinen, durch die das Sonnenlicht so schön schimmert, hat Elisabeth aus alten Tischdecken genäht.

LEFT *A striped cotton dhurrie and vintage wallpaper have been paired with a contemporary bed linen by Fine Little Day.* **ABOVE** *With an eye for detail, grandma-inspired crochet doilies and pincushion suit the character of this home.* **RIGHT** *Homemade hobby horses.*

LINKS *Ein gestreifter Dhurrie-Teppich und eine Vintage-Tapete wurden hier mit moderner Designer-Bettwäsche von Fine Little Day kombiniert.* **OBEN** *Von Oma inspirierte Spitzendeckchen und ein Stecknadelkissen zeugen von der Liebe zum Detail und passen zur Atmosphäre des Interieurs.* **RECHTS** *Selbstgemachte Steckenpferdchen.*

THE FURNITURE

One of the main features of the cottage is the tiled ceramic wood burner. The midcentury furniture in the living room is retro and kitsch, and the pine bed frames were sourced at antique shops. Whimsical watercolors are dotted throughout. Simply decorated with a string of bulbs, farmhouse table, and bistro folding chairs, the attic in the rafters of Elisabeth's combined barn, garage, and wood store is used for parties.

DIE MÖBEL

Als Blickfang im Haus dient der alte Kachelofen. Die Möbel im Wohnzimmer aus der Mitte des 20. Jahrhunderts sind retro und kitschig. Die Bettgestelle aus Pinienholz stammen aus Antiquitätenläden. Überall hängen charmante Blumenaquarelle. Der Dachboden von Elisabeths Scheune/Garage/Holzlager ist passend zu den freiliegenden Sparren mit einer Glühbirnenkette, einem Küchentisch und Klappstühlen einfach ausgestattet und wird für Partys benutzt.

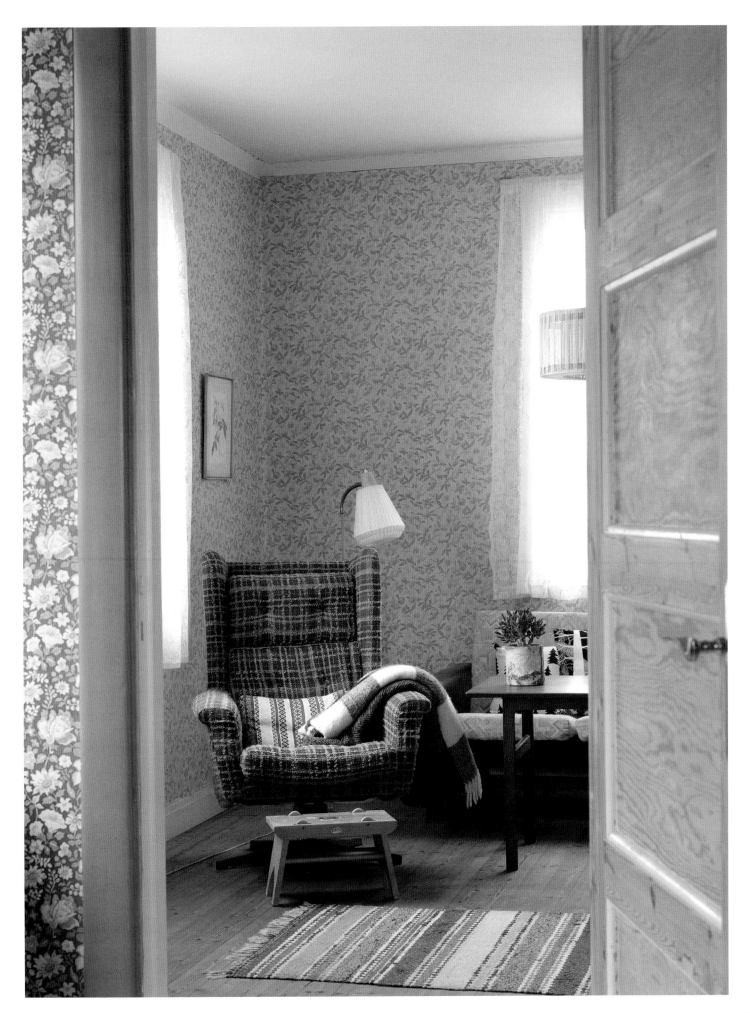

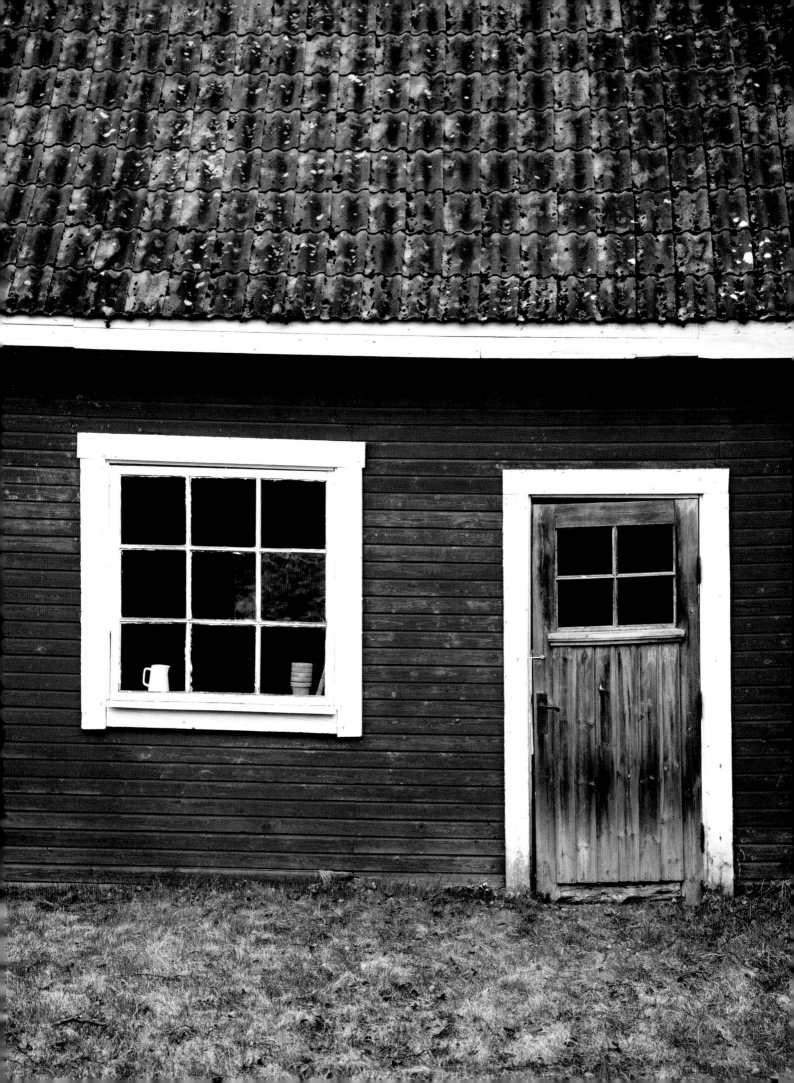

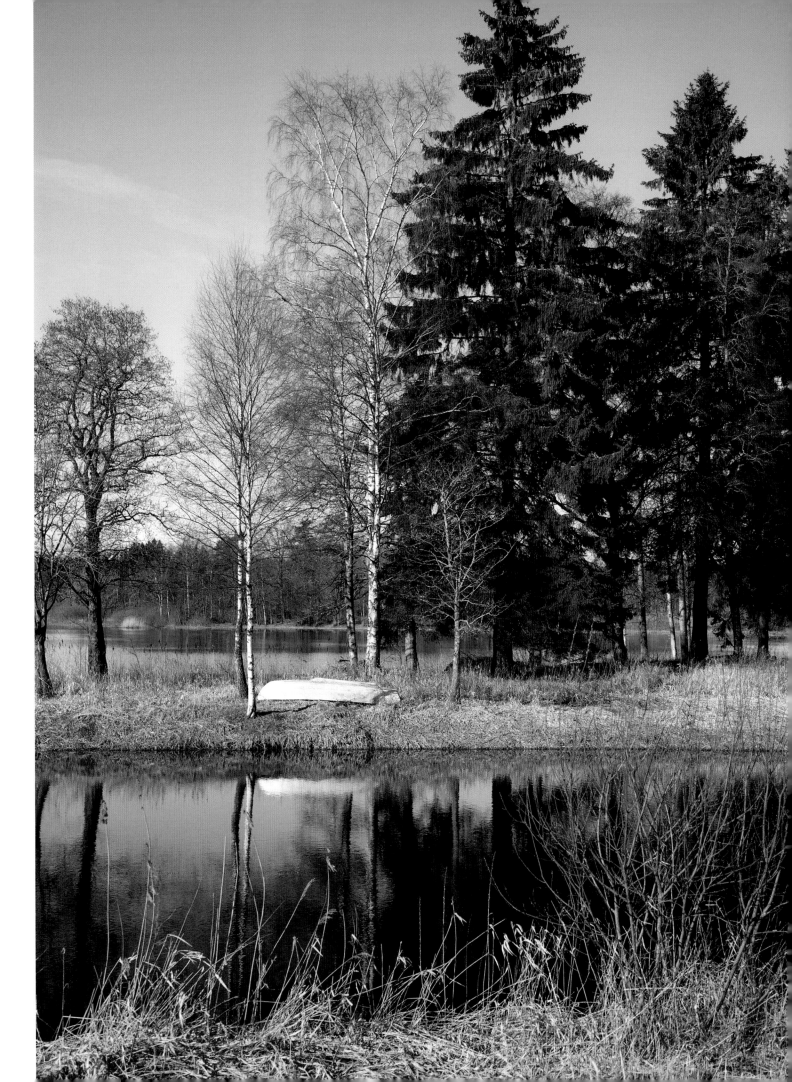

WAYS TO STYLE FLORALS

FLORALE MUSTER EINSETZEN

Choose a pale background to neutralize floor-to-ceiling floral. Balance large blousy prints with neat leaf silhouettes.

 Neutralisieren Sie deckenhohe Floraldesigns durch einen blassfarbigen Hintergrund und balancieren Sie Großgemustertes mit zierlichen Blattsilhouetten aus.

Future-proof your botanical obsession by picking blossom patterns in your favorite shades.

 Wählen Sie Blumenmuster in Ihren Lieblingsfarben, damit Ihre botanische Obsession längerfristig Bestand hat.

Add some attitude to a pretty vintage print with some gutsier pieces of furniture such as a rustic wood coffee table or industrial lamps.

 Ein hübsches Vintage-Muster bekommt etwas mehr Attitüde durch markige Möbelstücken wie einen rustikalen Couchtisch oder Lampen im Industrial Style.

For a multi-sensory floral experience, go for a plethora of print in a rainbow of colors. The main approach is a good sense of fun.

 Wenn schon, denn schon: Dekorieren Sie sich mit multiplen Mustern in allen Farben des Regenbogens in einen wahren Blumenrausch. Der Spaßfaktor zählt.

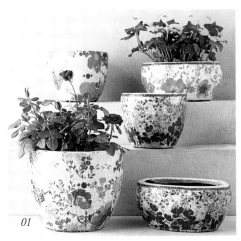

01

02

03

04

05

06

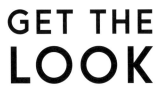

GET THE
LOOK

01. Aveyron Pot
02. Magnolia Shower Curtain
03. Tufted & Textured Apron
04. Petalpress Tea Towel Set
05. Mirana Bedding
06. Temera Dinnerware
all products by Anthropologie

01. Aveyron Pot
02. Magnolia Shower Curtain
03. Tufted & Textured Apron
04. Petalpress Tea Towel Set
05. Mirana Bedding
06. Temera Dinnerware
alle Produkte von Anthropologie

06

A RUSTIC FARMHOUSE

Sometimes, it's not the glamour and glitz, but the simple things in life that are most attractive. Imagine a stripped-down space where pale shades and bleached linens offset spectacular vintage designs. It is a casual glamour, all crystal chandeliers and pared-down plastered walls. With modernity pulling the look one direction and nostalgia in another, this is an interior that follows its own path. Here, less definitely means more.

In the building, there is an appreciation for traditional skills. Woodwork has gorgeous dovetail detailing, and stone worktops appear to be hewn from the earth. The ideal is to avoid anything mass-produced. It's a handmolded, beeswax-candle, shutters-on-the-window, fresh-air lifestyle that you're buying into as much as a decoration style. Furniture and fittings are kept to the bare minimum, focusing on the use of natural materials instead. Stone, clay, or wood, it is the contemporary, irregular shape of the housewares that dust off their granny shrouds.

Despite the simplistic looks, there's no compromise on comfort. To counter the stark emptiness of the interior, bring in the shaggiest, toe-sinking rugs you can find. Build in custom-made bookshelves to make the most of any irregular shaped walls. Painted the same color, they all blend into the simple surrounds. Similarly, in the kitchen, cabinets are handmade to maximize storage but also to emphasize any of the building's characterful curves. Don't forget a cheery wood-burning stove in the living room, and casually prop a massive ornate mirror on the floor to bounce all that beautiful, natural light around.

EIN RUSTIKALES BAUERNHAUS

Manchmal sind die einfachsten Dinge des Lebens attraktiver als Glitzer und Glamour. Stellen Sie sich schlicht gehaltene Räumlichkeiten vor, in denen blasse Farben und gebleichte Leinenstoffe den Hintergrund für spektakuläre Vintage-Teile bilden. Es ist ein legerer Glamour, geprägt von Kristalllüstern und weiß verputzten Wänden. Modernes Design zieht den Look in eine Richtung, Nostalgie in eine andere. Doch eins steht fest: In diesem Interieur ist weniger mehr.

Bei der Innenausstattung wird viel Wert auf traditionelle Handwerkskunst gelegt. Die ländlichen Holzmöbel haben Schwalbenschwanzverbindungen und die Arbeitsflächen aus Stein wirken wie direkt aus dem Felsboden gehauen. Idealerweise sollte auf Massenware verzichtet werden. Mehr noch als um eine Dekorationsrichtung geht es hier um einen Lebensstil, für den exemplarisch handgezogene Bienenwachskerzen, Fensterläden und viel frische Luft stehen. Möbel und Armaturen sind extrem reduziert und lenken den Blick auf die verwendeten Naturmaterialien. Dank ihrer ausgefallen-modernen Formen wirken die Haushaltswaren aus Stein, Ton oder Holz nicht altbacken.

Trotz der generellen Schlichtheit kommt der Komfort nicht zu kurz. Legen Sie die dicksten, flauschigsten Teppiche aus, die Sie finden können, um der Kargheit Paroli zu bieten. Maßgezimmerte Bücherregale nutzen unregelmäßige Wände optimal aus und verschmelzen mit diesen, wenn sie ebenfalls weiß gestrichen werden. In der Küche sind die Schränke extra angefertigt, um den Stauraum zu maximieren, aber auch um die charaktervollen Kurven des Gebäudes zu betonen. Installieren Sie im Wohnzimmer einen wohlige Wärme verbreitenden Holzofen und lehnen Sie einen massiven Spiegel mit Zierrahmen leger an die Wand, um das natürliche Licht zu reflektieren.

STYLE IN BRIEF

Simple yet stylish, the farmhouse interior shows that sometimes less really is more. In a nod to traditional French farmhouse style, period features such as a roll-top bath mingle with bleached linen towels and monogrammed bed sheets. Salvaged terracotta tiles coordinate with the earthy colors, and the wooden beams of the ceiling are left exposed.

STIL KURZ GEFASST

Schlicht und doch stylish: Das Interieur des Bauernhauses beweist, dass weniger manchmal wirklich mehr ist. Als Verbeugung vor dem traditionellen französischen Landhausstil werden hier stilechte Stücke wie eine freistehende alte Badewanne mit gebleichten Leinenhandtüchern und Bettwäsche mit Monogramm kombiniert. Alte Terrakotta-Fliesen harmonieren mit den vorherrschenden Erdtönen und die Dachbalken aus Holz bleiben frei sichtbar.

1

1 | *Traditional Windsor chairs suit the simple style.* 2 | *Part of the farmhouse experience: a rustic stone wall.* 3 | *A chandelier adds opulence to the raw beauty of this stone-clad room.*

1 | *Traditionelle Windsor-Stühle passen zum schlichten Stil.*
2 | *Kein Bauernhaus ohne rustikale Steinmauern.*
3 | *Ein Kronleuchter verleiht der rauen Schönheit der Steinwände einen Hauch von Glamour.*

HOME INSPIRATION
PURE AND SIMPLE
Natural materials and minimalism set the tone in this Provençal farmhouse.

———

EINRICHTUNGSINSPIRATIONEN
SCHLICHT UND SCHÖN
Naturmaterialien und Minimalismus geben in diesem provençalischen Bauernhaus den Ton an.

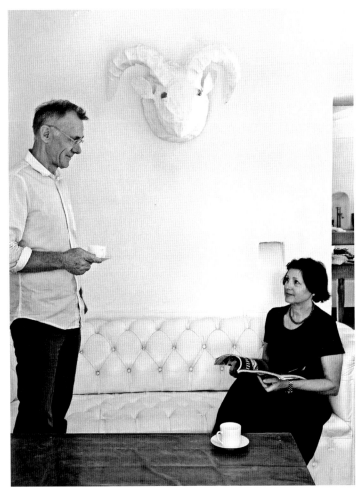
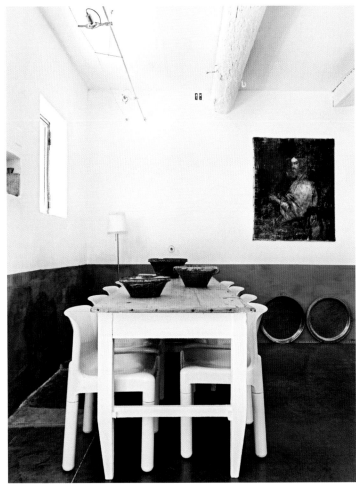

This old farmhouse personifies the spirit of a traditional Provençal country house but with a cool, contemporary twist. Owners Bruno and Michèle Viard followed a "less is more" policy in the restoration. "From the outset we wanted to create a space that had a sense of calm where people could relax and really enjoy the surroundings," explains Michèle. "We achieved this by paying special attention to the use of organic materials like stone, wood, and linen."

The interior has a pared-down, modern style with an emphasis on the building's features rather than clutter. Internal walls were opened out to expand the living space and metal-framed glass doors were used to increase the Provençal light. In harmony with the original building, it is difficult to tell what is old and what is new. "We stuck to traditional French country building methods in our approach, as well as in our choice of materials and colors," says Michèle. The wooden beams and stone were sourced from salvage yards, and the old sinks were finds at local flea markets.

Dieses alte Bauernhaus verkörpert den Geist eines traditionellen Landhauses, gibt dem Althergebrachten aber einen zeitgemäßen Dreh. Die Besitzer Bruno und Michèle Viard hielten sich bei der Renovierung an das Gebot „weniger ist mehr". „Wir wollten von Anfang an einen Ort erschaffen, der Ruhe ausstrahlt und an dem Menschen sich wirklich entspannen und die Landschaft genießen können", erklärt Michèle. „Das haben wir mit der Wahl von organischen Materialien wie Stein, Holz und Baumwolle erreicht."

Im Haus herrscht ein reduzierter, moderner Stil, der mehr Fokus auf die Struktur des Gebäudes legt als auf das Mobiliar. Zwischenwände wurden durchbrochen, um den Wohnraum zu vergrößern, und eisengerahmte Glastüren eingesetzt, um viel Licht einzulassen. Der Umbau wurde jedoch in so großem Einklang mit dem Originalbau vollzogen, dass man kaum zwischen alt und neu unterscheiden kann. „Im Hinblick auf Materialien und Farben haben wir uns an die traditionelle französische Bauweise auf dem Lande gehalten", sagt Michèle. Holzbalken und Steine kamen vom Recyclinghof, die alten Waschbecken von Flohmärkten in der Region.

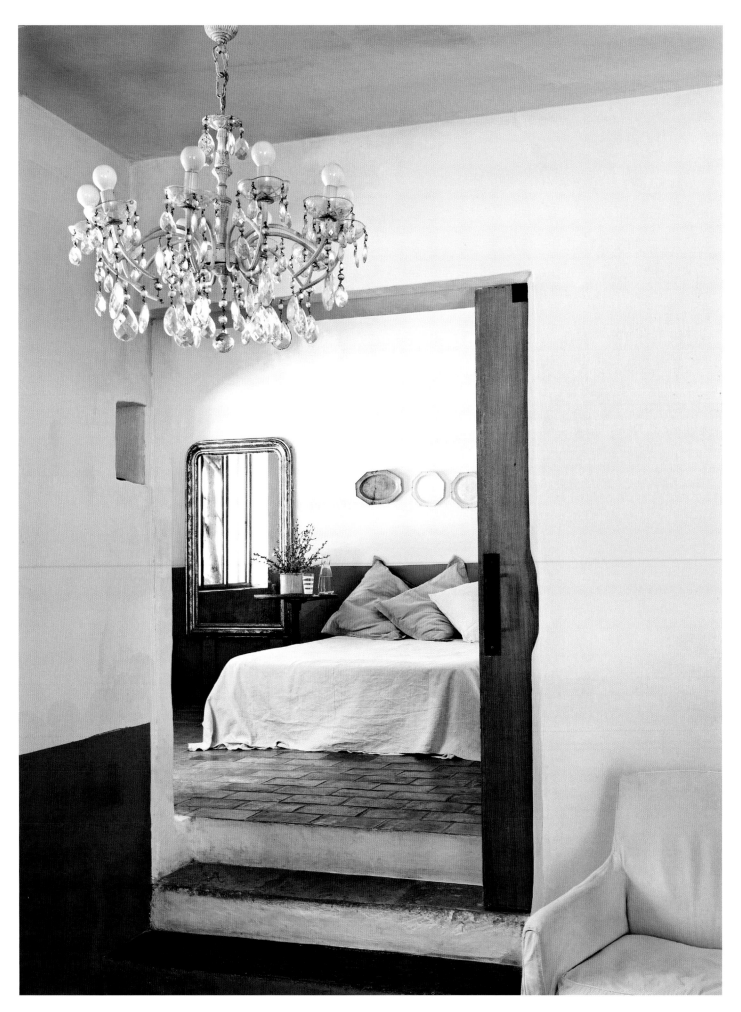

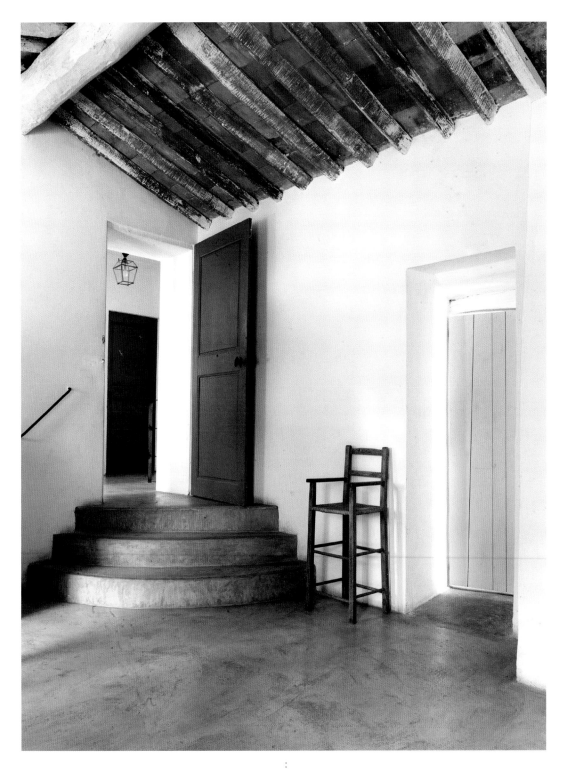

Among the mix of old and new furniture, little details catch the eye—like the base of old wine glasses set into the wall to provide coat hooks or olive branches pressed into the cement to create a natural pattern on the stairs. You can see Michèle's love of antique Provençal linen throughout. Simple ideas have maximum impact, like the clever use of an old shop roller blind used as a headboard or basic bedside lamps that just hang on their cords.

Unter dem Mix aus alten und neuen Möbeln fallen besonders kleine Details ins Auge, zum Beispiel alte Weinglasstiele, die als Kleiderhaken in die Wand eingelassen wurden, oder Olivenzweige, die in den noch feuchten Zement der Treppe eingedrückt wurden, um ein hübsches Naturmuster zu erzeugen. Überall macht sich Michèles Liebe zu antiken provençalischen Leinenstoffen bemerkbar. Einfache Ideen entfalten eine verblüffende Wirkung. So wurde ein alter Rollladen zum Kopfteil des Bettes umfunktioniert und die Nachttischlampen hängen einfach an langen, verzierten Kabeln von der Decke herunter.

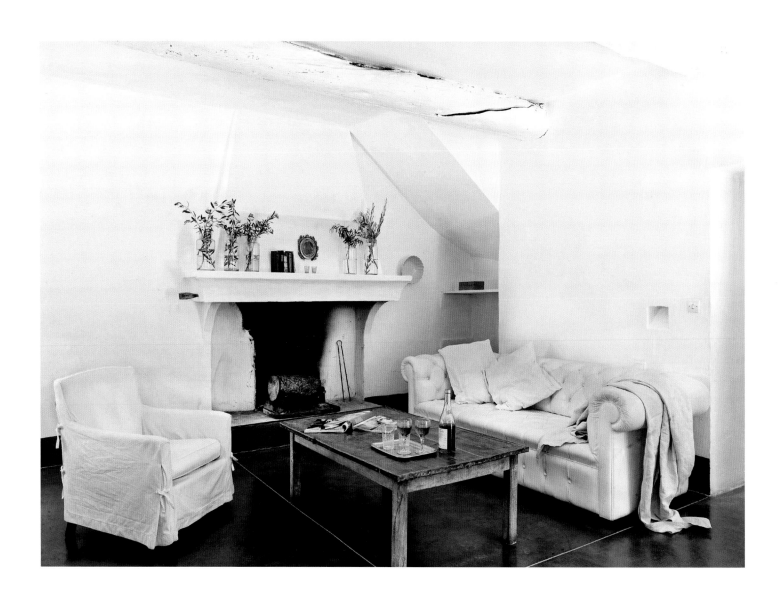

THE COLORS

A cool backdrop under the hot Provençal sun, gray and white form the basis of the palette here. Perhaps one of the most striking features is the deep blue-gray paint applied to the dado and then cleverly carried down to the cement floor of the kitchen and living room. The dramatic color scheme gives a contemporary feel that allows the rooms to flow into each other—the perfect, minimal rustic result. The original dark beams have been painted white to contrast with the dark slate floor tiles in the living room. Choose a good chalky finish to recreate this distemper effect.

DIE FARBEN

Als kühler Kontrast zur heißen Sonne Südfrankreichs besteht die Farbbasis aus Grau und Weiß. Eines der wirkungsvollsten Dekoelemente ist der dunkle, blaugraue Anstrich des unteren Wanddrittels, der sich im Betonboden von Küche und Wohnzimmer fortsetzt. Dieses clevere Farbschema lässt die Räume ineinander fließen und gibt ihnen einen modernen Touch. Ergebnis: ein minimal-rustikaler Gesamteffekt wie aus einem Guss. Die ursprünglich dunklen Holzbalken wurden weiß getüncht, um sich von den dunklen Schieferfliesen im Wohnzimmer abzuheben.

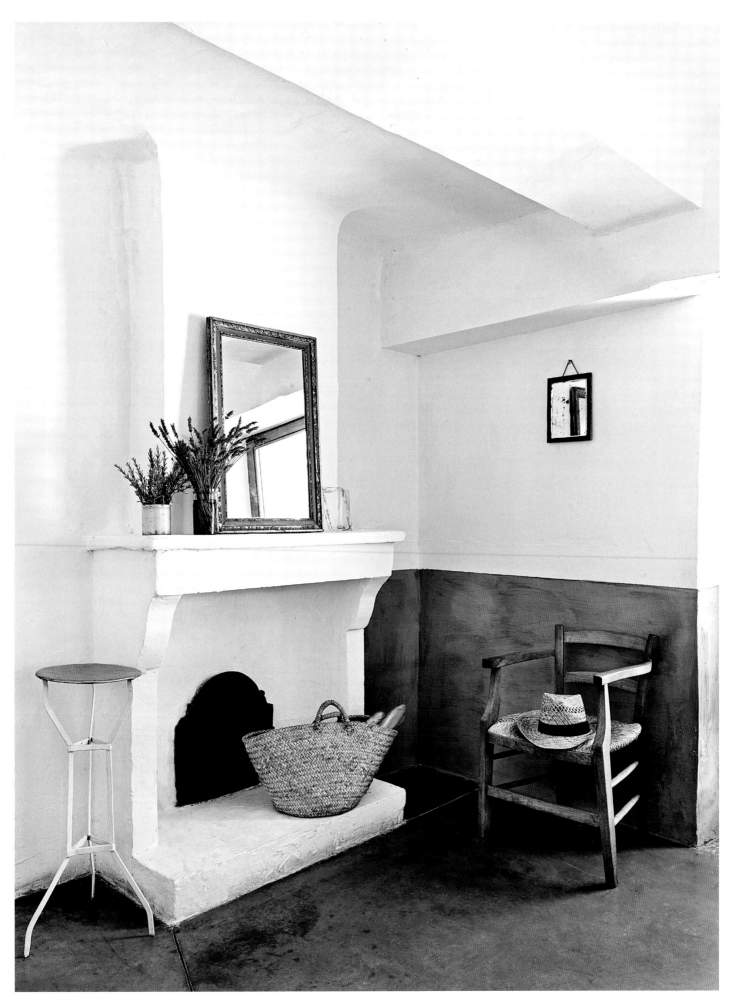

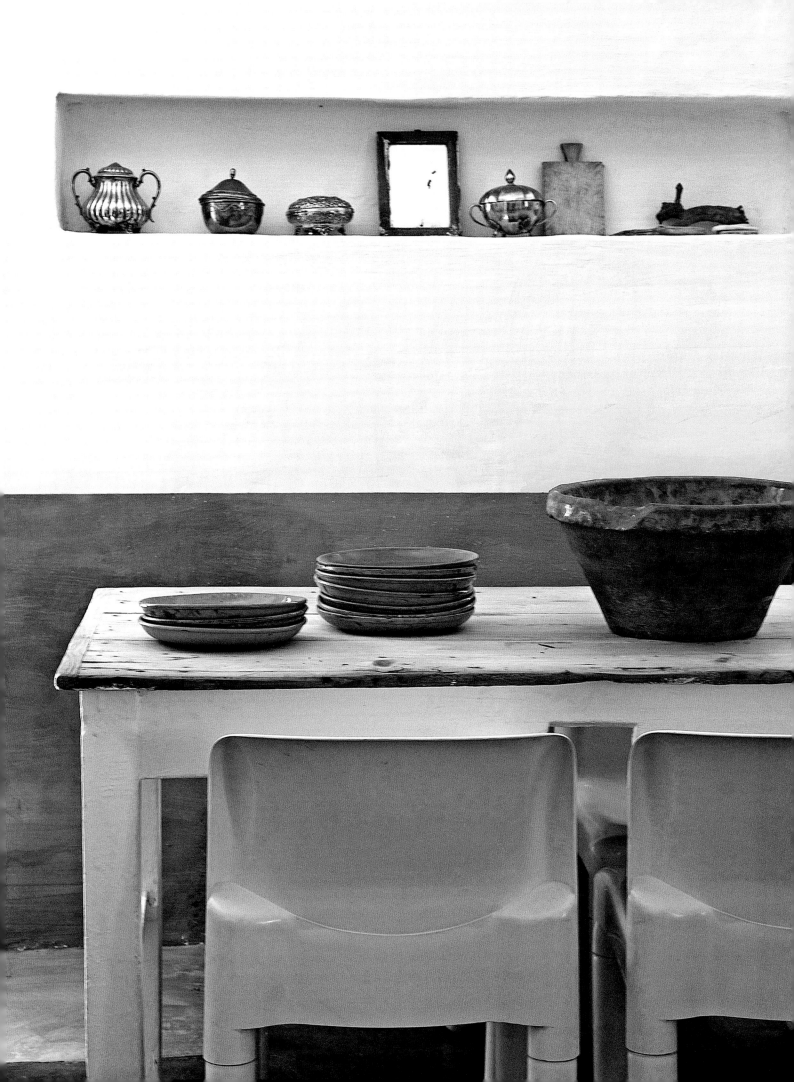

THE MATERIALS

As the scheme of this interior is so minimal, it allows the beauty of the natural materials to shine through. Limewashed wooden dressers, polished slate floors, distressed planks of wood—all of these come into sharp focus against the purity of the white-painted walls and beams. Loose linens cover the cushions and chairs in the living room and in the kitchen; it is all about stone.

DIE MATERIALIEN

Der Minimalismus des Einrichtungskonzepts bringt die Schönheit der Naturmaterialien zur Geltung. Gebleichte Kommoden, polierte Schieferböden, verwitterte Holzplatten – all diese Elemente heben sich vom Purismus der weiß gestrichenen Wände und Balken ab. Leinenbezüge bedecken Sofa und Sessel im Wohnzimmer und in der Küche dominiert Stein.

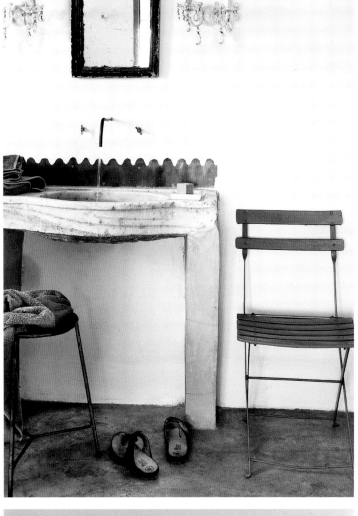

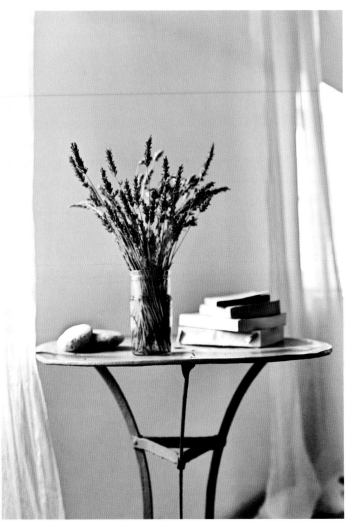

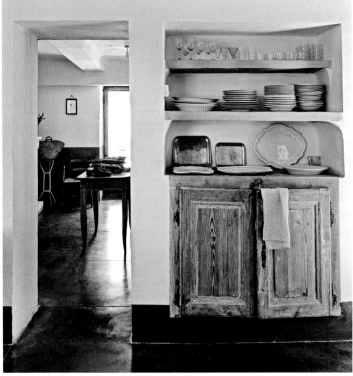

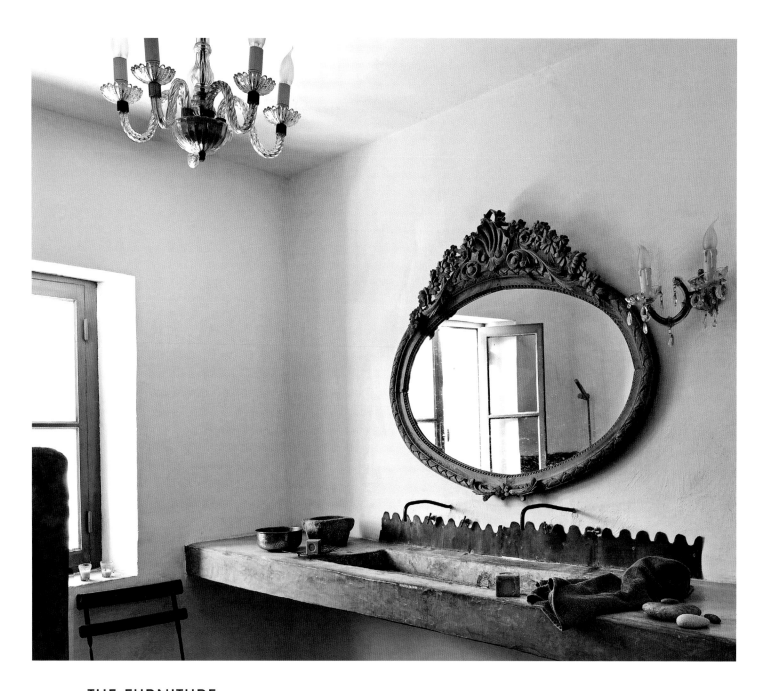

THE FURNITURE

There is a marked contrast between antique pieces and modern furniture in this farmhouse interior. Bedside lamps hang on cords from the ceiling and stand out against the carved white-painted bed. In the bathroom, a large stone sink sits alongside an ornate mirror. A chandelier adds to the charm of this minimal yet antique look. Almost monastic, the minimal dining room makes a feature of a scrubbed pine refectory table and an old painted canvas on the wall.

DIE MÖBEL

Ein kontrastreicher Mix aus antiken und modernen Stücken möbliert die Räume dieses Bauernhauses. Einfache Nachttischlampen hängen an langen Kabeln von der Decke und beleuchten das üppige Schnitzwerk am Kopfteil des weiß gestrichenen Betts. Im Bad hängt über dem Steinbecken ein Spiegel mit schön verziertem Rahmen. Ein Kristalllüster verstärkt noch den Charme dieses minimalistisch-antiken Looks. Das fast schon spartanisch ausgestattete Esszimmer stellt den großen Tisch aus Pinienholz in den Mittelpunkt. An der Wand hängt nur eine alte bemalte Leinwand.

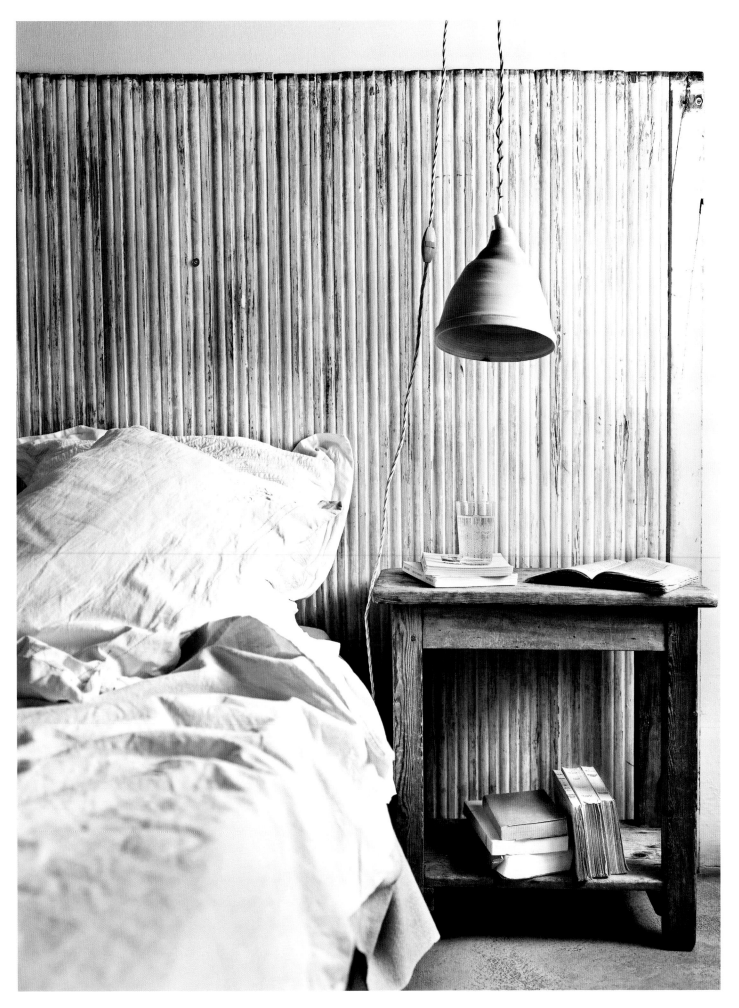

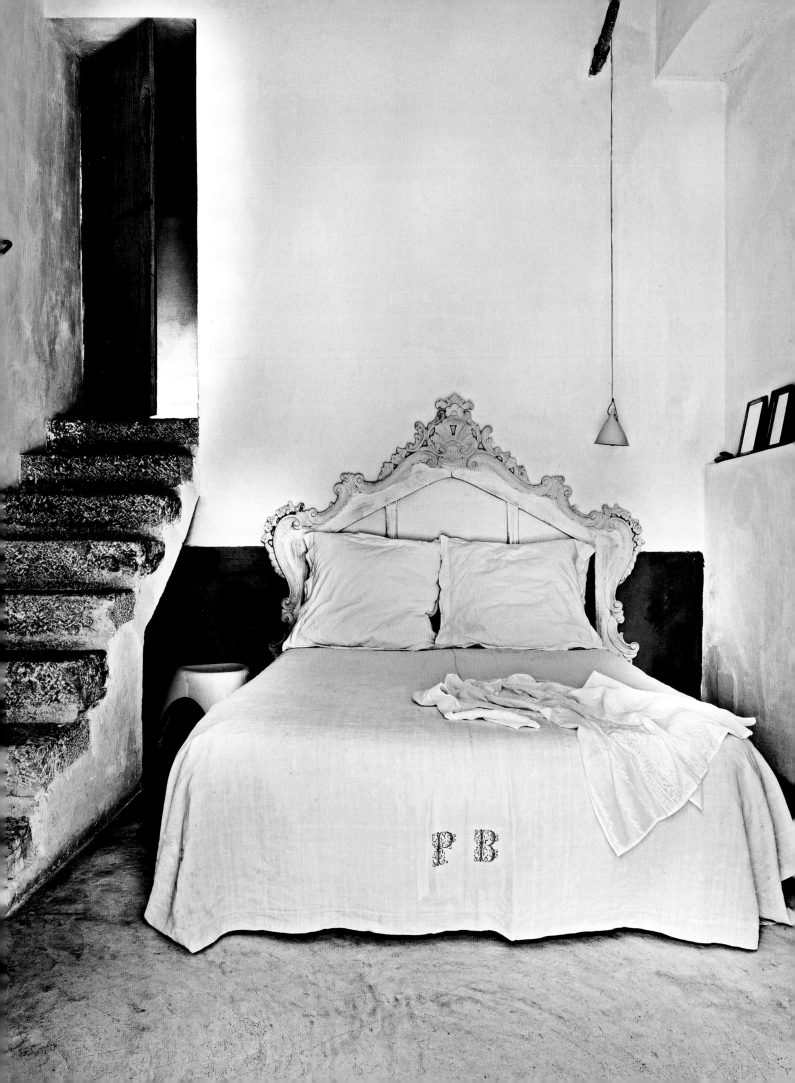

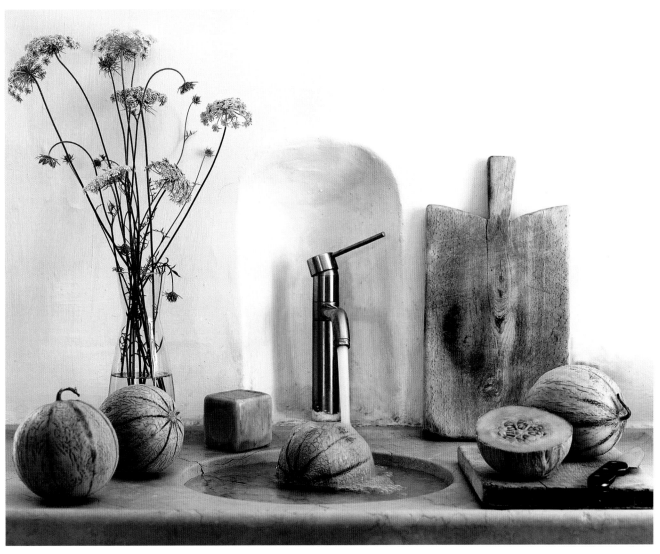

LEFT *A white-washed Baroque bed with beautiful monogrammed linen sits in contrast to the simple bedside lamp hanging on a cord.* **ABOVE** *An old chopping board and modern single-lever tap in the kitchen.* **RIGHT** *The simplicity of the farmhouse creates a relaxing atmosphere.*

LINKS *Ein weiß gestrichenes Barockbett mit wunderschön monogrammierter Leinenbettwäsche steht im Kontrast zu einer einfachen Nachttischlampe, die von der Decke baumelt.* **OBEN** *In der Küche einträchtig nebeneinander: ein altes Schneidebrett und eine moderne Mischbatterie* **RECHTS** *Die Schlichtheit des Bauernhauses verströmt eine entspannte Atmosphäre.*

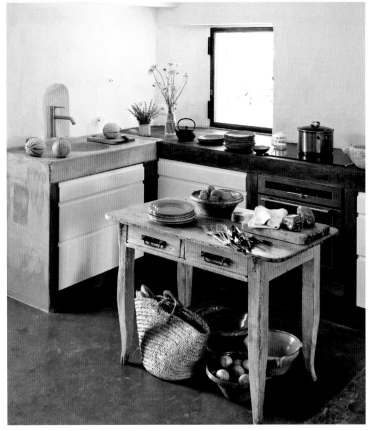

CREATING A SIGNATURE STYLE
EINEN EIGENEN STIL KREIEREN

Keep the basics simple so you can mix things up. By sticking to classic designs (neutral sofa, smart bookcase, plain kitchen), it's easy to switch between seasonal and fashion-friendly accessories.

Schlichte Basics lassen viel Freiheit zum Experimentieren. Wer bei Sofas, Bücherregalen und Küchenelementen auf klassisches Design setzt, kann Accessoires je nach Saison und Trend leicht variieren.

The fragrance you wear speaks volumes about who you are, so why not do the same for your home? Fill the air with scents—spicy or sweet—according to your mood.

Ihr Parfüm verrät viel über Ihre Persönlichkeit, warum also nicht auch dem Zuhause einen Duftstempel aufdrücken? Lassen Sie je nach Stimmung würzige oder süße Düfte durch die Räume wehen.

Monogramming makes for a timeless keepsake. There is endless scope here for kid's rooms, but grown-up linen sheets can be embroidered with initials, or personalize dinner places with the family emblem.

Monogramme schaffen ewige Andenken. Das Kinderzimmer bietet dafür endlose Optionen; Erwachsene erfreuen sich an Bettwäsche mit den eigenen Initialen oder Tischsets mit dem Familienwappen.

Tailor a chair—vintage or bought new—to suit your own taste by choosing any fabric from chenille to leather, neutral to patterned bright.

Geben Sie einem Stuhl – ob Vintage oder neu – durch die Wahl der Polsterung Ihren ganz persönlichen Touch. Von Chenille bis Leder, gedeckt bis quietschbunt ist alles erlaubt, was gefällt.

01

02

06

GET THE LOOK

01. *Celestial Pebble by OCHRE*
02. *Table Linens by Canvas Home*
03. *London Plane Platter*
 by Hampson Woods
04. *Leach Pottery Jug*
 by David Mellor Design
05. *Palladio Grey Porcelain tiles*
 by Mandarin Stone
06. *Provençal Black cutlery*
 by David Mellor Design

01. *Celestial Pebble von OCHRE*
02. *Table Linens von Canvas Home*
03. *London Plane Platter*
 von Hampson Woods
04. *Leach Pottery Jug*
 von David Mellor Design
05. *Palladio Grey Porcelain Kacheln*
 von Mandarin Stone
06. *Provençal Black Besteck*
 von David Mellor Design

03

05

04

07

THE STYLISH TOWNHOUSE

New Country style has been given a slick makeover when it comes to living in town. Everything about this look is pared down and unornamented. It has a sharper mood. From refined vintage pieces and a confident use of color, the vibe is formal but not ludicrously so. Despite the high style, it's a look that is warm and inviting.

Start with predominantly practical stuff—chairs, lighting, bed—choosing quality items that are beautifully made. Look out for furniture with sweeping, feminine shapes. Nothing says perfectly polished like an elegant sofa and midcentury design classics are right on track due to their leggy nature and simple lines. Bold colors and clean lines add a modern edge. Luxurious fabrics are also key. A room will always cut a dash with swish materials such as velvet and wool.

To keep the style country-like, the trick is to go distressed with the floor and walls. Timeworn floorboards temper the look from veering to glam—as will the addition of some lower-brow pieces of furniture. Think 1950s Formica tables in the kitchen and old metal trunks in the lounge. Mix in a few artisan details, and you're there.

A great tip for making a room seem bigger is to stick to the same palette and materials. If you view an interior as a single entity, then the end result will look smart and streamlined. So chuck out your chintz. Update your home with New Country's sophisticated end of the spectrum, showcasing simple silhouettes in smart neutral hues.

DAS STILVOLLE STADTHAUS

Im urbanen Umfeld bekommt New Country eine stylishe Rundumerneuerung. Alles an diesem Look ist reduziert und schlicht, ohne viel Chichi. Im Vergleich zu den Interieurs auf dem Lande geht es in der Stadt etwas strenger zu. Inmitten edler Vintage-Stücke und einer souveränen Farbgebung ist der Vibe formell, aber trotzdem warm und einladend.

Fangen Sie mit den praktischen Dingen an – Stühle, Beleuchtung, Betten – und entscheiden Sie sich für hochwertige, sorgfältig hergestellte Objekte. Möbelstücke mit geschwungenen, femininen Formen passen gut zu diesem Stil sowie auch elegante Sofas und Designklassiker aus der Mitte des 20. Jahrhunderts, die durch ihre schlanken Beine und Stromlinienförmigkeit bestechen. Klare Farben und Linien strahlen Modernität aus. Auch luxuriöse Stoffe stehen auf der Einkaufsliste: Edle Textilien wie Samt und Wolle werten jeden Raum auf.

Und wo bleibt bei so viel edlem Dekor der Landhauscharme? Alte Holzdielen sind hier der Clou. Deren leicht abgenutzte Aura verhindert nämlich, dass das Interieur ins Glamouröse abdriftet – genau wie ein paar eher einfachere Möbelstücke wie zum Beispiel Resopaltische aus den 1950er-Jahren in der Küche oder alte Metalltruhen im Wohnzimmer. Mischen Sie noch etwas Kunstgewerbliches dazu und voilà: New Country lebt.

Tipp: Die Räume wirken größer, wenn man sich durchgehend auf gleiche Farbtöne und Materialien beschränkt. Wenn Sie das Interieur des ganzen Hauses als Einheit betrachten, wird der Gesamteffekt fließender und wie aus einem Guss. Also raus mit den Chintz-Bezügen und rein mit dem Teil von New Country, der edle, schlichte Formen und zurückhaltende Farbtöne bevorzugt.

STYLE IN BRIEF

Classic designs, heirloom treasures, and colorful accessories bring distinctive character to a country-inspired home in the city. Simplicity is the starting point rather than overwrought and fussy. Stick to a nude color palette, selecting elegant seating—then add interesting details and eye-catching contemporary designs.

STIL KURZ GEFASST

Klassisches Design, Erbstücke und bunte Accessoires verleihen dem vom Landhausstil inspirierten Zuhause in der Stadt einen ganz eigenen Charakter. Auch hier geht es eher schlicht als überladen zu. Halten Sie sich an eine Farbpalette im Ton Nude, wählen Sie elegante Sitzelemente aus und setzen Sie dann Akzente mit interessanten Accessoires und ausgefallenen modernen Mustern.

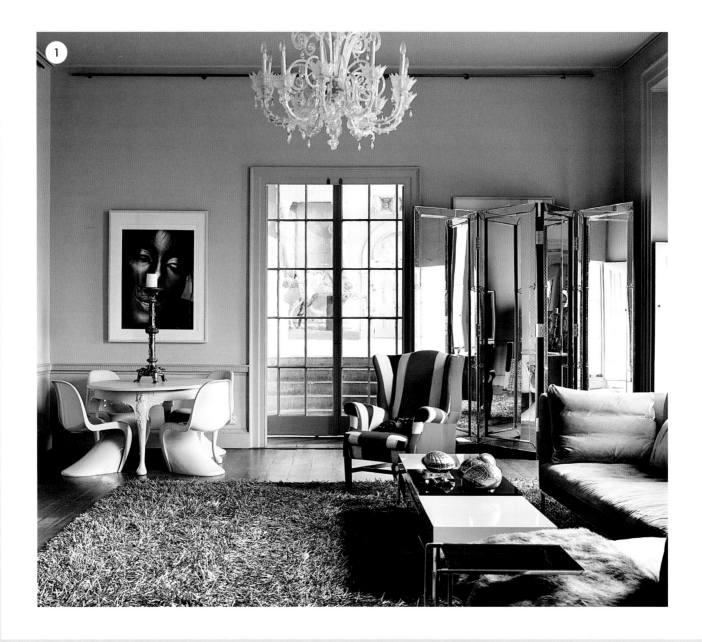

1 | *Surround yourself with sumptuous textures, classic furniture, and vintage chandeliers to make your home the perfect place to cozy up.* 2 | *Bring a rustic feel to your home with natural wood.* 3 | *A rustic countertop is in contrast to the sleek kitchen.*

1 | *Mit opulenten Stoffen, klassischen Möbeln und Vintage-Kronleuchtern wird Ihr Zuhause ein Hort eleganter Gemütlichkeit.* 2 | *Ursprüngliches Holz verleiht den Räumlichkeiten einen ländlich-schlichten Vibe.* 3 | *Die rustikale Arbeitsoberfläche setzt sich schön von der glänzenden Küchenfront ab.*

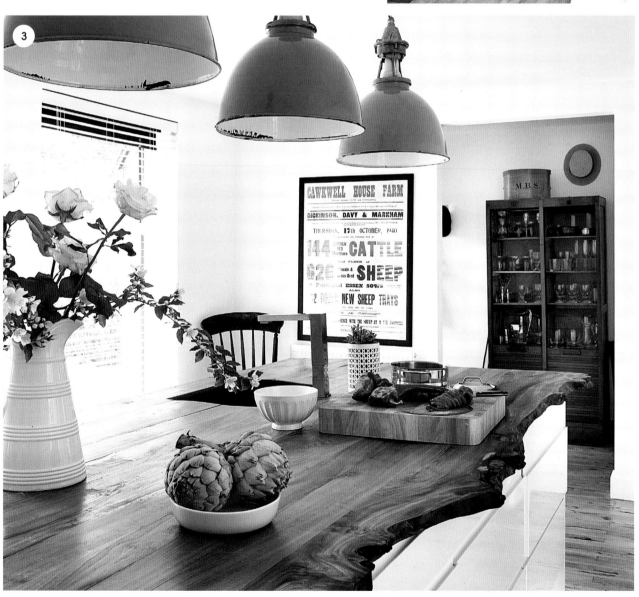

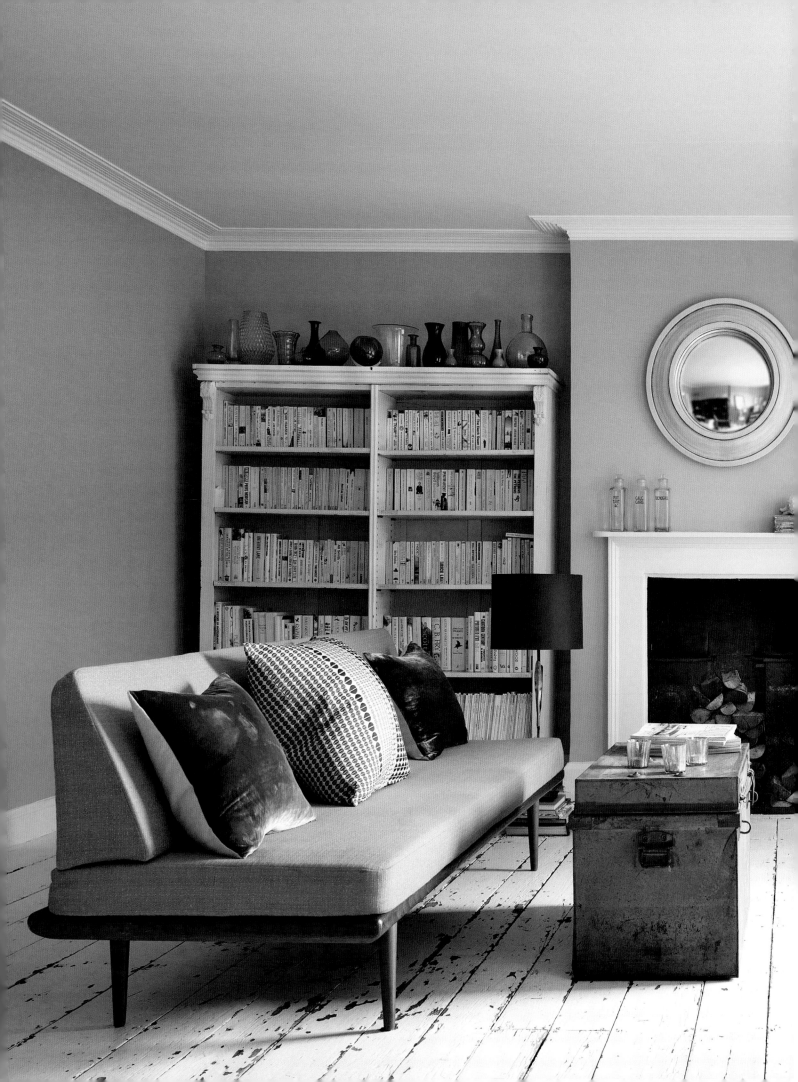

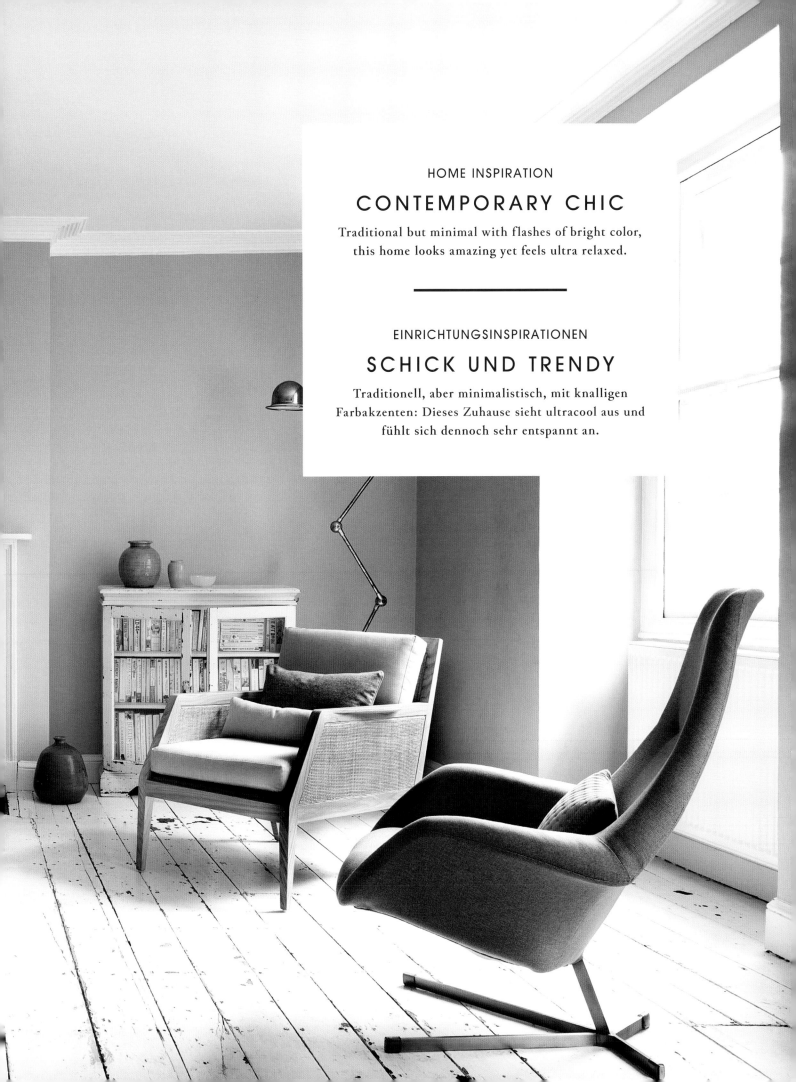

HOME INSPIRATION

CONTEMPORARY CHIC

Traditional but minimal with flashes of bright color,
this home looks amazing yet feels ultra relaxed.

———————————

EINRICHTUNGSINSPIRATIONEN

SCHICK UND TRENDY

Traditionell, aber minimalistisch, mit knalligen
Farbakzenten: Dieses Zuhause sieht ultracool aus und
fühlt sich dennoch sehr entspannt an.

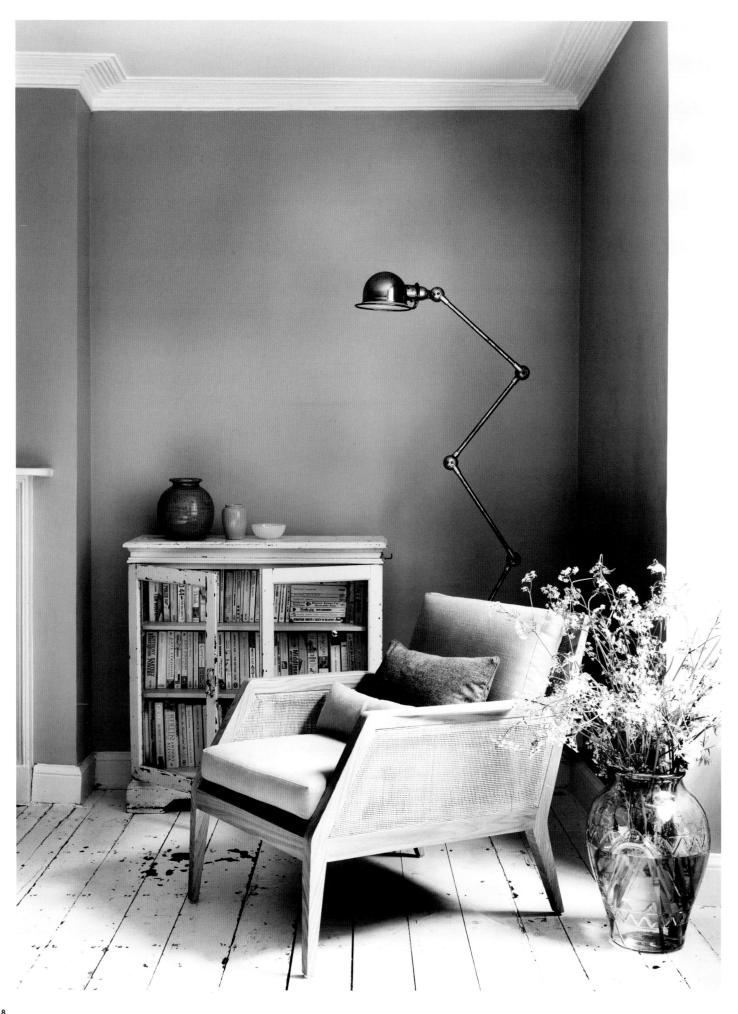

Interior designer Gabrielle Blackman's home embodies all that is simple and hip. Modern, rustic, and industrial sit alongside classic 20th-century glamour, heirlooms, and flea market finds—all mixed with some useful design ideas. "My professional life is focused on designing or fixing up other people's homes," says Gabrielle, "so my own home has to be easy to run, uncomplicated, and a welcoming place to come home to."

Practical ideas abound like the simple but functional kitchen with its space-saving granite countertops. Or there's the white-painted floor that runs throughout the home and acts like a blank canvas for the carefully chosen furnishings. As Gabrielle advises, "In a small home it is important to create an organic flow of materials and color to make the space seem bigger. For example, using different floor types can interrupt the eye and clutter the space."

When it came to decorating the walls, bright colors were avoided. Here, warm gray and white is used to create an illusion of a bigger space and a clean finish. It embraces the original architectural features and maximizes the natural light. "This type of palette suits the eclectic style of the interior and also compliments

Das Haus von Innenarchitektin Gabrielle Blackman verkörpert alles, was einfach und hip ist. Moderne, rustikale und industrielle Teile finden hier neben klassischem Glamour aus dem 20. Jahrhundert, Erbstücken und Flohmarktfunden ihren Platz. Zusammengehalten wird der bunte Mix von Gabrielles Designideen. „Mein Beruf besteht darin, die Häuser anderer Menschen zu renovieren und einzurichten", sagt Gabrielle. „Deshalb muss mein eigenes Zuhause praktisch, und unkompliziert sein und ein Ort, an dem ich ausspannen kann."

Praktische Ideen findet man überall, zum Beispiel in der funktionalen Küche mit ihren platzsparenden Arbeitsflächen aus Granit. Die weiß gestrichenen Holzdielen ziehen sich durchs ganze Haus und dienen als leere Leinwand für die sorgfältig ausgewählte Möblierung. Gabrielles Rat: „In kleineren Behausungen sollten Material und Farbe organisch fließen, um die Räume größer wirken zu lassen. Unterschiedliche Bodenbeläge unterbrechen den Blick und erzeugen den Eindruck von Enge."

Bei den Wänden wurden kräftige Farben vermieden. Ein warmes Grau und Weiß vermitteln Weite und Ordnung. Sie stellen sich ganz in den Dienst der architektonischen Originaldetails und

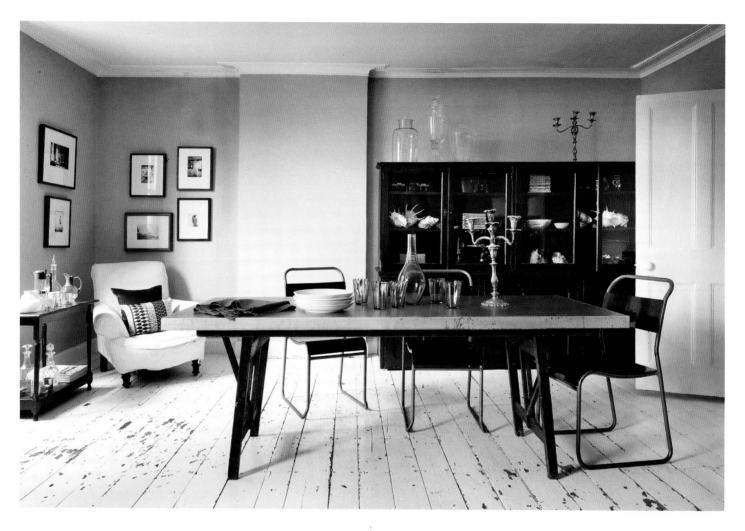

the paired down feel of the space," says Gabrielle, "but I do suggest the odd dark color to create contrast." A good example is the dark blue-gray cabinets in the dining area, which house a myriad of curios collected during her family's travels around the globe.

To prevent the white spaces feeling cold and unfriendly, Gabrielle selected textured, organic fabrics with character, like the indigo and gray natural linens on the bed. There is even the occasional piece of furniture she has designed herself such as the dining room table made from a zinc top attached to a set of folding legs found in a local junk shop. "It's a very practical solution when we need to be able to fold it away when we have parties," she explains.

Another functional idea is the use of salvaged vintage lockers on the landing that came from a local police station. Every member of the family has their own locker, so there are no untidy coat hooks crammed with a muddle of clothing. "Anything to make life easy," says Gabrielle. The result is a welcoming space that allows the eye to move freely between each room without a clash of styles.

nutzen das natürliche Licht maximal aus. „Diese Farbpalette passt zum eklektischen Einrichtungsstil und ergänzt die ruhige Atmosphäre", sagt Gabrielle „aber ich schlage vor, ab und zu als Kontrast auch eine dunkle Farbe einzusetzen." Ein gutes Beispiel dafür sind die blaugrauen Vitrinenschränke im Essbereich, in denen die umfangreiche Reiseandenkensammlung der Familie untergebracht ist.

Damit die weißen Flächen sich nicht zu kalt und unfreundlich anfühlen, hat Gabrielle organische Textilien mit Struktur und Charakter ausgewählt, für das Bett zum Beispiel indigoblaue und graue Baumwollstoffe. Einige Möbelstücke hat sie sogar selbst entworfen, darunter den Esstisch, der aus einer Zinkplatte und Klappbeinen aus dem örtlichen Trödelladen besteht. „Das ist sehr praktisch, weil wir ihn zusammenklappen können, wenn wir Partys feiern", erklärt sie.

Eine weitere funktionale Idee sind die Vintage-Spinde im Eingangsbereich, die von der örtlichen Polizeistation ausrangiert wurden. Jedes Familienmitglied hat seinen eigenen Spind, es gibt also keine mit Klamotten vollgehängte Garderobe. „Alles, was das Leben leichter macht", sagt Gabrielle. Das Ergebnis ist ein einladender Bereich, der das Auge ohne Stil-Clash frei zwischen den Räumen umherwandern lässt.

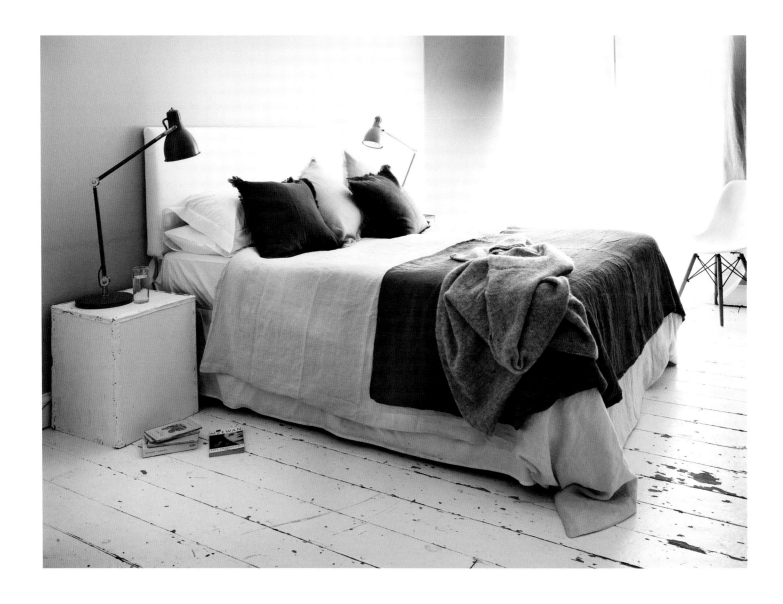

THE COLORS

Give a neutral color scheme character by adding in a bold color detail. Instead of a sandy sofa, try it in blue or yellow. If the rest of the room is simple, it will really stand out in the space. In the living room, Gabrielle has balanced her warm yellow sofa with cushions on the opposite side of the space. Likewise, the blue velvet cushions are picked up in the vintage metal trunk and glassware. The timber floor has been painted white to make the rooms feel larger and brighter.

DIE FARBEN

Details in kräftigen Farben geben einem neutralen Farbschema Charakter. Wie wär's zum Beispiel mit einer Couch in Blau oder Gelb, die in einem ansonsten schlicht gehaltenen Raum zum Blickfang wird? Gabrielle hat im Wohnzimmer ihr Sofa in einem warmen Gelbton mit gelben Kissen auf den gegenüber liegenden Sesseln ausbalanciert. Die Farbe der blauen Samtkissen wird wiederum von der Vintage-Metalltruhe und den Vasen aufgegriffen. Die Holzdielen wurden weiß gestrichen, um den Raum größer und heller erscheinen zu lassen.

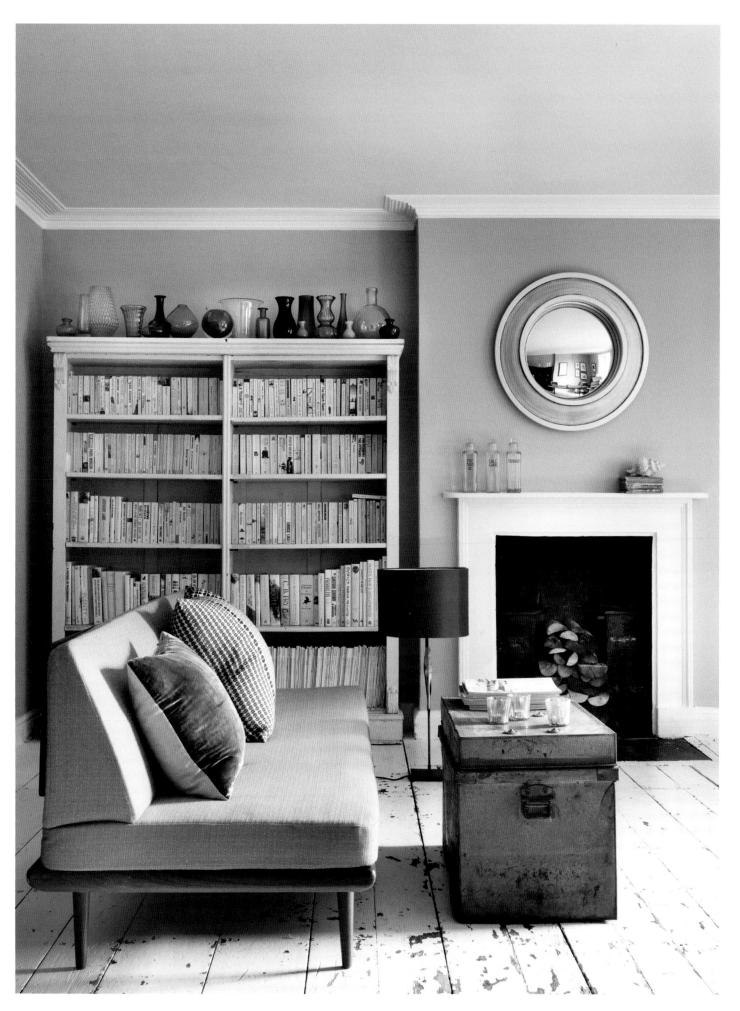

THE FURNITURE

The living room is simply decorated with a cool sofa and curvaceous armchair—these modern pieces contrast with the distressed wood surfaces and look all the more luxe when set against the industrial-looking elements such as the zinc-topped dining table and chairs. Neatly arranged, the restrained interior gives the room a chic mood, while the touchy-feely textiles soften things up.

DIE MÖBEL

Das Wohnzimmer ist mit einer coolen Couch und einem geschwungenen Sessel eher spärlich möbliert. Diese modernen Teile bilden einen Kontrast zu den leicht abgenutzten Holzoberflächen und sehen neben Industrial-Elementen wie der Esstischplatte aus Zink besonders edel aus. Das zurück-genommene und ordentlich arrangierte Interieur gibt dem Raum einen modernen Chic, während die haptischen Textilien Wärme vermitteln.

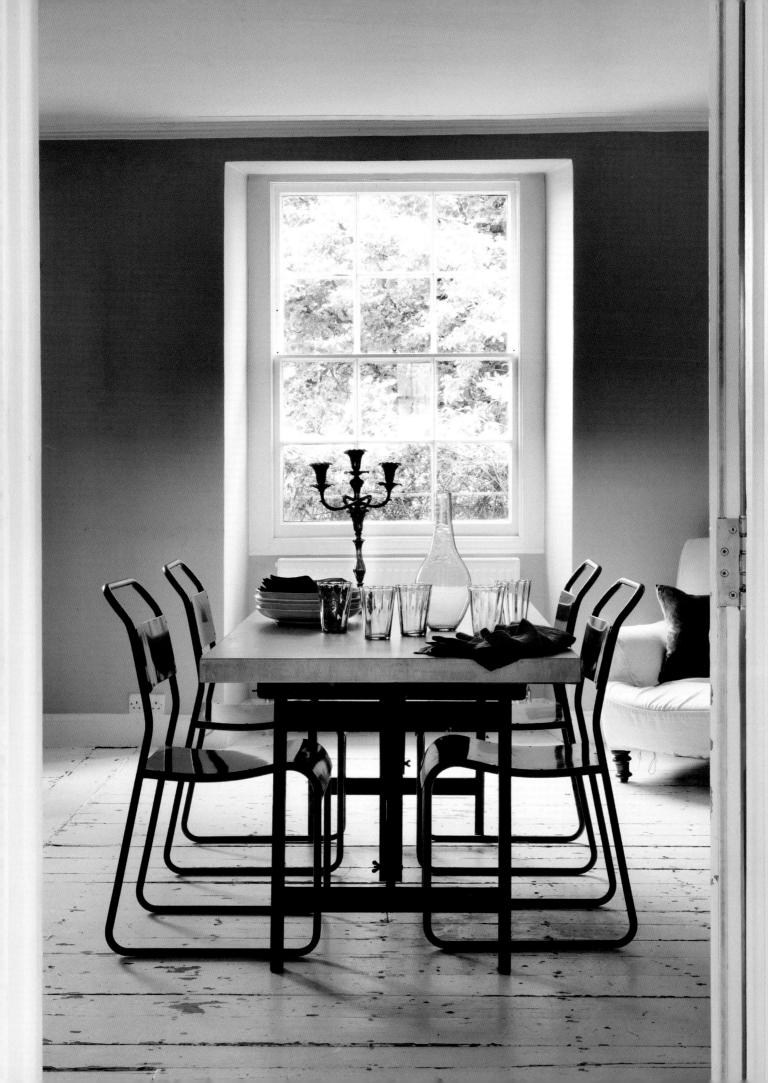

THE MATERIALS

Velvet is a big trend, and it makes for a super-luxe modern sofa. Everything about it feels luxurious and indulgent, so it suits this townhouse country spin. In the bedroom, soft linens cover the bed, whereas in the dining room, the surfaces are smooth and sleek. Think tarnished silver, handblown glass, and polished concrete. The mood is more homely in the kitchen with matte finishes and retro crockery setting the tone.

DIE MATERIALIEN

Samt liegt voll im Trend und ist der perfekte Bezug für ein modernes Superdeluxe-Sofa, dessen Glamour-Genussfaktor bestens zur Stadtvariante des Landhausstils passt. Im Schlafzimmer bedecken weiche Baumwollstoffe das Bett, im Esszimmer hingegen sind die Oberflächen glatt und glänzend. Denken Sie an patinierte Silberware, mundgeblasenes Glas und polierten Beton. In der Küche geht es gemütlicher zu: Hier geben Mattlackierungen und Retro-Geschirr den Ton an.

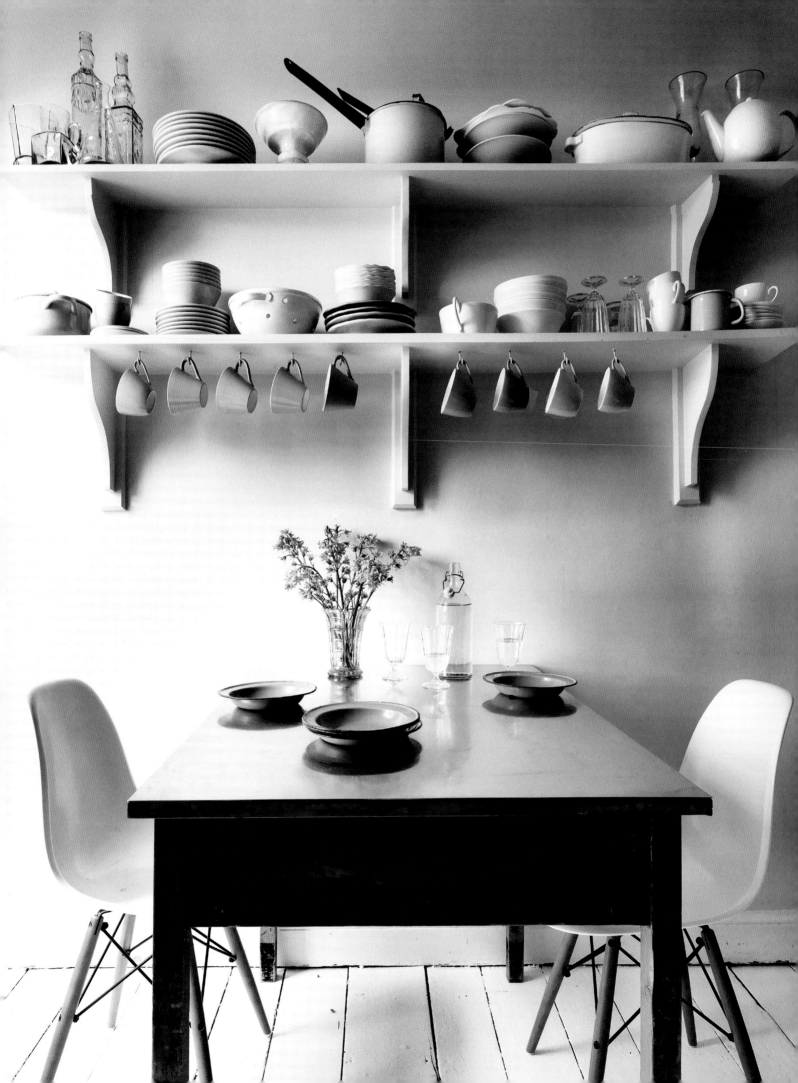

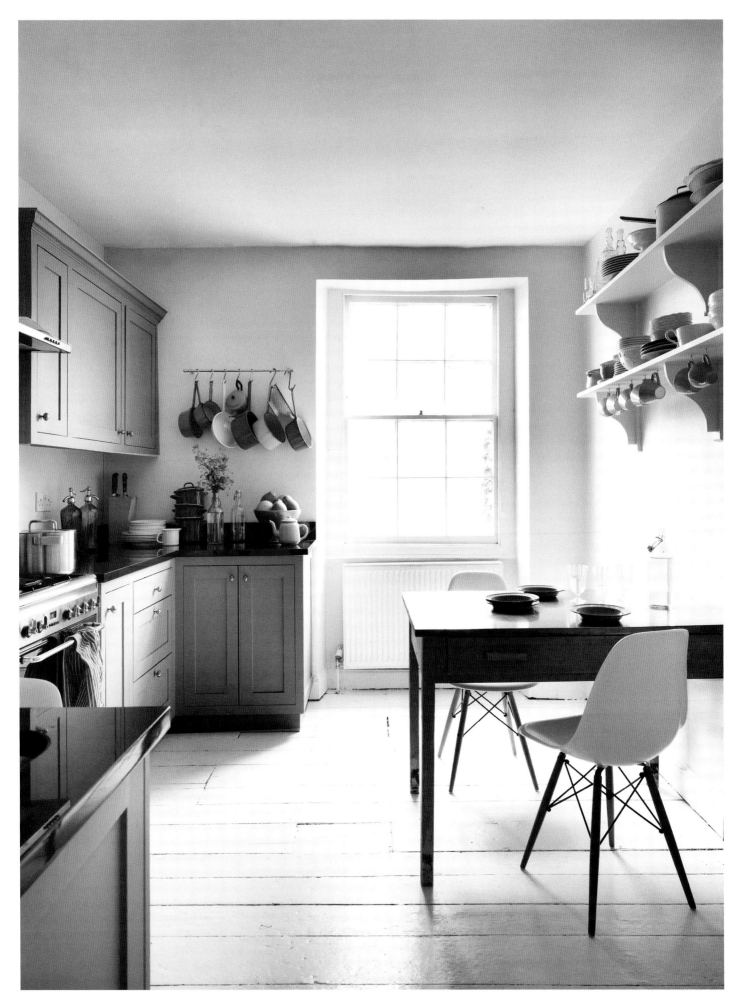

MAKING THE MOST OF SMALL SPACES

KLEINE RÄUME OPTIMAL AUSNUTZEN

Use white—lots of it. Used on the floor, ceiling, and walls, it reflects light around any narrow space and makes a small space feel larger and brighter.

Setzen Sie viel Weiß ein – auf dem Boden, der Decke und den Wänden. Weiß reflektiert das Licht und lässt kleine Räume größer und heller wirken.

Less is more. By having fewer things, you make a feature of more ornate designs and the room will feel less cramped.

Weniger ist mehr. Ausgewählte Objekte bekommen in reduzierten Einrichtungskonzepten mehr Aufmerksamkeit und der Raum wirkt weniger überladen und beengt.

Streamline a room by sticking to the same color palette and materials throughout. This creates a continuity of space that is easy on the eye.

Die Farbpalette und Hauptmaterialien sollten sich wie ein roter Faden durchs ganze Haus ziehen. Der Blick schweift ohne Unterbrechungen umher und es entsteht ein Gefühl von Weite.

A low bed is unobtrusive, making it a great option for a smaller room. The same applies for a streamlined sofa without arms. Also, look for furniture that can be used for multiple uses.

Ein niedriges Bett nimmt optisch weniger Platz ein und ist daher für kleine Räume geeignet. Dasselbe gilt für ein stromlinienförmiges Sofa ohne Armlehnen. Halten Sie außerdem nach multifunktionalen Möbelstücken Ausschau.

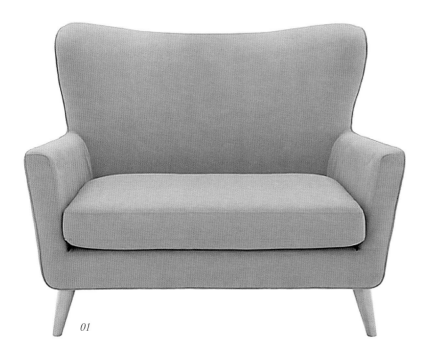

01

GET THE
LOOK

01. *Thomas Snuggler by John Lewis*
02. *Joyce sideboard by PINCH*
03. *Cordonetto linen by Lula Green*
04. *Iona drawer cheval by PINCH*
05. *Enamel Jug in Dorset Blue by Garden Trading*

01. *Thomas Snuggler von John Lewis*
02. *Joyce Sideboard von PINCH*
03. *Cordonetto linen von Lula Green*
04. *Iona drawer cheval von PINCH*
05. *Enamel Jug in Dorset Blue
 von Garden Trading*

05

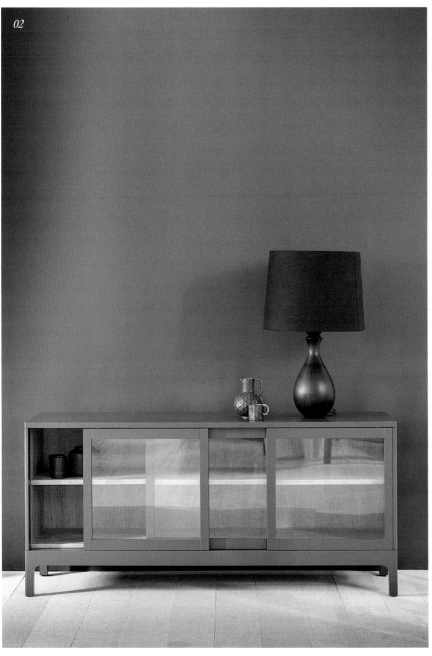

02

03

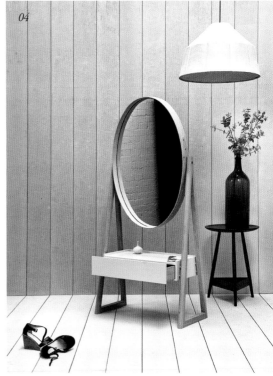

04

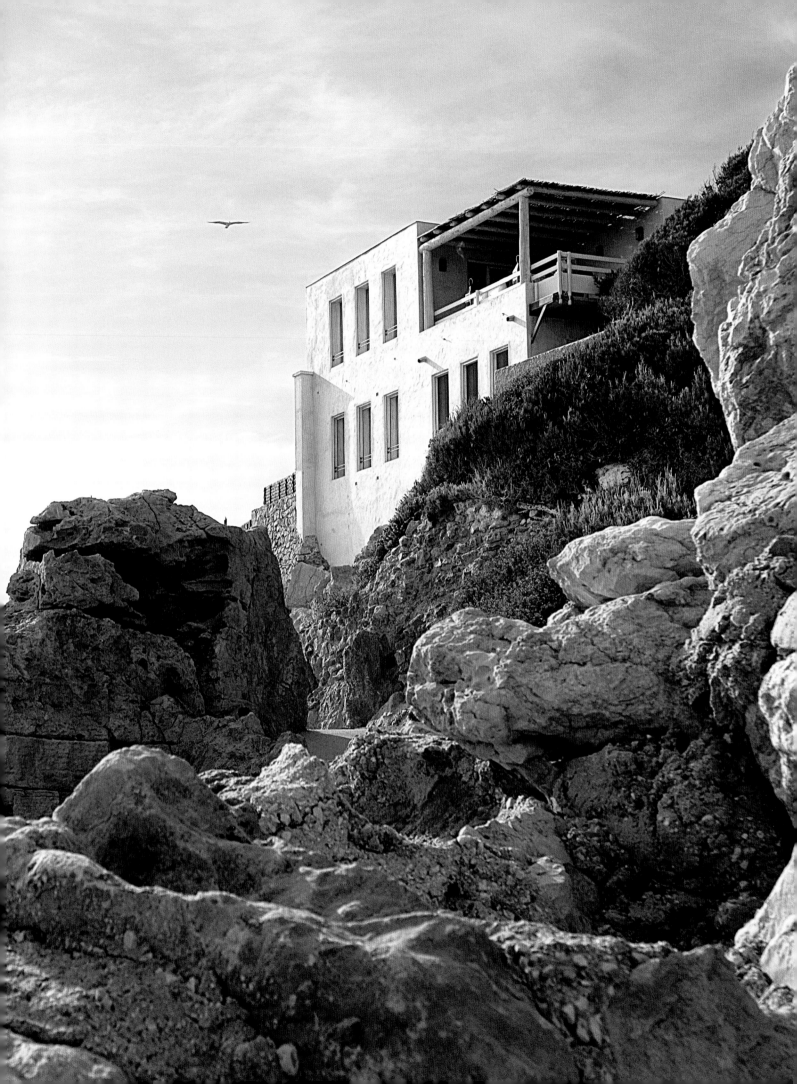

08

THE (MEDITERRANEAN) VILLA

There aren't many places where time appears to stand still, but the new-look villa is a lesson in serenity and enduring appeal. Space, light, and comfort are key—the design of these stylish holiday retreats feature luxurious, open-plan rooms that are stripped down to reveal the original features of the building and are more natural than rustic in style.

Inside the house, floor-to-ceiling glass windows seamlessly blend inside with out, and materials such as timber, stone, ceramic, and concrete are used to tactile effect. Soft, rounded seating decorates the living room—midcentury pieces are in their element here—and the play of light and shadow adds a vital dimension.

Colors are rich with a warm, chalky palette played off against graphic black-and-white to keep the look contemporary. Alternatively, cool, whitewashed walls and wide doorways provide a simple backdrop to showcase beautiful carvings, intricately tessellated tiles, and vast stretches of space.

With a nod to bohemian style, it all makes for a wonderful visual feast and given that there is no greater pleasure in life than lounging in the sun, it is perfect for entertaining and family life. Sun-kissed and spartan, the New Country villa may appear untouched by time—but also has a bit of an edge.

DIE (MEDITERRANE) VILLA

Hier scheint die Zeit stillzustehen: Die moderne Villa strahlt Gelassenheit und architektonisches Selbstbewusstsein aus. Weite, Licht und Komfort sind die Schlüsselkomponenten. Typisch für stylishe Ferienvillen sind großzügige und luxuriös ausgestattete offene Wohnflächen, die Originalelemente des Gebäudes freilegen und einen natürlichen, aber nicht allzu rustikalen Stil pflegen.

Innen schaffen raumhohe Fenster einen fast nahtlosen Übergang zum Außenbereich, das Spiel zwischen Licht und Schatten wird zum gestalterischen Element. Materialien wie Holz, Stein, Keramik und Beton werden haptisch eingesetzt. Das Wohnzimmer ist mit weichen, abgerundeten Sitzgelegenheiten ausgestattet – vor allem mit Stücken aus der Mitte des 20. Jahrhunderts.

Die Farben wurden aus einer Palette warmer, teilweise kreidiger Erdtöne ausgewählt und punktuell gegen grafisches Schwarz-Weiß gesetzt, um den Look modern zu halten. Alternativ bieten kühle, weißgetünchte Wände und breite Türeingänge einen schlichten Hintergrund für wunderschöne Schnitzereien, Fliesen im Mosaikmuster und weite Raumfluchten.

All dies ergibt ein Fest für die Augen mit unkonventionellem Touch – die perfekte Kulisse für Ferien mit der Familie oder Einladungen im großen Stil. Sonnendurchflutet und spartanisch: Die Villa im New-Country-Stil ist zugleich zeitlos und markant.

STYLE IN BRIEF

This simple but inspiring style marries contemporary style with rusticity. Global influences feature in textiles hung from the walls, the rich, earthy palette, down to the hand-carved wooden tables and stools. This roughness is only heightened by the addition of slick modern pieces in black-and-white.

STIL KURZ GEFASST

Dieser einfache, aber inspirierende Stil vereint Modernes und Rustikales. Mediterrane und nordafrikanische Einflüsse zeigen sich in den Stoffen an den Wänden, der erdig-warmen Farbpalette und den handgezimmerten Tischen und Stühlen. Die raue Anmutung wird durch einzelne moderne Hochglanzstücke in Schwarz und Weiß noch verstärkt.

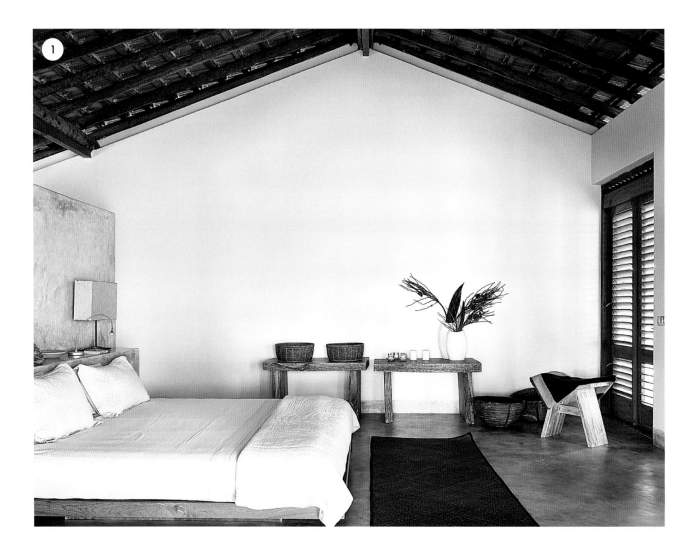

1 | The polished floor is made of concrete. Original beams have been left exposed in contrast with the modern style. **2 |** Through the use of natural materials such as wood and stone, this villa adapts perfectly to its surroundings. **3 |** Every room should have a centerpiece. Here, it is the contemporary modular sofa, the glamour offset by the rustic, woven rug. Muslin curtains hang at the windows.

1 | Der polierte Boden des Schlafzimmers wurde aus Beton gegossen. Die Original-Dachbalken bleiben sichtbar, um einen Kontrast zum modernen Stil zu bilden. **2 |** Durch den Einsatz von natürlichen Materialien wie Holz und Stein, fügt sich diese Villa perfekt in ihre Umgebung ein. **3 |** Jeder Raum sollte einen Mittelpunkt haben. Hier ist es das modulare Sofa, dessen modernes Design sich vom rustikalen Webteppich absetzt. Die Gardinen sind aus lichtdurchlässigem Musselin.

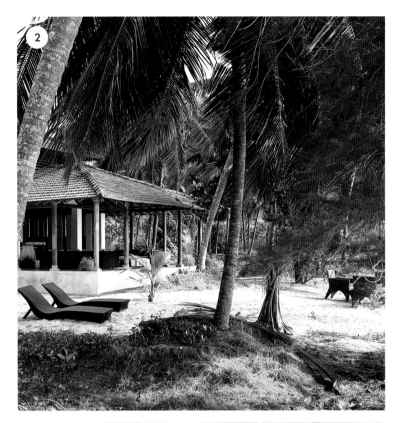

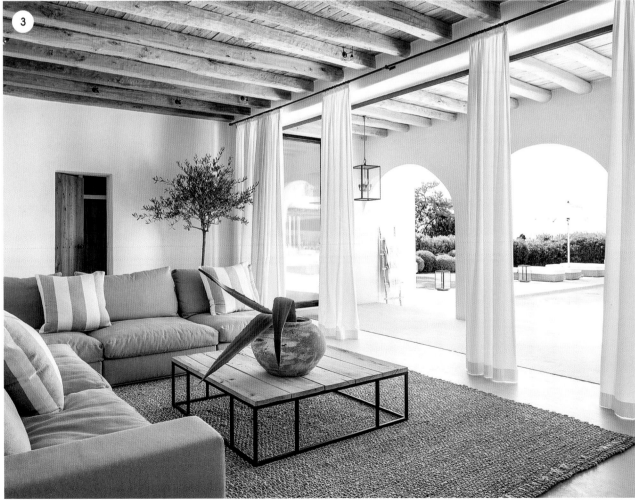

HOME INSPIRATION

UNDER THE SUN

Pink and gray make a striking pairing
in this modern Moroccan home.

———

EINRICHTUNGSINSPIRATIONEN

UNTER DER SONNE

Rosa und Grau gehen in diesem modernen
marokkanischen Zuhause eine harmonische
Verbindung ein.

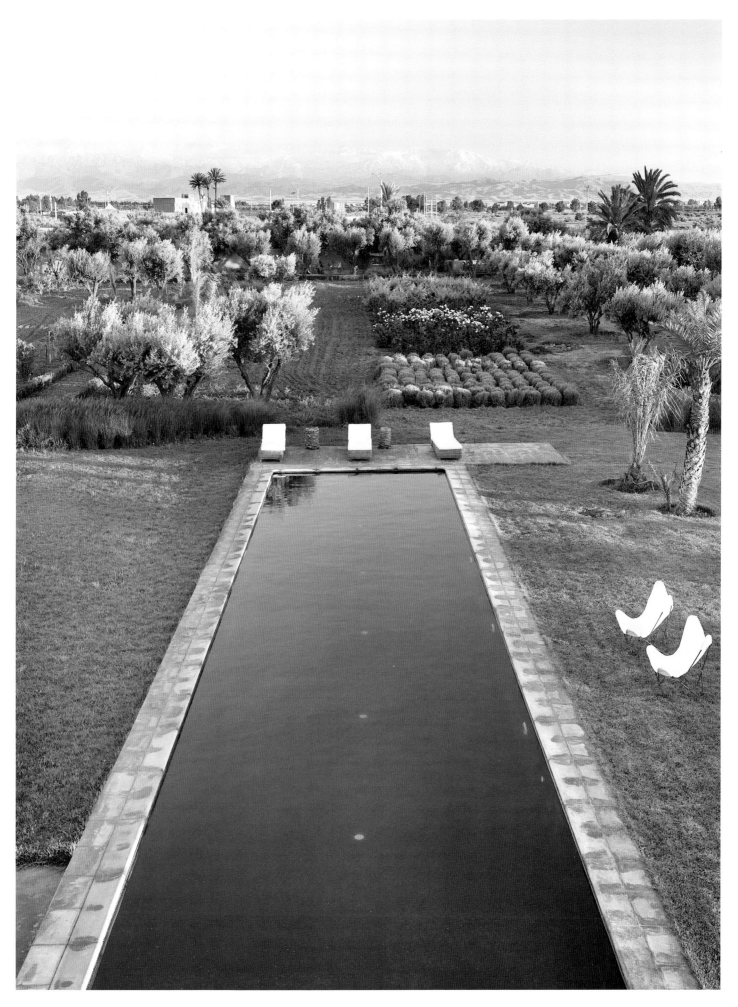

This Moroccan villa takes modern rustic style and adds warm, comforting colors and an eclectic twist to create a home that looks amazing and made for relaxation. Located on the outskirts of Marrakesh, the design echoes the simple farmhouses of the region. The walls are made using handmade earth and straw bricks, while traditional poles and sticks form the construction of the ceiling. On the floor, the cement and limestone floors are cleaned using black olive soap, and water is supplied by well. It paints an idyllic scene.

An interior designer, the homeowner furnished the space with a quirky mix of antiques and artisanal pieces created for him by local craftsmen. Here, nothing obviously matches—a Verner Panton pendant light is partnered with old Sahrawi leather and straw mats. Reclaimed farmhouse and giant iron-framed doors are juxtaposed against the rose-tinted walls. Luxurious Italian silk furnishings are placed alongside African textiles.

An exercise in preservation and perennial style, this is a house that entirely fits its surroundings. History is felt in every inch of its architectural bones. The calm and curated interior effortlessly balances a mix of old and new furniture, a variety of textures, and beautiful detailing—the sum of parts making it relevant for the 21st century and bringing it right up to date.

..

In dieser marokkanischen Villa wurden einem modern-rustikalen Stil Wärme, beruhigende Farben und ein Schuss Eklektizismus in der Möblierung hinzugefügt, um ein attraktives und entspannendes Zuhause zu erschaffen. Das Haus liegt am Stadtrand von Marrakesch und ist vom Design her an die einfachen Bauernhäuser der Region angelehnt. Die Mauersteine wurden aus Lehm und Stroh handgeformt, traditionelle Balken und Holzstangen bilden die Dachkonstruktion. Die Beton- und Kalksteinböden werden mit schwarzer Olivenseife gereinigt und das Wasser kommt aus dem Brunnen. Eine wahrhaft idyllische Szenerie.

Der Besitzer, ein Innenarchitekt, hat die Räume mit einer bunten Mischung aus antiken Teilen und von örtlichen Handwerkern hergestellten Möbeln bestückt. Eine Hängelampe von Verner Panton wird mit alten Sahraui-Matten aus Leder und Stroh kombiniert. Riesige alte, eisengerahmte Bauernhoftüren schwingen vor Wänden in Altrosa auf und zu. Luxuriöse italienische Seidenstoffe existieren friedlich neben afrikanischen Textilien.

Das Haus passt sich perfekt an die Umgebung an und ist auf Bewahrung und Nachhaltigkeit ausgerichtet. Jeder Stein ist hier von Geschichte durchdrungen. Dem Ruhe ausstrahlenden, sorgfältig zusammengestellten Interieur gelingt es mühelos, altes und neues Mobiliar, viele verschiedene Texturen und wunderschöne Details unter einen Hut zu bringen. Die Summe ihrer Teile macht diese Villa zu einem zeitgemäßen Zuhause.

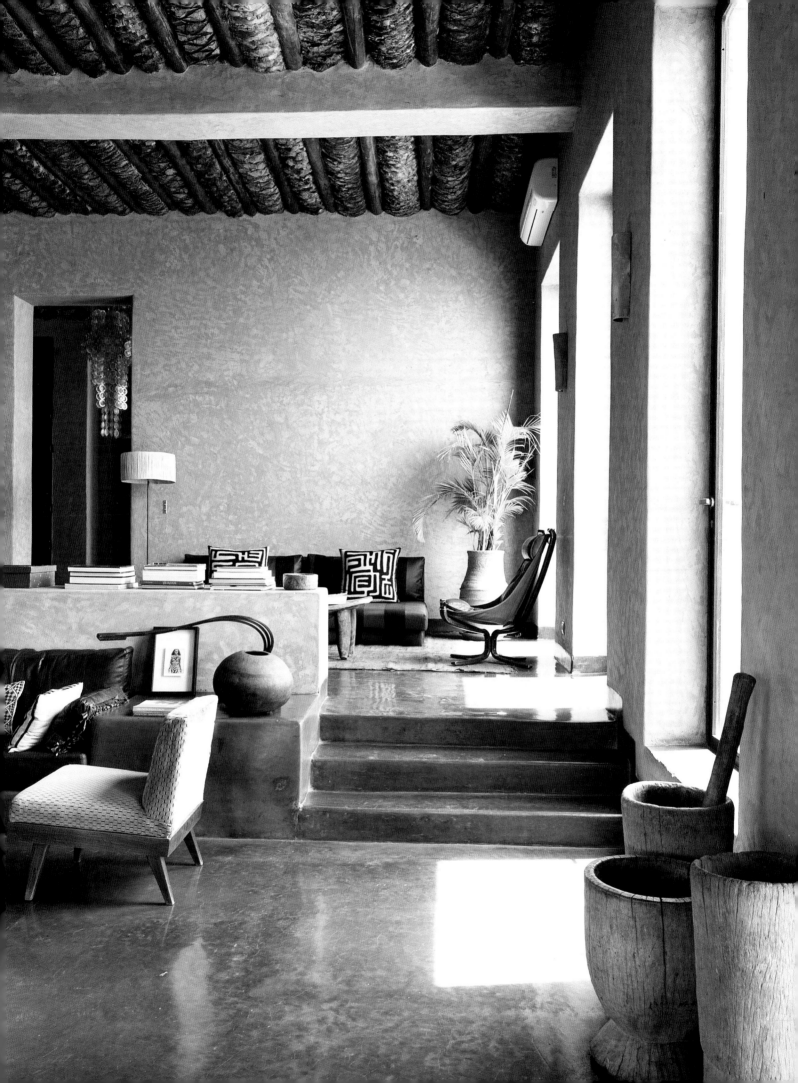

THE COLORS

A varying palette of terracotta, gold, and gray creates a warm interior in tune with the sunbaked Moroccan landscape. The colors are carried through the entire house—gray taking the lead for a coolly chic bathroom, whereas in the bedroom, the colors are soft blush for a tranquil space. Accents of graphic black and elegant ivory punctuate the décor to keep it feeling chic.

DIE FARBEN

Eine variantenreiche Palette aus Terrakotta, Gold und Grau erzeugt ein warmes Ambiente, das zur sonnengetränkten marokkanischen Landschaft passt. Die Farben ziehen sich durchs ganze Haus – Grau bestimmt das kühl-elegante Badezimmer, während im Schlafzimmer sanfte Blautöne für Entspannung sorgen. Schwarz und Elfenbein setzen Akzente und lassen das Dekor stylish wirken.

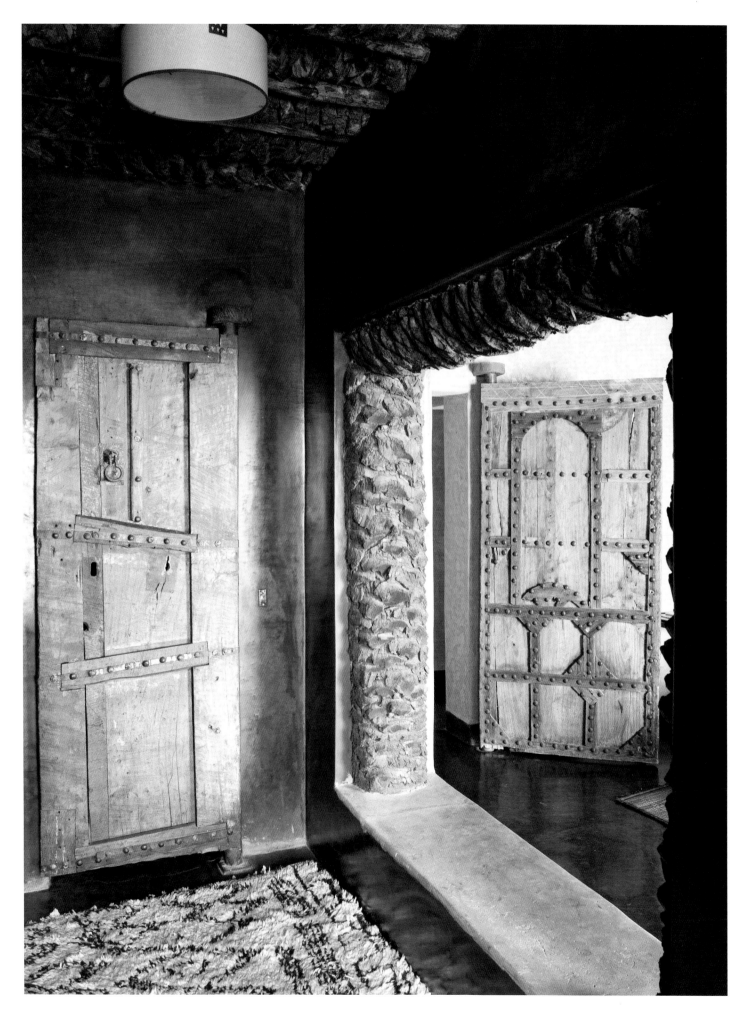

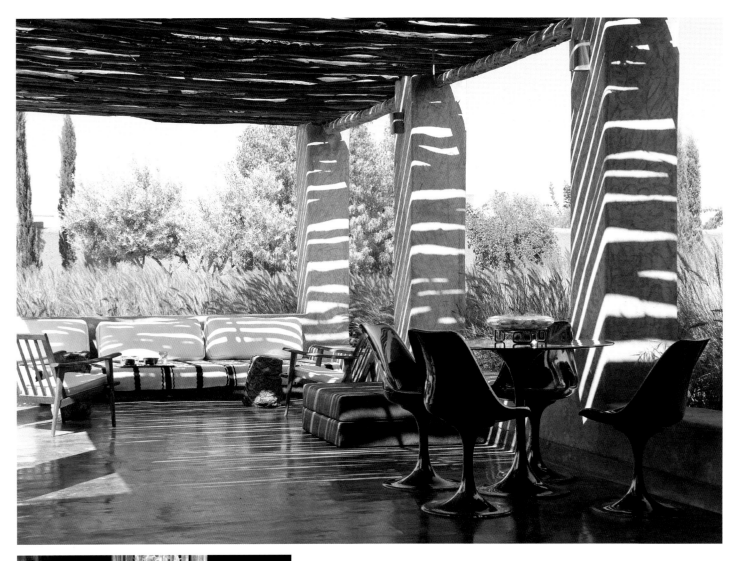

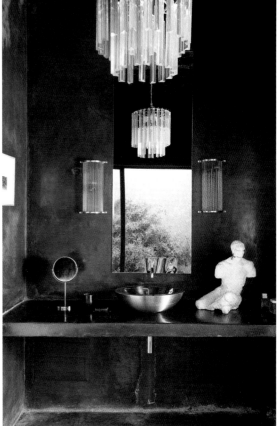

THE MATERIALS

The natural materials add texture and are key to giving this interior its soulful mood. From poured concrete through to decorative timber and glossy plastics, there's a diverse mix that defines the different spaces. The kitchen is made of lava-black clay and is proportioned to fit. Similarly, in the bathroom, the polished plaster walls and sunken bath emphasize the cocoon-like feel of the space; stainless steel basins add a modern edge. In the bedroom, the materials are softer with original timber beams and Berber rugs on the floor.

DIE MATERIALIEN

Die Naturmaterialien wirken sehr plastisch und verleihen diesem Interieur eine beseelte Stimmung. Von gegossenem Beton bis hin zu dekorativem Holz und glänzendem Kunststoff: Unterschiedliche Materialien definieren die einzelnen Wohnbereiche. Die maßgefertigte Küche besteht aus lavaschwarzem Ton. Auch im Bad verströmen die glatt verputzten Wände und die in den Boden eingelassene Wanne eine höhlenartige Gemütlichkeit, die durch Waschbecken aus Edelstahl einen modernen Touch bekommt. Im Schlafzimmer kommen neben den Original-Deckenbalken mit Berberteppichen weichere Materialien zum Einsatz.

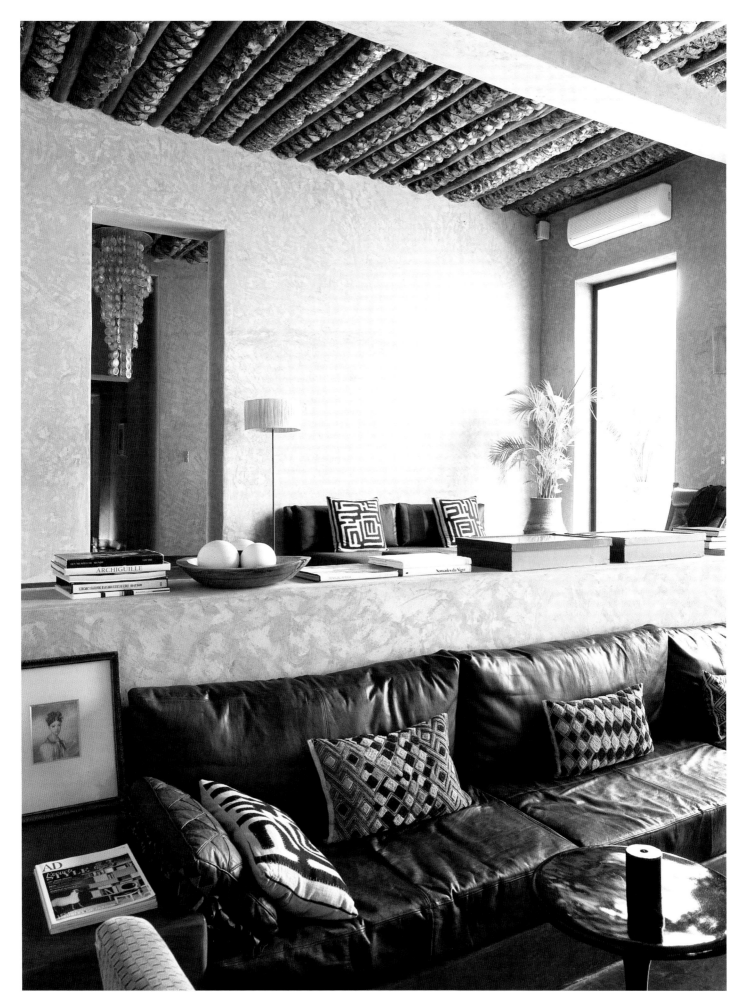

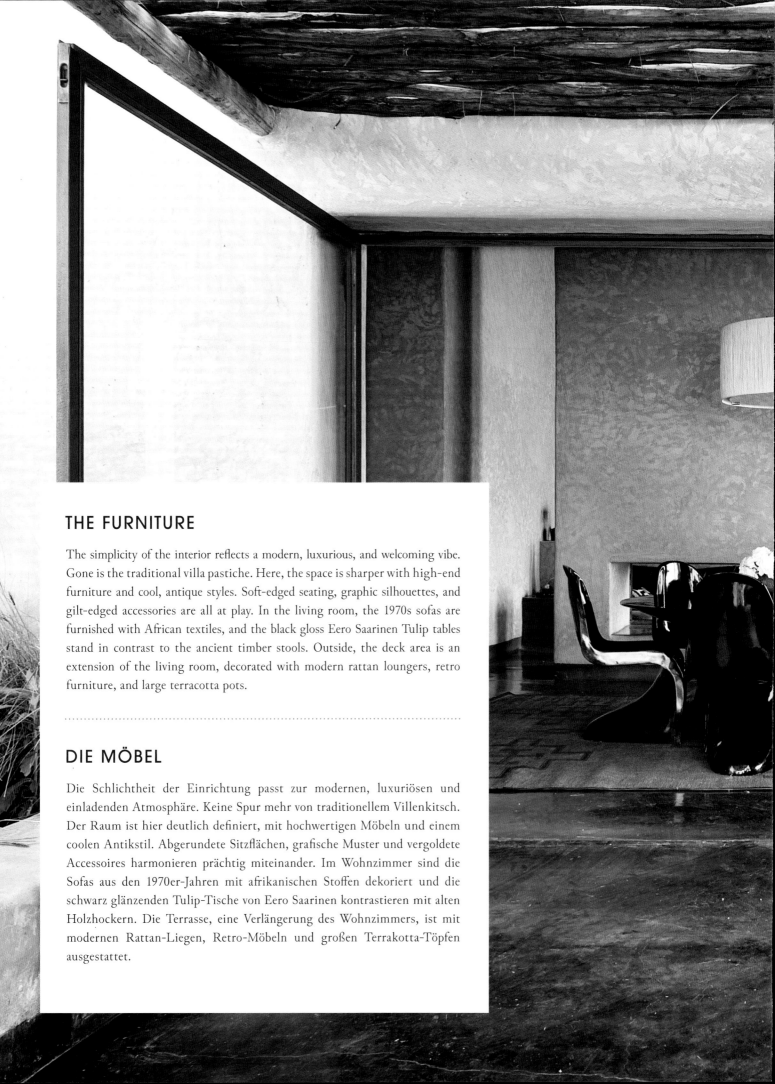

THE FURNITURE

The simplicity of the interior reflects a modern, luxurious, and welcoming vibe. Gone is the traditional villa pastiche. Here, the space is sharper with high-end furniture and cool, antique styles. Soft-edged seating, graphic silhouettes, and gilt-edged accessories are all at play. In the living room, the 1970s sofas are furnished with African textiles, and the black gloss Eero Saarinen Tulip tables stand in contrast to the ancient timber stools. Outside, the deck area is an extension of the living room, decorated with modern rattan loungers, retro furniture, and large terracotta pots.

DIE MÖBEL

Die Schlichtheit der Einrichtung passt zur modernen, luxuriösen und einladenden Atmosphäre. Keine Spur mehr von traditionellem Villenkitsch. Der Raum ist hier deutlich definiert, mit hochwertigen Möbeln und einem coolen Antikstil. Abgerundete Sitzflächen, grafische Muster und vergoldete Accessoires harmonieren prächtig miteinander. Im Wohnzimmer sind die Sofas aus den 1970er-Jahren mit afrikanischen Stoffen dekoriert und die schwarz glänzenden Tulip-Tische von Eero Saarinen kontrastieren mit alten Holzhockern. Die Terrasse, eine Verlängerung des Wohnzimmers, ist mit modernen Rattan-Liegen, Retro-Möbeln und großen Terrakotta-Töpfen ausgestattet.

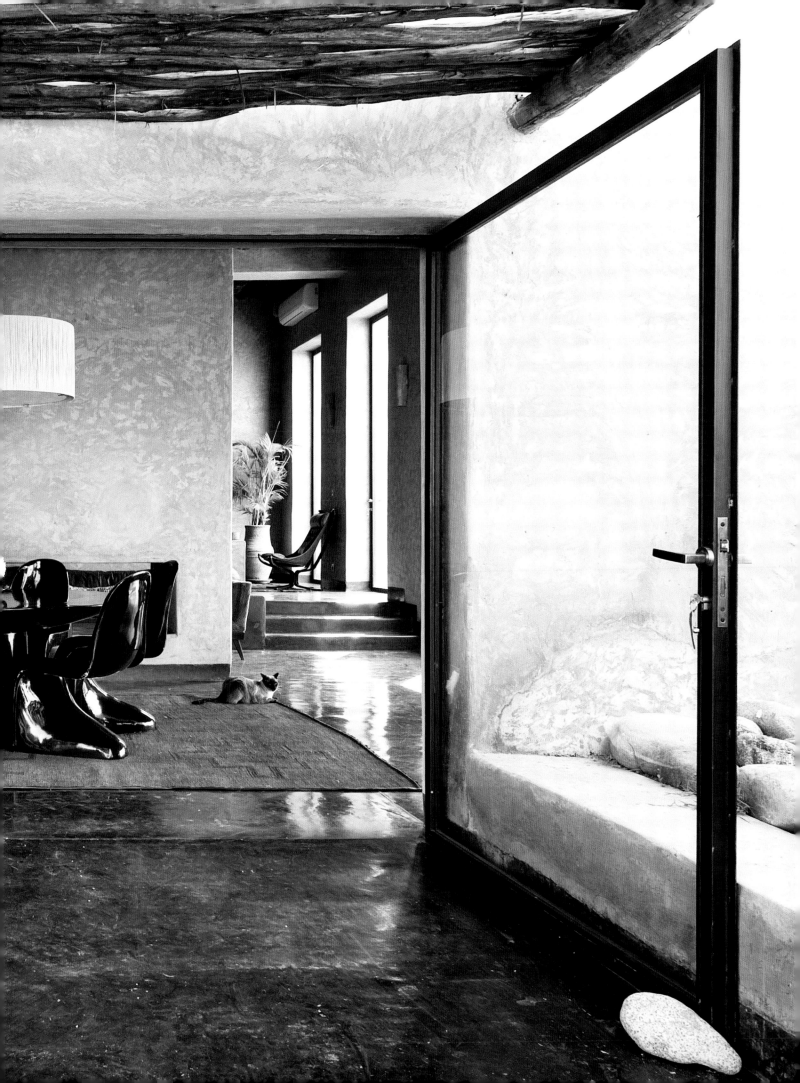

HOW TO ACHIEVE THE VILLA STYLE

DEN VILLA-STYLE NACHEMPFINDEN

Factor in modernity to avoid rustic overload. Classic midcentury designs and lived-in leather sofas suit an open-plan layout.

Mit einem Schuss Modernität vermeiden Sie, dass das Rustikale die Oberhand gewinnt. Designklassiker aus der Mitte des 20. Jahrhunderts und Ledersofas mit Abnutzungsspuren passen zu einer offenen Wohnraumgestaltung.

Give a plain space character with the clever repurposing of old shutters and reclaimed timber doors. Consider how they can be used in unusual ways, such as an eye-catching headboard or kitchen cabinet fronts.

Ein einfacher Raum bekommt durch den originellen Einsatz von alten Fensterläden oder Holztüren Charakter. Solche recycelten Elemente können zum Beispiel eine neue Aufgabe als auffälliges Kopfende fürs Bett oder Küchenschrank-Front erhalten.

Add some extra texture, contrasting smooth concrete-effect porcelain tiles with luxurious silks and rough linens.

Bringen Sie mehr Textur ins Spiel, indem Sie glatte Porzellankacheln in Betonoptik mit luxuriösen Seiden- und groben Leinenstoffen kombinieren.

From rose earth walls to cool gray floors, use color to add warmth to any room. Combine monochrome with neutrals, and accent wood with metallics.

Ob Erdtöne oder Altrosa: Farben machen Räume wärmer. Beleben Sie monochrome Flächen mit neutralen Farben und setzen Sie Holz ab mit Metall.

GET THE LOOK

01. Line One floor lamp in oxidized metal by NORR11 (available at Heal's)
02. Panton Chair Classic by Vitra
03. Ercole outdoor fire pit by AK47 Design (available at Encompass)
04. Estoperoles Plant Pots by Aurea (available at Maison Numen)
05. Grands vases en terre cuite by Comptoir Azur
06. Sarpaneva cast iron casserole pot by Iittala

01. Line One, oxidized von NORR11
02. Panton Chair Classic von Vitra
03. Ercole Outdoor-Feuerstelle von AK47 Design
04. Estoperoles Plant Pots von Aurea (erhältlich bei Maison Numen)
05. Grands vases en terre cuite von Comptoir Azur
06. Sarpaneva Kasserolle aus Gusseisen von Iittala

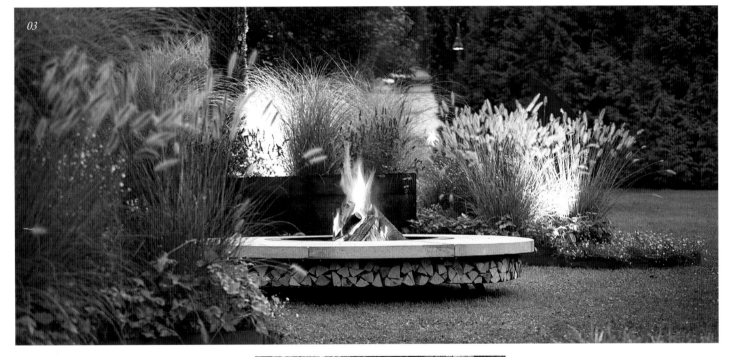

MANUFACTURERS & SUPPLIERS

AGA RANGEMASTER
AGA Rangemaster produces a wide range of hugely popular cookers, including the iconic AGA, which can trace its heritage back to 1922. Today, the company offers a selection of fully programmable models, including the innovative AGA Total Control, which features ovens and hotplates that can be controlled independently.
www.agaliving.com

AK47 DESIGN
AK47 is the benchmark company for those who are searching for the best Made in Italy design outdoor fire pits.
www.ak47design.com

ANOTHER COUNTRY
Another Country is a company that designs and makes contemporary craft furniture and accessories. Products are inspired by archetype, calling on the familiar and unpretentious forms of British Country kitchen style, Shaker, traditional Scandinavian and Japanese woodwork.
www.anothercountry.com
+44 (0)20 7486 3251

ANTHROPOLOGIE
Founded in 1992 in Wayne, Pennsylvania, Anthropologie has grown into a one-of-a-kind destination for those seeking a curated mix of clothing, accessories, gifts, and home décor to reflect their personal style and fuel their lives' passions. Taking inspiration from the worlds of fashion, art, and entertaining, we are committed to offering our customers signature products and unmatched service.
www.anthropologie.com

CATCHPOLE & RYE
Catchpole & Rye is a British manufacturer of luxury baths, bathroom sanitary ware, taps, and accessories. All products are designed and made in Kent.
www.catchpoleandrye.com

CHARNWOOD
As UK manufacturers of the finest multi-fuel & wood burning stoves we aim to simplify the real fire process and bring an enduring sense of warmth and satisfaction to the very heart of your home. Designed and built using the latest technology, our clean burning stoves burn wood, coal, and smokeless fuels at maximum efficiency and output low emissions.
www.charnwood.com

CIRE TRUDON
Founded in 1643, on the threshold of the reign of Louis XIV, Cire Trudon is the oldest candlemaker in the world still active today.
trudon.com

COMPTOIR AZUR
Comtoir Azur offers interior objects and accessories, handicrafts, beautiful and unique products for the home that are inspired by the Mediterranean and manufactured by local craftsmen.
www.comptoirazur.fr, contact@comptoirazur.com

DAVEY LIGHTING
With roots dating back to the shipyards of nineteenth century London, Davey Lighting combines industrial design, traditional craftsmanship, and the finest raw materials. Authentic and unique, lights are manufactured in England with the same attention to detail required for their original industrial purpose. Simplicity of design, choice of finish, and an extensive collection of bathroom and outdoor IP-rated lights make Davey equally suited to domestic or contract schemes.
www.davey-lighting.co.uk
+ 44 (0)207 351 2130

DAVID MELLOR DESIGN
David Mellor Design operates on the simple principle that well-designed equipment can improve your life. A collection of high-quality tableware and kitchenware is constantly evolving and includes many items of in-house design as well as the finest examples of British crafts and the best of international design.
www.davidmellordesign.com

DE LE CUONA
It was a love of linen and an attention to detail that first fired Bernie de Le Cuona's desire to create beautiful fabrics. Now after some twenty years in the business Bernie has a reputation that is second to none for developing exquisite fabric collections harnessing the color and beauty produced by the best International master weavers.
www.delecuona.com

ENCOMPASS FURNITURE
Founded in 1997, Encompass are specialists in premium-quality modern garden & contemporary outdoor furniture & accessories, modern log burners, and fireside accessories.
www.encompassco.com

ERCOL
From the early 1920's, through to today, ercol has worked with craftsmen, manufacturers, and retailers to create and extend the ercol furniture collection to the widest audience. The ercol brand has become synonymous with great design combined with functionality.
www.ercol.com

FINE LITTLE DAY
Fine Little Day is a design company that believes in the expression of play, passionate craftsmanship, hand drawn lines, and in ideas with a story to tell. It stands for environmentally friendly products with high artistic quality. The range includes everything from bed linen, kitchen and interior fabrics, posters, and fashion, for children and young-at-heart adults.
www.finelittleday.com

THE FRENCH BEDROOM COMPANY
The French Bedroom Company was founded in 2006 by Georgia Metcalfe, an interiors guru with a background in interior design and styling. Born out of a fascination of French designs, textures, craftsmanship, heritage, and history, the collections of French furniture are fun and feminine—with quality at the core.
www.frenchbedroomcompany.co.uk

GARDEN TRADING
At Garden Trading our focus is to design and produce functional products for the home and garden, without having to compromise on style. From a bread bin to an exterior light— we are passionate about making products that will last for years.
www.gardentrading.co.uk

HEAL'S
Heal's has been designing, making, and selling quality furniture for more than two centuries now, so it's no surprise that it's known as "the home of modern and contemporary designer furniture". Starting out as bed-makers in 1810, and later embracing the ideals of the Arts and Crafts movement, Heal's has a long history of collaborating with prominent designers.
www.heals.com
+44 (0)333 212 1915

MANUFACTURERS & SUPPLIERS

HOUSE DOCTOR

House Doctor is a family-run interior design business with its own consulting room in Denmark and dealers around the world. Our style is provocative, personal, and informal. We believe that the time is right for mixing elements rather than trying to match them all up. House Doctor gives you a daily vitamin boost for a more stylish, more inspiring, and more personal home.

housedoctor.dk

HOWE LONDON

Christopher Howe has established a trusted reputation and over the years has furnished works for some of Britain's most famous cultural institutions. From dealing antiques to creating his own designs, traditionally made bespoke furniture now makes up half the business where emphasis on craftsmanship has won Howe a dedicated following amongst the world's best known interior designers.

howelondon.com

IITTALA

As a company based in Finland, where quality, aesthetics, and functionality are important values, Iittala believes in interior design that lasts a lifetime.

www.iittala.com

JOHN LEWIS

John Lewis offers upmarket products for the home as well as fashion, electronics, and more in department stores throughout the UK as well as online.

www.johnlewis.com

LIGNE ROSET

Ligne Roset is synonymous with modern luxury and invites consumers to revel in a contemporary, design-forward lifestyle. The company is also known for its artful collaborations with both established and up-and-coming talents in contemporary design.

www.ligne-roset.com

LOAF

Brit-brand Loaf makes laid-back furniture for people to kick-off their shoes and lead happier, more relaxed lives. The homeware brand has made it their mission to encourage people to enjoy their homes more. With two showrooms in London and an online shop, Loaf has got every room of the home covered with insanely comfy, handmade beds, sofas, furniture, and accessories for Loafers.

www.loaf.com

LULA GREEN

Lula Green is the world's first organic luxury bed linen company with a 100% GOTS certified product range. Julia Otto, the brand's cofounder, launched the business in Spring 2016 after spotting a gap in the bed linen market and carrying out two years of thorough research into organic cotton and sustainable luxury. The products are handmade in Italy by craftsmen.

www.lulagreen.com

MAISON NUMEN

Maison Numen is an online platform for collectible artisan design products. The site, a global portal to the hidden talent of craftspeople from far corners of the world combines its carefully-selected retail offering with the stories of the people behind the pieces. A Maison Numen object is the perfect mix of beauty, technique, and tradition.

maisonnumen.com

MANDARIN STONE

Mandarin Stone offer an extensive collection of both natural stone and porcelain tiles for the home and garden and have 10 inspirational UK showrooms.

mandarinstone.com
+44 (0)1600 715444

NORR11

At NORR11 we seek to innovate and rethink design classics in order to improve upon, and create truly iconic pieces that withstand the test of time, both physically and aesthetically. Our furniture reflects a heritage stemming from the Danish Modern movement of the mid-1900s: clean, pure lines, naturalness, and excellent craftsmanship. NORR11's furniture is timeless.

www.norr11.com

OKA

OKA provides beautiful luxury furniture and home accessories, sourced with an eye for beauty, comfort, and unique style.

www.oka.com
+44 (0)844 815 7380

PINCH

PINCH was started by Russell Pinch and Oona Bannon in 2004 with a single aim; to design and make furniture and lighting that they would want to live with. Their work celebrates simplicity of form, the purity of a good shape, and an emotional connection with the materials around us.

pinchdesign.com

TOAST

TOAST creates and curates simple, functional, thoughtful pieces for women, the house & home. Established in West Wales in 1997 by Jessica and Jamie Seaton, TOAST has grown from loungewear and nightwear to become a unique lifestyle brand renowned for its thoughtful contemporary design and ability to re-energize traditional textiles.

www.toa.st

VITRA

A family business for eighty years, Vitra believes in lasting relationships with customers, employees, and designers, durable products, sustainable growth, and the power of good design.

www.vitra.com

THE WHITE COMPANY

The White Company specializes in supplying stylish, white, designer-quality items for the home that are affordable. What started as a range of essentials for the linen cupboard—duvet covers, pillows, fitted sheets, and luxury towels in timeless white—has become a full range of lifestyle products—from home accessories to clothing and childrenswear.

www.thewhitecompany.com

HERSTELLER & LIEFERANTEN

AGA RANGEMASTER
AGA Rangemaster produziert eine ganze Reihe von populären Herden, unter anderem den ikonischen Aga, dessen Geschichte bis ins Jahr 1922 zurückreicht. Heutzutage bietet die Firma eine breite Auswahl an programmierbaren Modellen, wie den innovativen Aga Total Control, deren Öfen und Herdplatten individuell gesteuert werden können.
www.agaliving.de

AK47 DESIGN
Ak47 ist die Anlaufstelle für hochwertige Outdoor-Feuerstellen und Designobjekte für die Gartengestaltung, die die Symbiose aus Zweckmäßigkeit und Design Made in Italy perfekt umsetzen.
www.ak47design.com

ANOTHER COUNTRY
Another Country entwirft und fertigt moderne Möbel und Accessoires, die sowohl von Urformen, dem familiären und unprätentiösen britischen Landhausküchen-Stil als auch von traditionellen skandinavischen und japanischen Holzarbeiten inspiriert sind.
www.anothercountry.com

ANTHROPOLOGIE
Anthropologie, 1992 in den USA gegründet, hat sich zu einem begehrten Einkaufsziel für die entwickelt, die einen einzigartigen Mix aus Kleidung, Accessoires, Geschenkartikeln und Produkten für Haus und Heim suchen, um ihren persönlichen Stil und ihre Leidenschaft auszudrücken. Inspiriert von der Mode-, Kunst- und Unterhaltungswelt, bietet das Unternehmen seinen Kunden unverkennbare Produkte und besten Service.
www.anthropologie.com

CATCHPOLE & RYE
Catchpole & Rye ist ein britischer Hersteller luxuriöser Badewannen, Sanitärmöbel, Armaturen und Accessoires für das Badezimmer. Alle Produkte werden in Kent entworfen und gefertigt.
www.catchpoleandrye.com

CHARNWOOD
Als Hersteller bester Brennstoff- und Holzöfen zielt das britische Unternehmen darauf, den Brandprozess zu vereinfachen und ein Gefühl von Wärme und Zufriedenheit in jedem Heim zu erzeugen. Diese sauberen Öfen, die mit modernster Technologie gebaut werden, verbrennen Holz, Kohle und rauchlose Brennstoffe bei maximaler Effizienz und niedrigen Emissionen und ermöglichen so einen ungetrübten Blick auf das Feuer.
www.charnwood.com

CIRE TRUDON
Cire Trudon ist die älteste noch aktive Kerzenmanufaktur der Welt. Sie wurde 1643 gegründet, im selben Jahr in dem König Ludwig XIV. gekrönt wurde.
trudon.com

COMPTOIR AZUR
Comtoir Azur vertreibt Einrichtungsobjekte und -accessoires, Kunsthandwerk, schöne und einzigartige Produkte für das Zuhause, die vom mediterranen Lebensstil inspiriert sind und von lokalen Kunsthandwerkern hergestellt werden.
www.comptoirazur.fr
contact@comptoirazur.com

DAVEY LIGHTING
Davey Lighting, dessen Wurzeln zu den Londoner Werften des 19. Jahrhunderts zurückreichen, verbindet Industriedesign, traditionelle Handwerkskunst und feinste Rohstoffe. Authentisch und einzigartig – die Leuchten werden in England mit Liebe zum Detail hergestellt, damals wie heute. Davey-Lampen sind durch ihr funktionales Design, die Wahl der Oberflächen und eine umfangreiche Sammlung von Bad- und Außenleuchten gleichermaßen für den häuslichen als auch gewerblichen Gebrauch geeignet.
www.davey-lighting.co.uk

DAVID MELLOR DESIGN
David Mellor Design folgt dem einfachen Prinzip, dass formschöne Produkte das Leben bereichern. Die Kollektion hochwertiger Küchenutensilien wird stetig erweitert und schließt sowohl eigene Entwürfe als auch die besten Beispiele britischer und internationaler Handwerkskunst ein.
www.davidmellordesign.com

DE LE CUONA
Es war die Liebe zu Leinen und die Aufmerksamkeit für Details, die Bernie de Le Cuona anfänglich dazu veranlassten wunderschöne Stoffe zu entwerfen. Jetzt, 20 Jahre später, hat sie den Ruf, exquisite Textilkollektionen zu entwickeln, die von den besten internationalen Webern produziert werden.
www.delecuona.com

ENCOMPASS FURNITURE
Encompass, 1997 gegründet, ist spezialisiert auf moderne Garten- und Outdoor-Möbel, zeitgemäße Feuerstellen, Außenkamine und Accessoires von höchster Qualität.
www.encompassco.com

ERCOL
Seit den frühen 1920er-Jahren arbeitet ercol eng mit Handwerkern, Herstellern und Händlern zusammen, um die eigene Möbelkollektion weiterzuentwickeln und einem breiten Publikum zugänglich zu machen. Die Marke steht für großartiges Design und Funktionalität.
www.ercol.de

FINE LITTLE DAY
Die Designfirma Fine Little Day vertraut auf leidenschaftliches Kunsthandwerk, Leichtigkeit, Handgezeichnetes und Entwürfe, die eine Geschichte erzählen. Die Produkte sind umweltfreundlich und von hoher künstlerischer Qualität. Das Sortiment umfasst Bettwäsche, Textilien aller Art, Poster und Mode für Kinder und Junggebliebene.
www.finelittleday.com

THE FRENCH BEDROOM COMPANY
The French Bedroom wurde 2006 von Georgia Metcalfe, einer Einrichtungsexpertin mit Wurzeln in Innenarchitektur und Raumgestaltung, gegründet. Aus einer Faszination für französisches Design, Texturen, Handwerk, Tradition und Geschichte entstehen Kollektionen französisch inspirierter Möbel, die feminin sind und Spaß machen – mit dem Fokus auf Qualität.
www.frenchbedroomcompany.co.uk

GARDEN TRADING
Garden Trading entwirft und produziert funktionale und stilvolle Produkte für Haus und Garten. Vom Brotkasten bis zur Außenlampe – das Unternehmen entwickelt mit Leidenschaft Produkte, die die Zeit überdauern.
www.gardentrading.co.uk

HEAL'S
Heal's enwirft, produziert und verkauft seit zwei Jahrzehnten Qualitätsmöbel, daher ist es keine Überraschung, dass die Firma auch als die Anlaufstelle für moderne Designermöbel bezeichnet wird. Heal's wurde 1810 als Hersteller für Betten gegründet, schloss sich später der Arts-and-Crafts Bewegung an und kollaboriert seit langem mit namhaften Designern.
www.heals.com

HERSTELLER & LIEFERANTEN

HOUSE DOCTOR

House Doctor ist ein Design-Familienbetrieb mit eigener „Praxis" in Dänemark und Händlern fast überall in der Welt. Der Stil ist provokant, persönlich und nicht übermäßig formell. Die Firmenphilosophie beruft sich darauf, Elemente eher miteinander zu mischen, als sie passend aufeinander abzustimmen. House Doctor ist wie eine tägliche Vitaminspritze, die ein Zuhause schöner, anregender und persönlicher macht.

housedoctor.dk

HOWE LONDON

Christopher Howe hat sich über die Jahre einen hervorragenden Ruf erarbeitet und bereits einige der bedeutendsten Kulturinstitutionen Großbritanniens ausgestattet. Vom Antiquitätenhandel bis zur Herstellung eigener Entwürfe, traditionell hergestellte Möbel nach Maß machen heutzutage die Hälfte des Geschäftes aus. Seine Leidenschaft für Handwerkskunst hat Howe eine große Anhängerschaft unter den bekanntesten Innenarchitekten der Welt eingebracht.

howelondon.com

IITTALA

In Finnland sind Qualität, Ästhetik und Funktionalität wichtige Werte. Und als finnisches Unternehmen setzt Iittala auf Einrichtungsdesign, das ein Leben lang Bestand hat.

www.iittala.com

JOHN LEWIS

John Lewis verkauft exklusive Produkte für Haus und Hof sowie Mode, Technik und mehr, sowohl in eigenen Kaufhäusern in ganz Großbritannien als auch im Internet.

www.johnlewis.com

LIGNE ROSET

Ligne Roset steht für kreative, innovative und hochwertige Designmöbel. Die Kollektionen werden in Zusammenarbeit mit vielen namhaften Designern entwickelt.

www.ligne-roset.de

LOAF

Die britische Marke Loaf stellt lässige Möbel her, die für ein entspannteres und glücklicheres Leben sorgen sollen. Das Unternehmen hat es zu seiner Aufgabe gemacht, Menschen zu ermutigen sich an ihrem Zuhause stärker zu erfreuen. Loaf deckt mit seinem Sortiment jeden Raum des Hauses ab und bietet unter anderem unglaublich komfortable Betten, Sofas, Möbel und Accessoires an.

www.loaf.com

LULA GREEN

Lula Green ist das erste Unternehmen, das luxuriöse Bio-Bettwäsche mit 100 % GOTS (Global Organic Textile Standard) Zertifizierung anbietet. Mitbegründerin Julia Otto lancierte die Marke im Frühjahr 2016, nachdem sie eine Nische im Bettwäschemarkt entdeckt und zwei Jahre ausgiebig zu den Themen Biobaumwolle und nachhaltiger Luxus recherchiert hatte. Die Produkte werden in Italien handgemacht.

www.lulagreen.com

MAISON NUMEN

Maison Numen ist eine Internetplattform für Kunsthandwerk und Designobjekte. Die Webseite ist das globale Portal zu versteckten Kreativtalenten in der ganzen Welt. Hier werden sorgsam ausgewählte Produkte mit den Geschichten der Entstehung und der Macher dahinter kombiniert. Ein Objekt von Maison Numen vereint den perfekten Mix aus Schönheit, Technik und Tradition.

maisonnumen.com

MANDARIN STONE

Das Sortiment von Mandarin Stone besteht aus einer umfangreichen Kollektion von Naturstein- und Porzellanfliesen für Haus und Garten.

mandarinstone.com

NORR11

Bei NORR11 streben wir nach Innovationen und danach Designklassiker neu zu überdenken, um sie zu verbessern. Wir kreieren ikonische Stücke, dic die Zeit überdauern, sowohl physisch als auch ästhetisch. Unsere Möbel spiegeln ein Erbe wider, dass aus der Bewegung der dänischen Moderne des 20. Jahrhunderts stammt: klare Linien, Natürlichkeit und exzellente Handwerkskunst. NORR11 Möbel sind zeitlos.

www.norr11.com

OKA

OKA produziert und verkauft schöne und luxuriöse Möbel und Accessoires – mit besonderem Fokus auf Anmut, Komfort und einzigartigen Stil.

www.oka.com

PINCH

PINCH wurde 2004 von Russell Pinch und Oona Bannon mit dem Ziel gegründet, nur Möbel und Leuchten zu entwerfen, mit denen sie selbst gerne leben wollen. Ihre Arbeit zelebriert einfache Formen, gute Konturen und eine emotionale Bindung zu den verwendeten Materialien.

pinchdesign.com

TOAST

TOAST entwirft und kuratiert einfache, funktionale und wohlüberlegte Stücke für das Heim. 1997 von Jessica und Jamie Seaton in Wales gegründet, entwickelte sich TOAST von einer Marke für Nacht- und Freizeitmode zu einem einzigartigen Lifestyle-Unternehmen, das für seine durchdachten modernen Designs und die Wiederbelebung traditioneller Textilien bekannt ist.

www.toa.st

VITRA

Vitra – ein Familienunternehmen seit 80 Jahren – pflegt dauerhafte Beziehungen zu Kunden, Mitarbeitern und Designern und steht für langlebige Produkte, ein nachhaltiges Wachstum und die Kraft guten Designs.

www.vitra.com

THE WHITE COMPANY

The White Company ist auf den Vertrieb stilvoller, weißer, qualitativ hochwertiger und erschwinglicher Produkte für daheim spezialisiert. Angefangen hat alles mit einem Sortiment für den Wäscheschrank, bestehend aus Bettbezügen, Kissen, Laken und Luxushandtüchern in zeitlosem Weiß. Mittlerweile wurde daraus eine umfassende Auswahl an Lifestyle-Produkten, die Wohnaccessoires und Kleidung einschließt.

www.thewhitecompany.com

CLAIRE BINGHAM

Claire Bingham is an interiors journalist who writes about architecture,
design, and style for several publications worldwide.
Before becoming an author with her first book *Modern Living*,
she was the Homes Editor for UK *Elle Decoration* and her work has been featured
in international glossies, including *Vogue Living* and *Architectural Digest*.
Scouring the globe for inspiring interiors and discovering the talents behind the scenes, she is interested in
well-considered design that fits with our individual needs.
Ultimately, she writes about the design and decoration of people's homes
and how they like to live.

www.clairebingham.com

Die Einrichtungsjournalistin Claire Bingham schreibt für eine Reihe von Zeitschriften weltweit
über Architektur, Design und Stil. Bevor sie mit *Modern Wohnen* ihr erstes Buch veröffentlichte,
war sie Wohnredakteurin der britischen *Elle Decoration* und in internationalen Hochglanzmagazinen
wie *Vogue Living* und *Architectural Digest* vertreten. Wenn sie rund um den Globus
nach inspirierenden Interieurs sucht und hinter den Kulissen die Talente entdeckt, interessiert sie sich
in erster Linie für gut durchdachte Designs, die zu unseren individuellen Bedürfnissen passen.
Im Ergebnis schreibt Bingham über die Gestaltung und Dekoration von Eigenheimen und darüber,
wie Menschen gerne wohnen.

www.clairebingham.com

PHOTO CREDITS/BILDNACHWEISE

We extend our thanks to all of the manufacturers, suppliers,
and dealers who allowed us to use their photographs in *Modern Living New Country*.
Wir danken allen Herstellern, Lieferanten und Händlern, die uns ihr Bildmaterial
für *Modern Wohnen New Country* zur Verfügung gestellt haben.

Cover: © Andreas von Einsiedel;
Back Cover: (top) © Karel Balas/Milk/VegaMG;
(bottom) © Catchpole & Rye / photo: Simon Bevan

p 4 © Michael Paul/Living Inside; pp 6-21 © Andreas von Einsiedel;
p 23 (01 & 04) © courtesy of Another Country; (02) © The White Company / photo:
Rita Platts; (03) © The White Company / photo: Anders Schonemann;
(05) © Tim James / Mabel Gray / AGA Rangemaster; (06) courtesy of Heal's;
p 24 © courtesy of HOWE London; pp 26-29 © Andreas von Einsiedel;
pp 30-47 © courtesy of HOWE London; p 49 (01) © ercol; (02) © courtesy of TOAST;
(03 & 04) © courtesy of HOWE London; (05) © David Mellor Design;
(06) © A J Wells & Sons Ltd / courtesy of Charnwood; pp 50-65 © Andreas von Einsiedel;
p 67 (01) © OKA; (02) © de Le Cuona / photo: Jon Day Photography;
(03) © Cire Trudon / photo: Cyrille Robin; (04 & 05) © courtesy of The French Bedroom Co;
(06) © Catchpole & Rye / photo: Simon Bevan; pp 68-73 © Andreas von Einsiedel;
pp 74-87 © Karel Balas/Milk/VegaMG; p 89 (01) © courtesy of Loaf.com;
(02) © courtesy of Davey Lighting; (03 & 04) © House Doctor; (05) © courtesy of TOAST /
photo: David Lothian; pp 90-93 © Andreas von Einsiedel;
pp 94-107 © GAP Interiors/Chris Tubbs; p 109 © Anthropologie;
pp 110-113 © Andreas von Einsiedel; pp 114-129 © Michael Paul/Living Inside;
pp 131 (01) © OCHRE; (02) © Canvas Home / photo: Ryan K. Liebe;
(03) © Hampson Woods / photo: Arthur Woodcroft Photography;
(04 & 06) © David Mellor Design; (05) © Mandarin Stone; pp 132-135 © Andreas von Einsiedel;
pp 136-149 © Michael Paul/Living Inside; p 151 (01) © courtesy of John Lewis;
(02 & 04) © PINCH / photos: James Merrell; (03) © Lula Green / photo: Darrin Jenkins;
(05) © Garden Trading Ltd.; pp 152-167 © Andreas von Einsiedel; p 169 (01) courtesy of Heal's;
(02) © Vitra AG; (03) courtesy of Encompass Furniture & Accessories;
(04) courtesy of Maison Numen; (05) © Comptoir Azur; (06) © Fiskars Finland Oy Ab / photo:
Timo Junttila, Design: Timo Sarpaneva; p 174 © Ellie Cotton, Dandelion Photography

ICONS & PATTERNS/ICONS & MUSTER

(front & endpapers / Vor- und Nachsatz, p 2 & p 176) © designed by freepik.com

TEXT CREDITS/TEXTNACHWEISE

Words for Barn Home Inspiration adapted from original text by /
Scheuneninspirationen adaptiert aus einem Text von: Johanna Thornycroft
Words for Chateau Home Inspiration adapted from original text by /
Chateauinspirationen adaptiert aus einem Text von: Johanna Thornycroft
Words for Farmhouse Home Inspiration adapted from original text by /
Bauernhausinspirationen adaptiert aus einem Text von: Michael Paul
Words for Townhouse Home Inspiration adapted from original text by /
Stadthausinspirationen adaptiert aus einem Text von: Michael Paul
Words for Villa Home Inspiration adapted from original text by /
Villeninspirationen adaptiert aus einem Text von: Johanna Thornycroft

IMPRINT | IMPRESSUM

© 2017 teNeues Media GmbH & Co. KG, Kempen

Words/Texte **Claire Bingham**
Copy editing/Lektorat **Maria Regina Madarang (English)**,
Lucia Rojas, derschönstesatz (Deutsch)
Translation/Übersetzung (German/Deutsch) **Ronit Jariv, derschönstesatz**
Editorial management/Projektmanagement **Nadine Weinhold**
Design & Layout **Christin Steirat**
Production/Herstellung **Alwine Krebber**
Imaging & proofing/Bildbearbeitung & Proofing **Jens Grundei**

Published by teNeues Publishing Group

teNeues Media GmbH & Co. KG
Am Selder 37, 47906 Kempen, Germany
Phone: +49 (0)2152 916 0
Fax: +49 (0)2152 916 111
e-mail: books@teneues.com

Press department: Andrea Rehn
Phone: +49 (0)2152 916 202
e-mail: arehn@teneues.com

teNeues Publishing Company
7 West 18th Street, New York, NY 10011, USA
Phone: +1 212 627 9090
Fax: +1 212 627 9511

teNeues Publishing UK Ltd.
12 Ferndene Road, London SE24 0AQ, UK
Phone: +44 (0)20 3542 8997

teNeues France S.A.R.L.
39, rue des Billets, 18250 Henrichemont, France
Phone: +33 (0)2 48 26 93 48
Fax: +33 (0)1 70 72 34 82

www.teneues.com

English Edition
ISBN 978-3-8327-3496-1
Library of Congress Control Number: 2016957909

Deutsche Ausgabe
ISBN 978-3-8327-3497-8

Printed in the Czech Republic